Works of Love are Works of Peace

Mother Teresa of Calcutta
and the
Missionaries of Charity

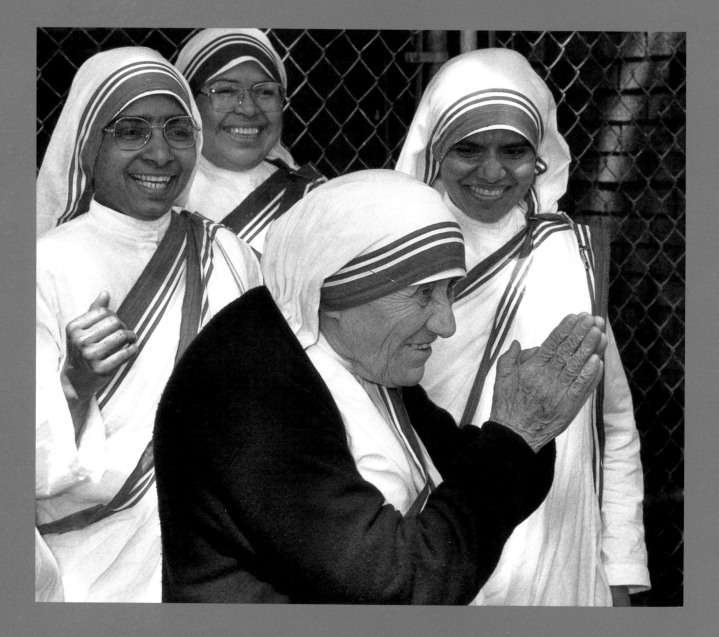

WORKS OF LOVE
ARE
WORKS OF PEACE

Mother Teresa of Calcutta
and the Missionaries of Charity

A Photographic Record by Michael Collopy

Quotes and Spiritual Counsel by Mother Teresa
With the Daily Prayers of the Missionaries of Charity

IGNATIUS PRESS • SAN FRANCISCO

Photographs copyright © by Michael Collopy

Cover design by Toki Design

© 1996 Ignatius Press, San Francisco
All Rights Reserved

ISBN 0-89870-561-4
Library of Congress catalogue number 96-76127

Printed in Hong Kong by C & C Printing Co., Ltd.

"Too Many Words…
Let Them Just See What We Do."
— Mother Teresa

Contents

Introduction

By Michael Collopy

I FIRST CAME TO KNOW ABOUT MOTHER TERESA through Malcolm Muggeridge's film *Something Beautiful for God,* which I saw while I was in high school. I remember being profoundly moved by what I saw—a simple woman serving the poor in Calcutta. A glowing light in the darkness of the modern world. Mother had such an impact on me that I began to try to find out more about her through books, magazines and newspaper articles.

It wasn't until years later, in 1982, that I attempted to meet her in person. I had heard that she was coming to the United States in order to establish a novitiate in San Francisco, and I wanted to see her and find out more about her and the work of the Missionaries of Charity. When she arrived in San Francisco, I had the opportunity to speak with her face to face. That brief encounter led to a greater friendship with Mother and the rest of her Sisters. It is a relationship that I have treasured and which has been very important to me in my life.

As my career as a portrait photographer was evolving, my interest grew in wanting to document the work of the Missionaries of Charity, primarily to make a portrait of Mother. Since I was blessed to have the novitiate in nearby San Francisco, I began to photograph the Sisters taking their vows and making their first profession in religious life. As I got to know them better, I spent time with them sharing in their work and prayer life without the camera. They treated me like part of their family. This to me was a great privilege.

My initial attempts to get Mother to sit for a formal portrait were unsuccessful. This was due in part to time constraints put on her because of her responsibilities as the General Superior of a world-wide religious order, and probably in no small part to the fact that she really doesn't enjoy having her picture taken and thinks she should spend her time doing other things. Finally, after a couple of phone calls and some letters spanning a period of two years, Mother finally gave in and agreed to be photographed—more as a favor to me and to the Sisters than anything else, I suspect.

The photographs that you will see in this book, though taken over the period of ten years, offer merely a glimpse into the life of this multi-faceted religious community and the people that they love and serve. Much of the life of the Missionaries of Charity is hidden in hours of prayer. Everything they do flows from and is an expression of their loving contact with God in prayer. In fact, their work cannot be understood properly outside the context of their prayer life. As Mother has said,

> "We did not come to be social workers but to belong to Jesus.
> Pray with Jesus, and Jesus will pray through you. All we do—our prayer,
> our work, our suffering—is for Jesus. Our life has no other reason or motivation.
> This is a point many people do not understand."

It is for this reason that in this book we include, published for the first time with Mother's special permission, an Appendix that contains the daily prayer book of the Missionaries of Charity as well as a very personal letter on prayer written by Mother to those in the Society. This daily prayer book and "I Thirst" letter give a new and incredibly deep insight into the interior life of Mother Teresa and the Missionaries of Charity. With gratitude we thank Mother for the permission to reprint her personal letter and these prayers, and we hope that they will be a source of spiritual light and encouragement to all who read and pray along with them.

I have never before in my life experienced such a profound sense of peace and joy as I have while being in the presence of Mother Teresa and the M.C. Sisters. Through these photographs, I wish to share with you what I have seen and convey a sense of how the Missionaries of Charity care, so beautifully, for the minds, bodies and souls of each individual they come in contact with—always seeing in each one Jesus Himself.

Perhaps there would be no better way to end this introduction and begin our "photographic journey" into the world of the Missionaries of Charity than with Mother's hopes for what may be accomplished in the pages of this book and the hearts of all who come across it:

> Let us pray that this book will draw people to Jesus,
> help them to realize how much God loves them,
> and help them to want to pray.

> Let it be for the glory of God and the good of His people.

God bless you.

Mother Teresa mc

Acknowledgements

I WOULD NEVER HAVE PURSUED THIS PROJECT had I not been given Mother's blessing for this work. In the years I have known her, she has always made time for me and given me her complete trust and support—always seeing in each project an opportunity for doing something beautiful for the greater glory of God.

I have been so deeply enriched by the experience of knowing Mother and the Missionaries of Charity. I give my heartfelt thanks to Mother Teresa and my loving Sisters in Christ—the M.C.s who opened up their lives and their world to embrace me—especially Sr. M. Sylvia, who, along with Sr. M. Kateri, died in an automobile accident on July 6, 1996, shortly before this book was to go to press. This book project would never have been accomplished without Sr. Sylvia who played a major role in its making with her inspiration and guidance. Sr. Sylvia was the first M.C. sister that I met, and I will be forever grateful for her love, laughter, spiritual example and infinitely tender thoughtfulness. May God reward you, Sr. Sylvia and Sr. Kateri. Besides my family, I dedicate this book to you.

I am also thankful for the careful direction of Roxanne Mei Lum whose tireless and selfless effort from conception to completion were essential in bringing this book together.

I owe much to Michael Jensen and the staff of Jensen Communications whose help was invaluable and truly a driving force through the production and publicity phases.

I would like to express my gratitude to Nila Santos for her support in the early stages of the work and to Richard Dunn and the Knights of Malta who supported the final stages of the print making process.

I would like to acknowledge Fr. Al Vucinovich for showing me the Malcolm Muggeridge film *Something Beautiful for God.* And Fr. Bob Cipriano and Fr. Matt Elshoff, O.F.M. Cap. who conducted the hours of interviews with Mother.

My appreciation also goes out to Kirk Michael Sanchez of HiFi Lab in San Francisco who so beautifully made the original photographic prints from which this book was reproduced, as well as to Roger Graham who helped in preparing the finished prints for reproduction.

My thanks also to Michi Toki for her thoughtful and sensitive design throughout the book.

To Joan Daschbach for her inspiration and friendship.

To my mother, and to my father, who has always been a mentor to me, whose direction and example were integral to this book and my formation as an artist. And finally, to God's greatest blessing in my life: my wife Alma and sons Sean and Paul. I love you and dedicate this book to you.

MAP OF THE MISSIONARIES OF CHARITY FOUNDATIONS WORLD-WIDE, 1996

The Vocation of the Missionaries of Charity

THE MISSIONARIES OF CHARITY GREW from small beginnings. The Society sprang from a simple response to the sufferings of human beings in a great city.

First one woman, Mother Teresa, then a little band of young volunteers went out on the streets of Calcutta. A million refugees thronged the city, which lacked food, shelter, and all resources for them. Earlier, a dreadful famine had dislocated the life of Calcutta and the surrounding province of Bengal.

Mother Teresa started in 1948 with a slum school to teach the children of the poor. In 1949, some of her former pupils joined her. As Sister Teresa, a Sister of Loreto, Mother Teresa had been a teacher for twenty years. When they found men, women, and children dying on the streets, they took them to hospitals, sometimes in a wheelbarrow. When the hospitals, already full, had to turn them away, the group rented a room so that they could care for helpless people otherwise condemned to die in the gutter.

"In the choice of works", explained Mother Teresa, "there was neither planning, nor preconceived ideas. We started our work as the sufferings of the people called us. God showed us what He wanted us to do."

In 1950, the group was established by the Church as a Diocesan Congregation of the Calcutta Diocese. It was known as the Missionaries of Charity. The spirit was that of seeing Jesus in every person, in the "distressing disguise", especially of the poorest person, of the person lying in the gutter or suffering from leprosy. The Sisters took, in addition to the three vows of poverty, chastity and obedience, a fourth vow, "to give wholehearted and free service to the poorest of the poor". To be able to understand the poor, the Sisters choose poverty, which has become, says Mother Teresa, "their freedom, joy, and strength".

Schools were started to give free instruction to street and slum children. A Home for the Dying was opened in 1952 in space made available by the Corporation of Calcutta, namely, the Pilgrims' Hostel of the Temple of Kali. Shortly afterward, a home was opened for children found abandoned and dying. Soon there were enough Sisters to open Mother and Child Clinics and eventually a mobile medical service for groups of people suffering from leprosy.

The Congregation of Missionaries of Charity was recognized by the Vatican as a Pontifical Congregation in 1965.

The Missionaries of Charity could then begin work outside India. Already there were communities of the Missionaries of Charity in most of the large cities of India. Invitations to work for the poor came to the Missionaries of Charity from corners of need in the entire world. Only when the invitation came from the local bishop, could the Sisters respond. Communities of Missionaries of Charity moved among the sick, the needy, and unwanted in over thirty countries in Asia, Australia, Africa, Latin America, Central America, Europe, and North America.

The Missionary Brothers of Charity, founded in 1963, are working in Calcutta and other cities of India as well as in several countries overseas.

The Co-Workers of Mother Teresa were affiliated with the Missionaries of Charity in 1969.

The Co-Workers consist of people of all religions and denominations throughout the world who seek to love God in their fellow men through wholehearted free service to the poorest of the poor and who wish to unite their lives in a spirit of prayer and sacrifice with the work of the Missionaries of Charity.

The Missionary of Charity Fathers were founded in 1984.

Sisters, Brothers and Fathers of the Missionaries of Charity can be "adopted spiritually" by a Sick or Suffering Co-Worker, and the M.C.s in their turn will pray for their sick and suffering "links". As Mother Teresa has written, "I want especially the paralyzed, the crippled, the incurables to join. How happy I am to have you all—often when the work is very hard I think of each one of you, and tell God—look at my suffering children and for their love, bless this work. You are a Treasure House, the Power House of the Missionaries of Charity."

Keep the joy of
loving the Poor
and share this joy
with all you meet
Remember
Works of love are
Works of Peace
God bless you
Mc Teresa mc

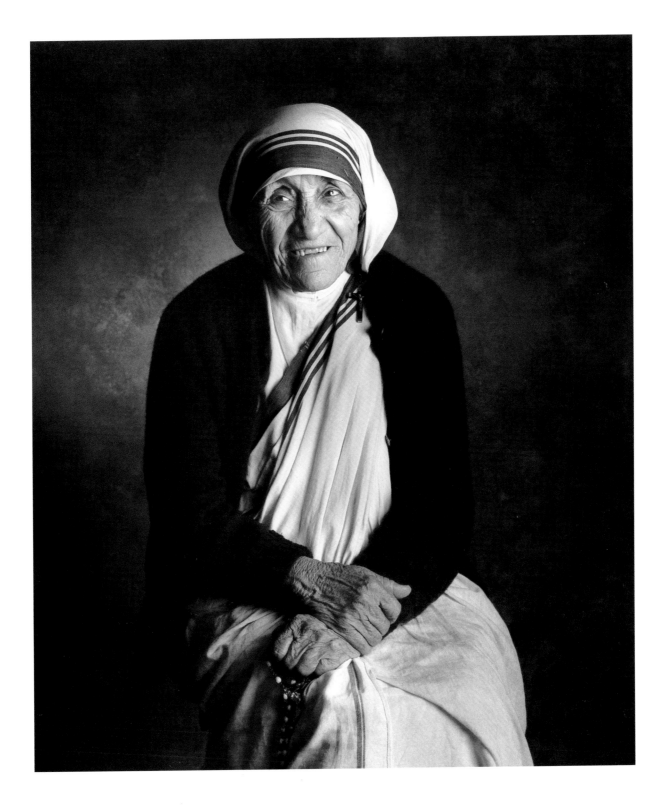

MOTHER TERESA, 1989

Yesterday is gone.

Tomorrow has not yet come.

We have only today.

Let us begin.

FRONT DOOR, MOTHER HOUSE, CALCUTTA, 1995

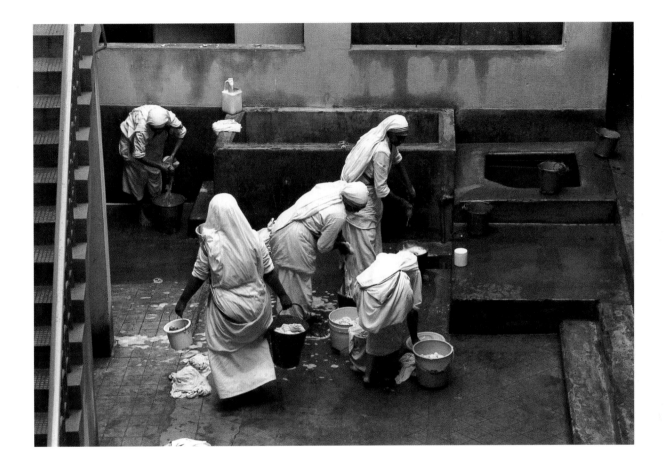

17

MORNING CHORES AT THE MOTHER HOUSE, 1995

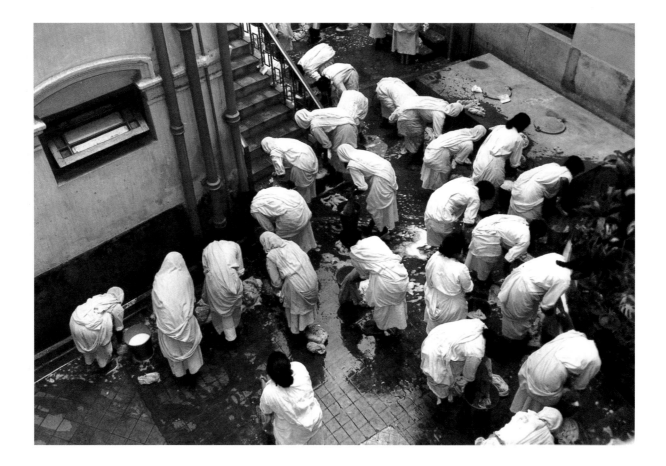

I arrive at the Mother House at around 4:45 A.M. There is the smell of fragrant incense in the air and I see the Sisters washing their saris (one of two for daily wear), each in her own bucket. Like the other poor people of Calcutta, they share a pump. Two pumps for three to four hundred Sisters. I go upstairs to the chapel and find Mother already praying in the back. I wonder when or how long she sleeps—her days seem long. After Mass, Mother insists that we go down for breakfast—tea, bread and bananas. When I go back upstairs to find out which house I will visit today, I find Mother down on her knees cleaning just like the rest of the Sisters. — M. Collopy

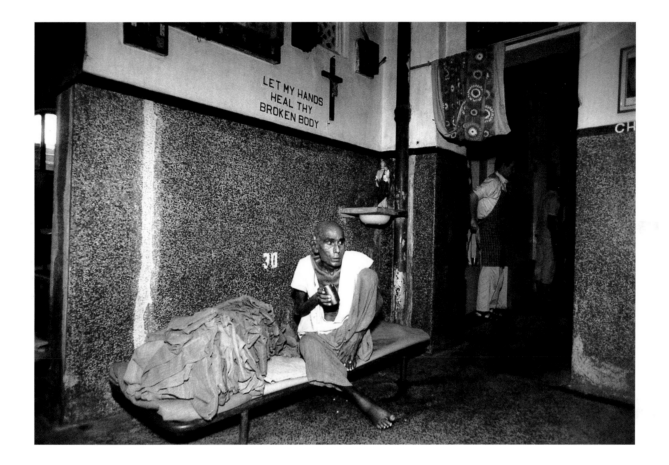

Nirmal Hriday, Kalighat, the Home for the Dying, 1995

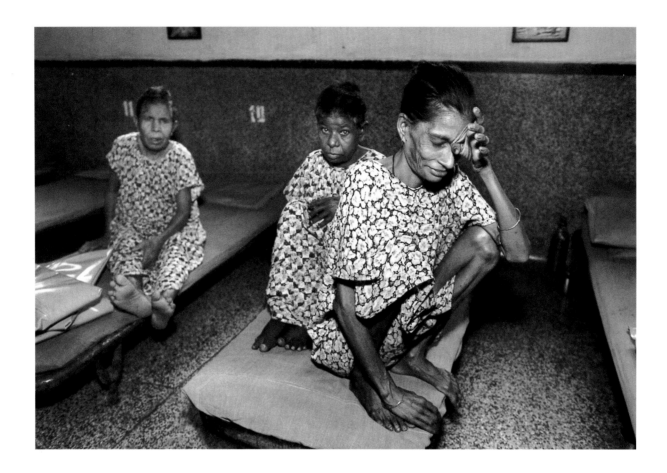

When I arrived at Kalighat, the home for the dying, I thought that I would be prepared for anything I might see. It is the shocking smell of death, disease, excrement and decay, however, that hits me first and hardest as I walk in. Looking around I see people experiencing real suffering. Some have gaping wounds with bones exposed. There is the sound of constant coughing and spitting. I keep my lips sealed as tightly as possible. Those who have died are wrapped in shrouds and taken out. Even though I am a professional photographer by trade, I find it hard to take pictures here. I pass up on a lot of shots. Despite the intensity of the situation, I am struck by the pervading sense of peace that is here. And the special luminosity. A very unusual light. — M. Collopy

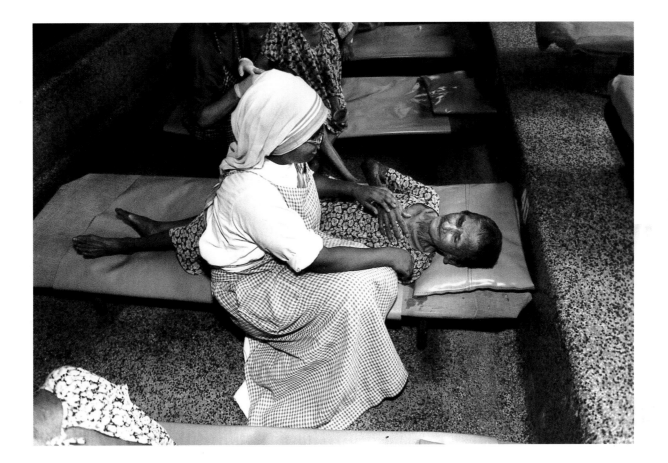

21

Home for the Dying, 1995

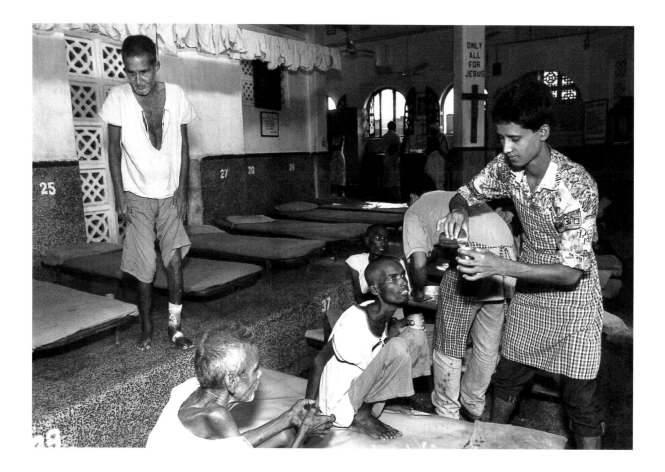

Home for the Dying, 1995

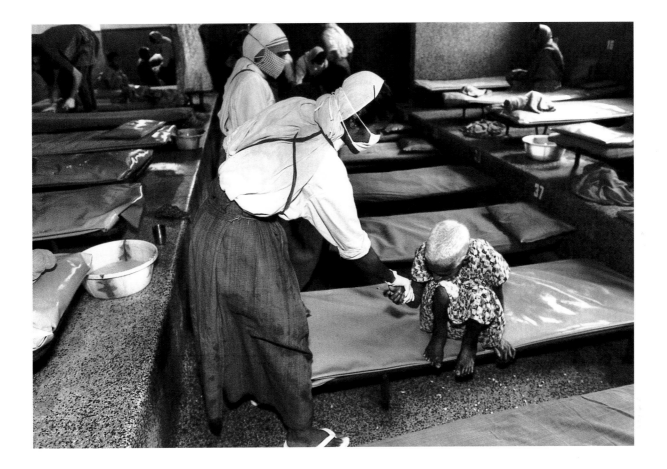

23

HOME FOR THE DYING, 1995

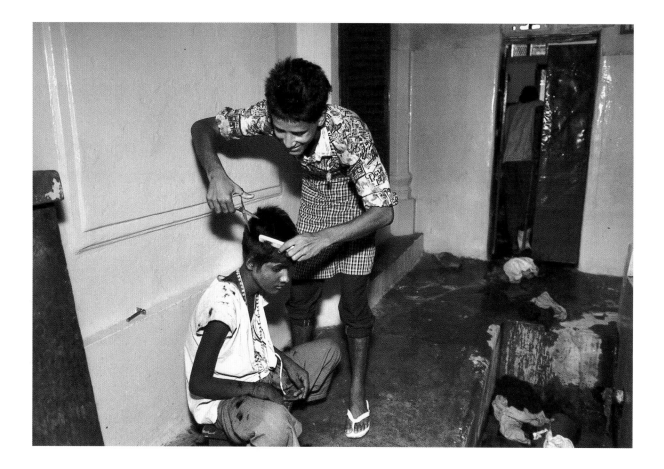

Like Jesus we belong to the whole world living not for our-
selves but for others. The joy of the Lord is our strength.

HOME FOR THE DYING, 1995

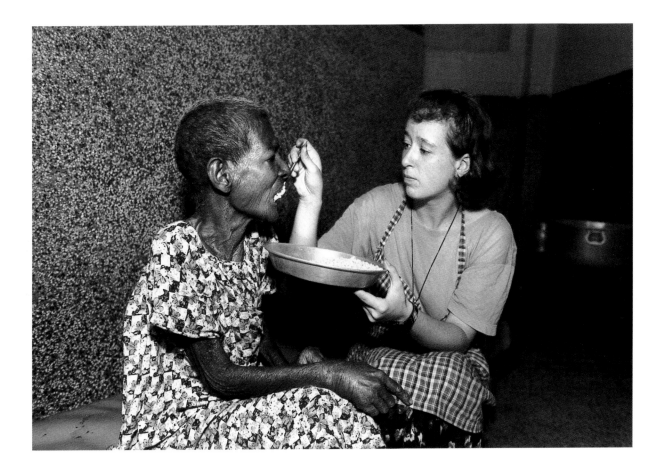

HOME FOR THE DYING, 1995

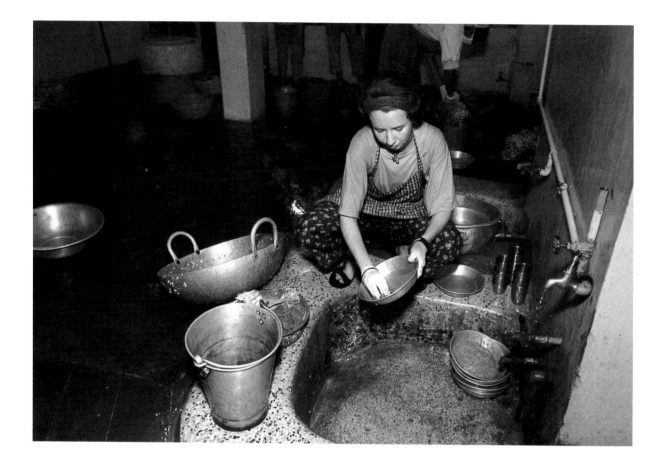

VOLUNTEER AT THE HOME FOR THE DYING, 1995

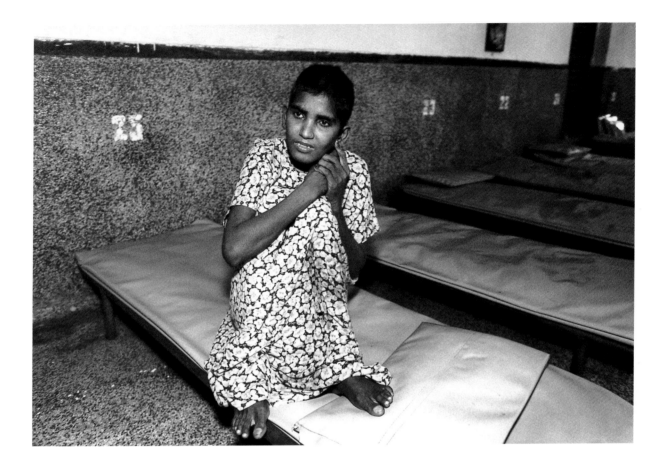

There was a young woman there that looked healthy compared to the others. I wondered why she was there. Later, a Sister told me that the girl had been living out on the streets and had come down with tuberculosis. She probably wouldn't be living long. — M. Collopy

HOME FOR THE DYING, 1995

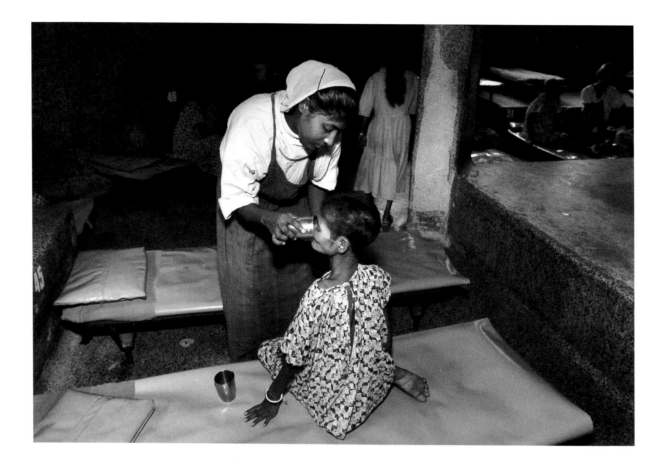

Every act of love is a work of peace no matter how small.

HOME FOR THE DYING, 1995

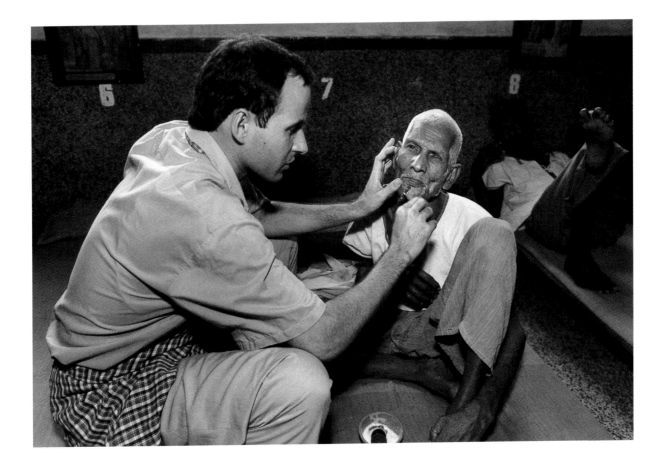

29

Home for the Dying, 1995

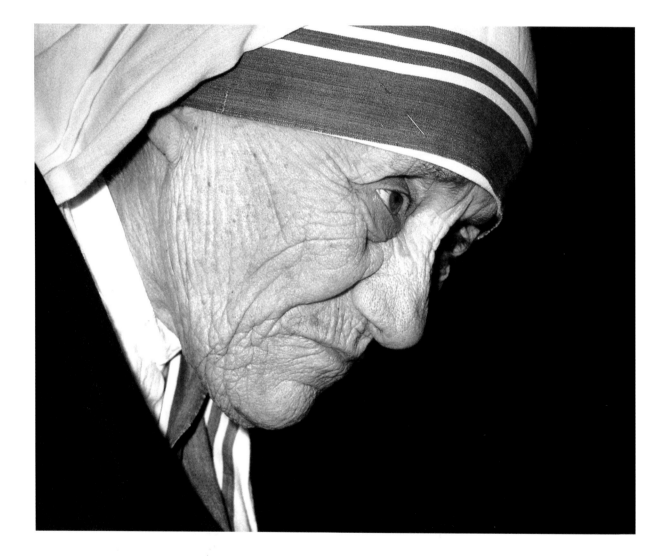

Seeking the face of God in everything, everyone, everywhere, all the time and seeing His hand in every happening is contemplation. No contemplation is possible without asceticism and self abnegation.

Love to be real, it must cost—it must hurt—it must empty us of self.

HOME FOR THE DYING, 1995

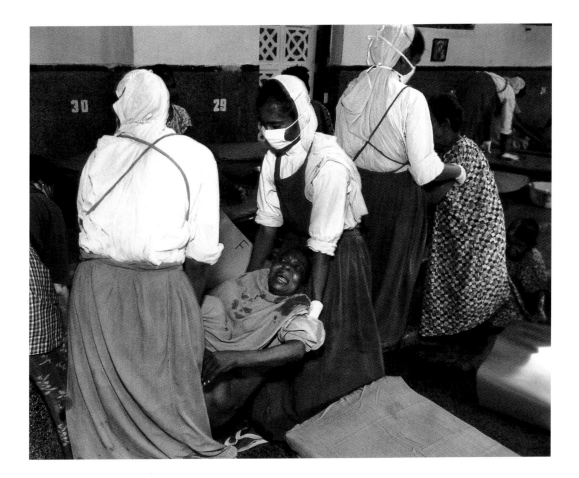

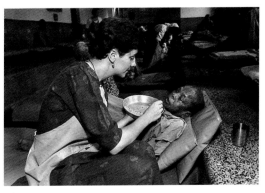

KALIGHAT, HOME FOR THE DYING, 1995

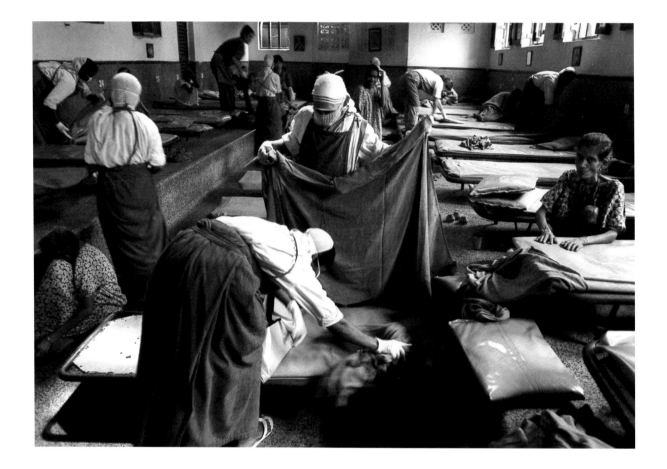

HOME FOR THE DYING, 1995

33

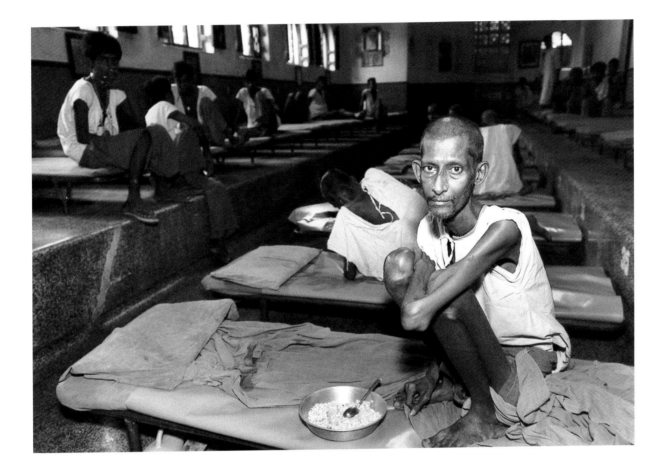

HOME FOR THE DYING, 1995

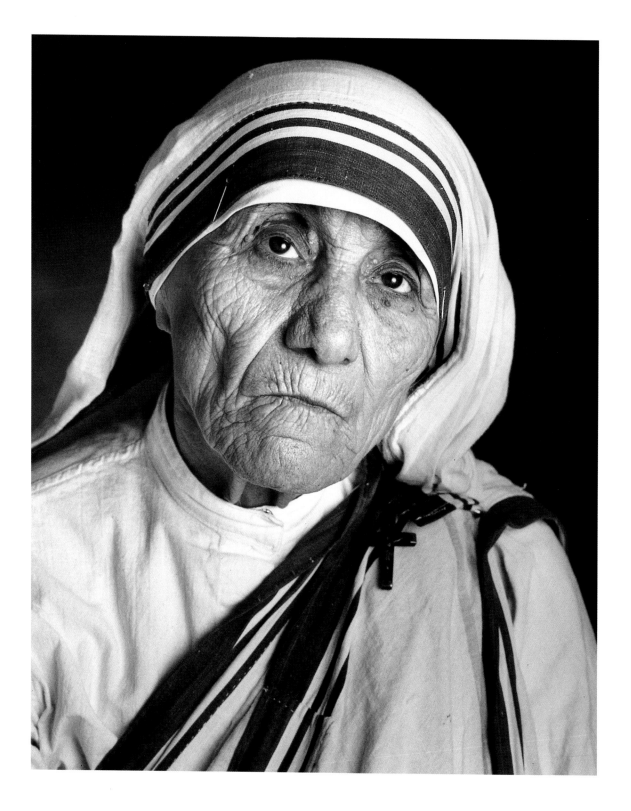

MOTHER TERESA, 1987

I NEVER LOOK AT THE MASSES AS MY RESPONSIBILITY.
I look only at the individual. I can love only one person at a time.
I can feed only one person at a time.

Just one, one, one.
You get closer to Christ by coming closer to each other. As Jesus
said, "Whatever you do to the least of my brethren, you do it
to me."

So you begin…I begin.

I picked up one person—maybe if I didn't pick up that one
person I wouldn't have picked up the others.

The whole work is only a drop in the ocean. But if we don't
put the drop in, the ocean would be one drop less.

Same thing for you. Same thing in your family. Same thing
in the church where you go. Just begin…one, one, one.

AT THE END OF OUR LIVES, we will not be judged by
how many diplomas we have received, how much money we
have made or how many great things we have done. We will be
judged by "I was hungry and you gave me to eat. I was naked
and you clothed me. I was homeless and you took me in."

Hungry not only for bread—but hungry for love.

Naked not only for clothing—but naked of human dignity
and respect.

Homeless not only for want of a room of bricks—but homeless
because of rejection.

This is Christ in distressing disguise.

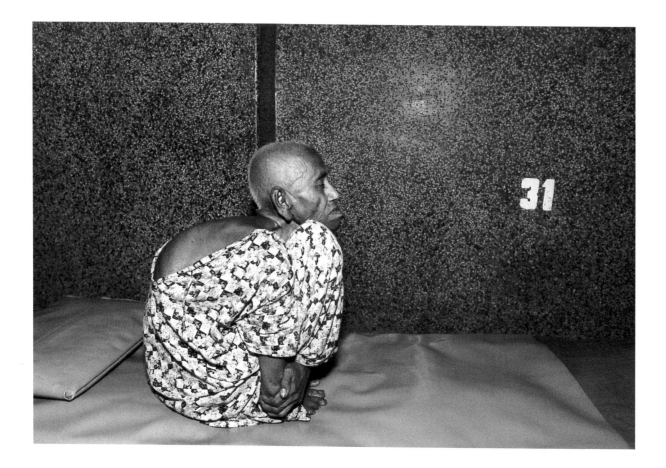

The Sisters tell me that this woman was a beggar all her life. She stays in this position all day. She is bent, bowed and twisted yet her head is held high and dignified. She does not speak or cry out. All she wants is to be caressed.

— M. Collopy

HOME FOR THE DYING, 1995

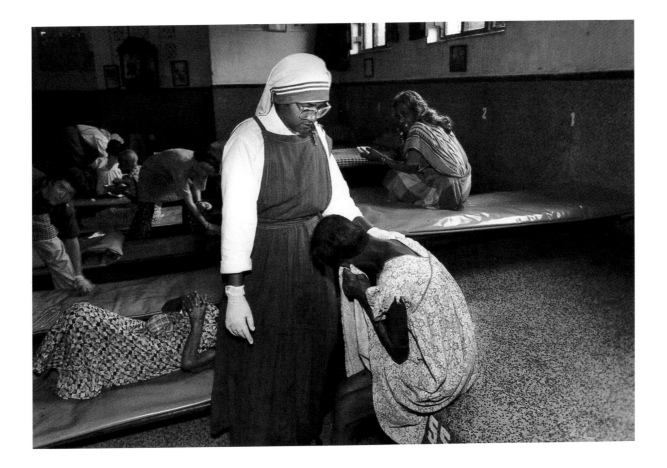

HOME FOR THE DYING, 1995

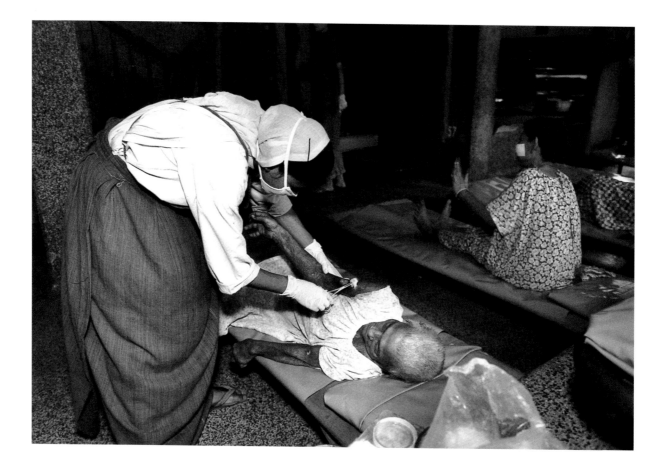

HOME FOR THE DYING, 1995

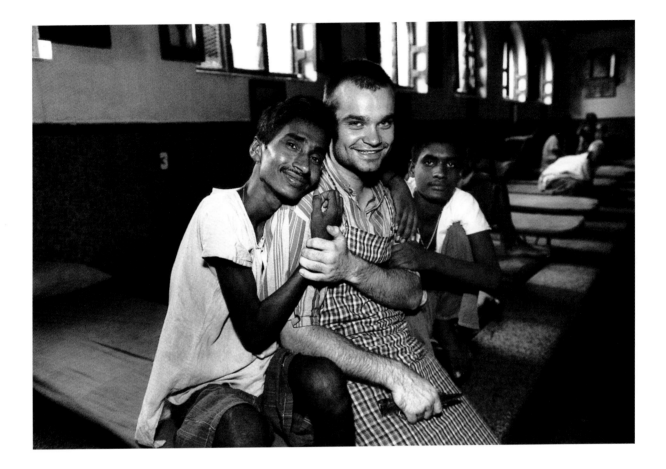

HOME FOR THE DYING, 1995

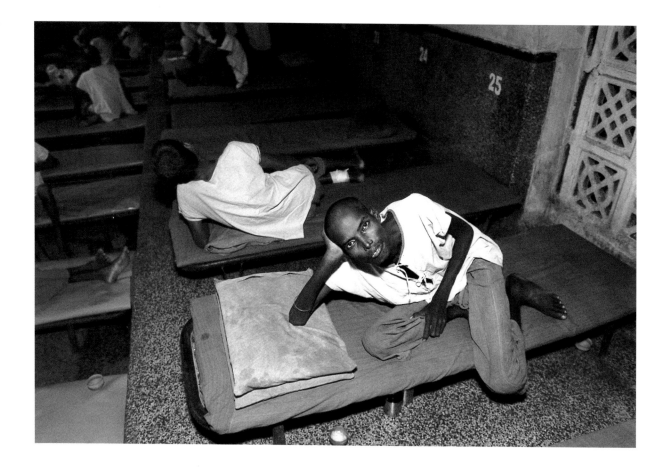

HOME FOR THE DYING, 1995

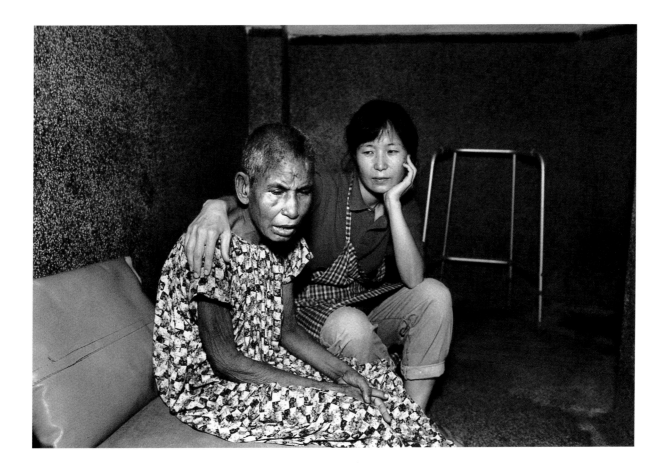

When people come from other countries from around the world, sometimes communication in a common language is impossible. The "language" of a simple touch and sympathetic glance, however, is universal. — M. Collopy

HOME FOR THE DYING, 1995

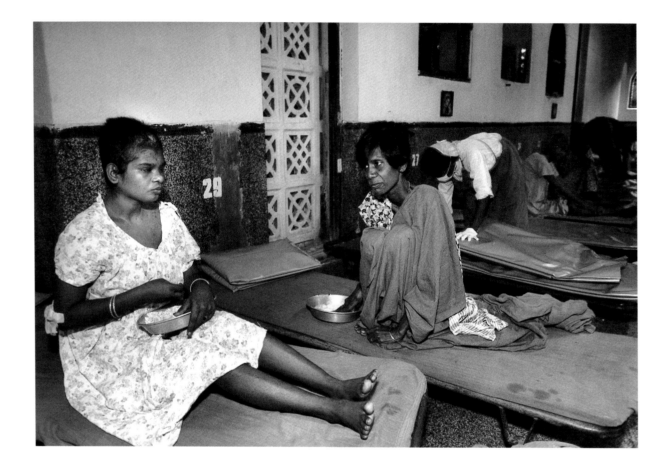

HOME FOR THE DYING, 1995

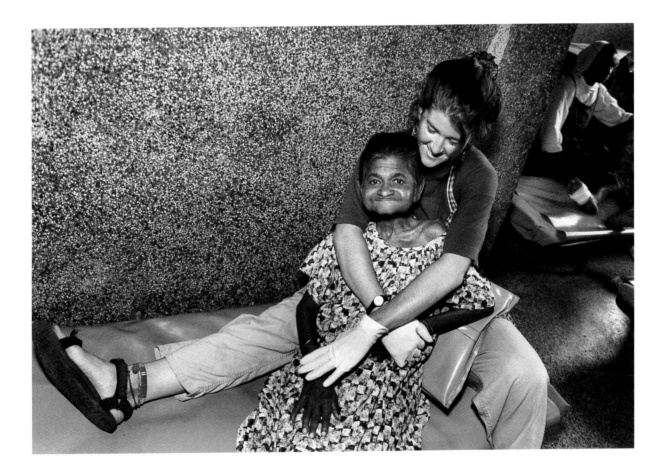

It really made an impression on me to see the genuine love and care of the Sisters, Brothers and volunteers for the sick and dying. They would get in there and do anything they could to comfort these people in their need; feed them, bathe them, change them, dress their wounds, talk with them, embrace them. I look at the volunteers and think to myself, "Here are normal, ordinary looking people. They could be my neighbors from back home."

— *M. Collopy*

HOME FOR THE DYING, 1995

44

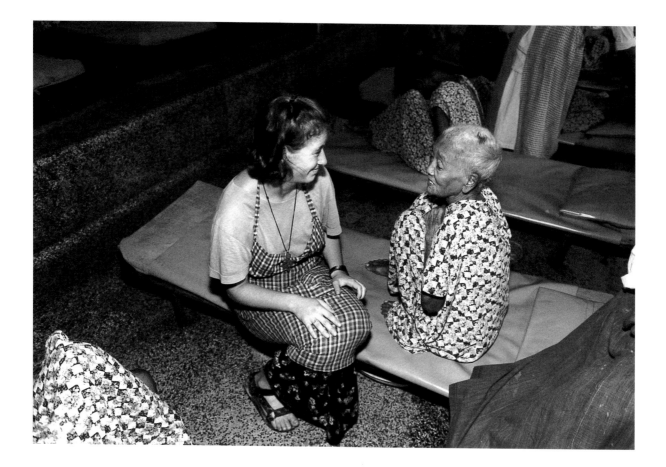

Home for the Dying, 1995

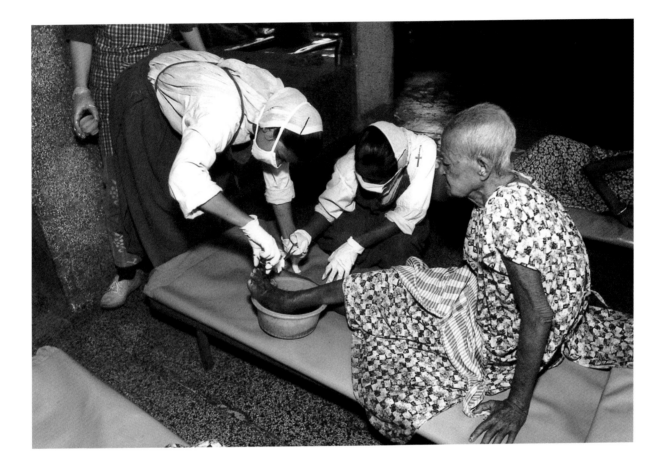

HOME FOR THE DYING, 1995

WE TAKE GREAT CARE of the dying. I am convinced

that even one moment is enough to ransom an entire miserable

existence, an existence perhaps believed to be useless. All souls

are precious to Jesus, who paid for them with His blood.

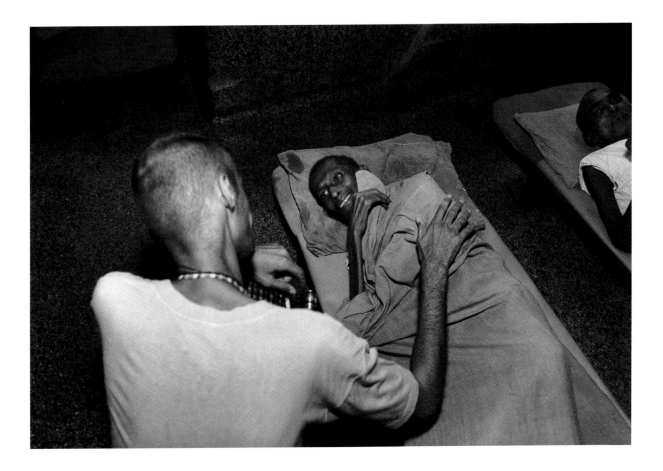

Today I saw a man struggling for life, very close to death being comforted by a volunteer. He was so grateful for the littlest things done for him. His smile is something I will never forget. — M. Collopy

HOME FOR THE DYING, 1995

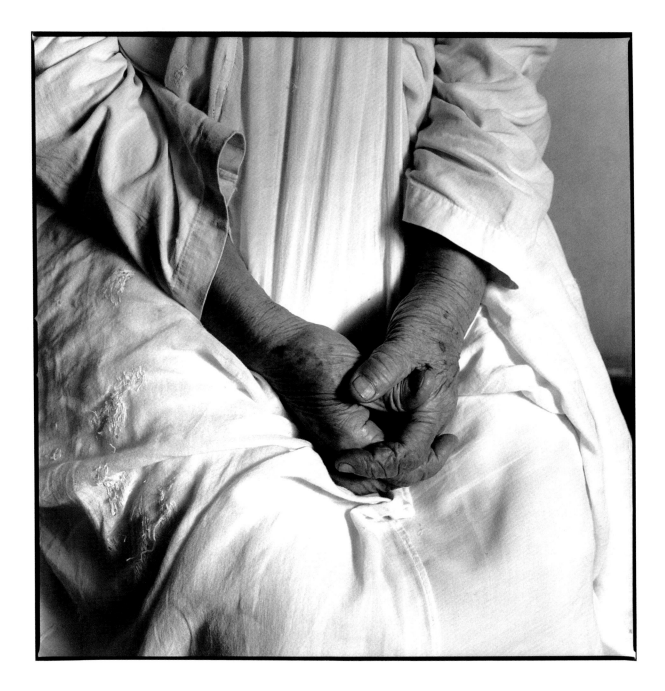

THE HANDS OF MOTHER TERESA, 1995

RADIATING CHRIST

Dear Jesus,
Help us to spread Your fragrance everywhere we go.
Flood our souls with Your Spirit and life.
Penetrate and possess our whole being, so utterly,
 that our lives may only be a radiance of Yours.
Shine through us, and be so in us,
 that every soul we come in contact with
 may feel Your presence in our soul.
Let them look up and see no longer us, but only
Jesus.
Stay with us, and then we shall begin to shine
 as You shine;
So to shine as to be a light to others.
The light , O Jesus, will be all from You,
 none of it will be ours;
It will be You shining on others through us.
Let us thus praise You in the way you love best
 by shining on those around us.
Let us preach you without preaching,
 not by words but by our example,
By the catching force, the sympathetic influence
 of what we do,
the evident fullness of the love our hearts bear to
You. Amen.

— JOHN HENRY CARDINAL NEWMAN

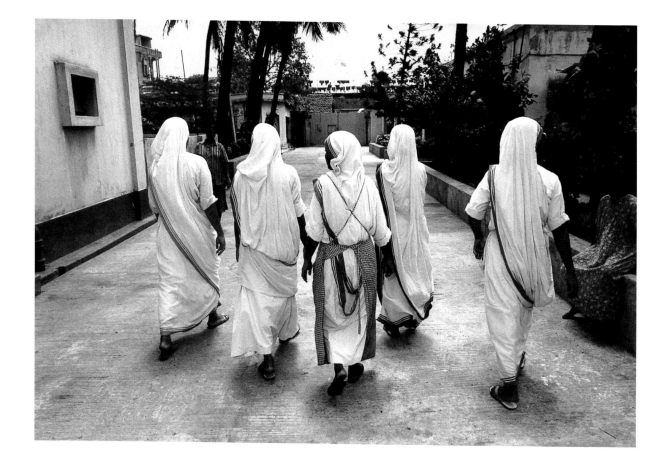

THE SISTERS AT PREM DAN, HOME FOR THE ELDERLY AND THE MENTALLY HANDICAPPED, CALCUTTA, 1995

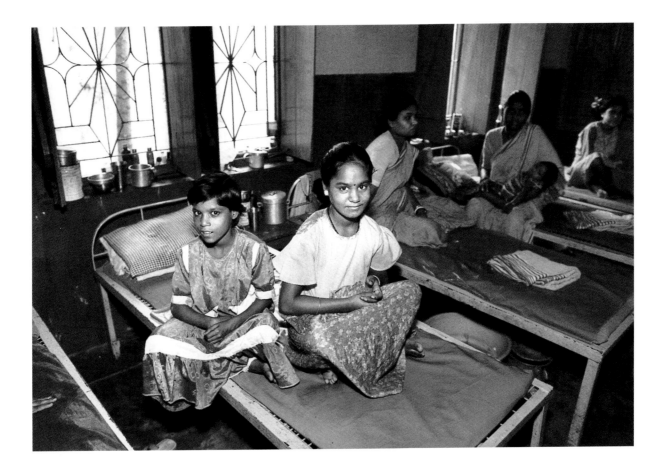

Today I walk through Titagarh with one of the Missionary of Charity Fathers. I meet two beautiful young girls. After we leave them, Father tells me that their parents abandoned them after finding out that they, the girls, had leprosy. How sad they must feel. My heart cries out. I think of my own children back home. — M. Collopy

TITAGARH, LEPROSY CENTER, GANDHIJI PREM NIVAS (ABODE OF LOVE), 1995

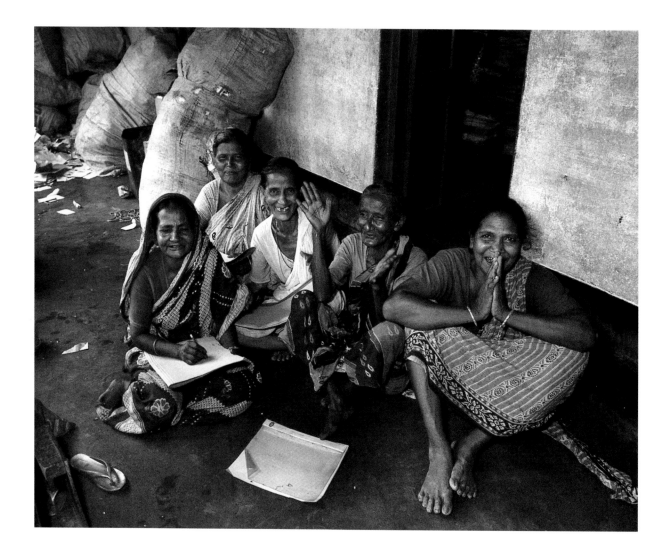

One thing that has made a real impression on me is the interior beauty of the Indian people. Even in the worst of material circumstances they are dignified and gracious. They smile easily and genuinely. They are so welcoming.
— M. Collopy

WOMEN ON THE STREETS OUTSIDE PREM DAN, 1995

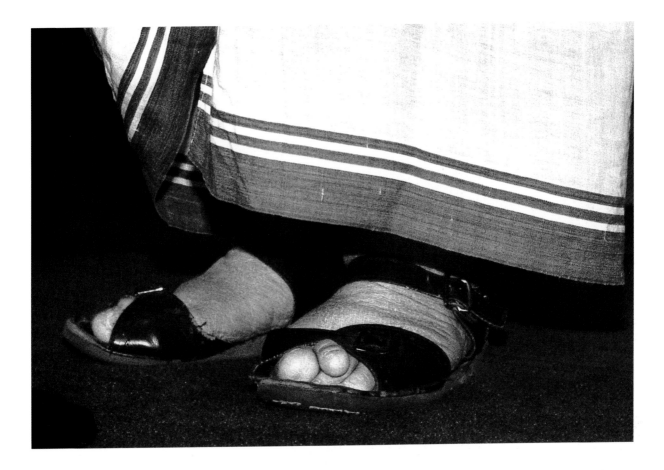

Of my free will, dear Jesus, I shall follow You wherever
You shall go in search of souls, at any cost to myself and
out of pure love of You.

THE FEET OF MOTHER TERESA, 1991

WE HAVE THOUSANDS OF LEPERS here. They are so great, so beautiful in their disfigurement! In Calcutta, we have a Christmas party for them every year. Once I went to them and I told them that what they have is the gift of God, that God has a very special love for them, that they are very dear to Him, that what they have is not a sin. One old man who was completely disfigured tried to come nearer to me, and he said, "Please repeat that once more. It did me good. I have always heard that nobody loves us. It is wonderful to know that God loves us. Please say that again!"

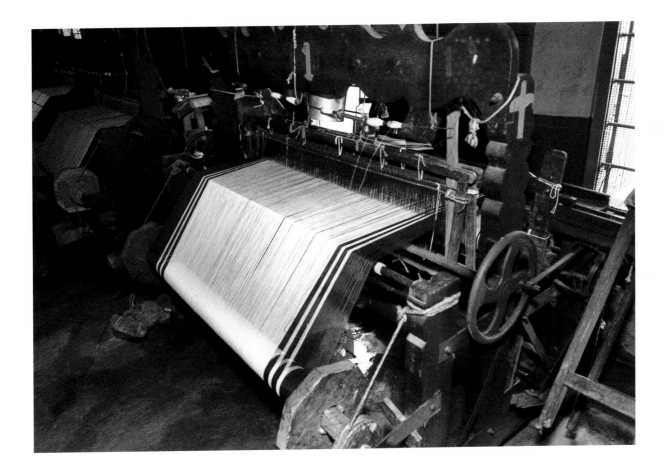

The lepers here make all of the Sisters' saris. It is really a labor of love for them and they are so happy to be able to do something for the Sisters. I am told that some, even with only stumps for hands are able to work the loom.

— M. Collopy

LOOM USED TO MAKE THE SISTERS' SARIS, TITAGARH, 1995

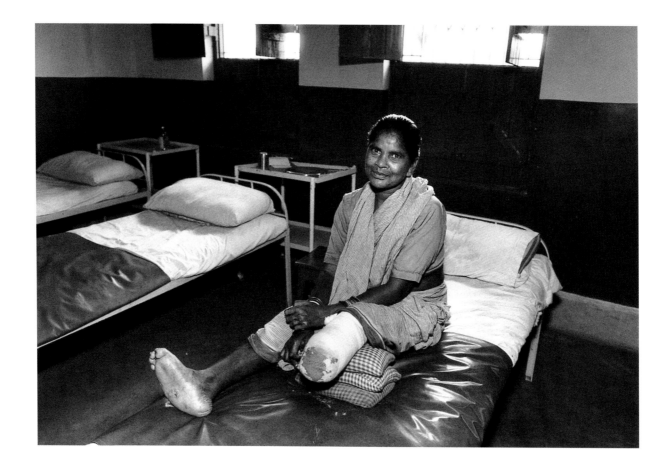

Father brings me into the first room. I see two women. One is sleeping and the other greets me with a beautiful, serene smile. Our eyes meet. Then it takes me a moment to realize that one of her legs has just been amputated. I am stunned. I hope I did not stare at her too long. — M. Collopy

TITAGARH, 1995

STANDARD ARTIFICIAL LIMB MADE AT TITAGARH, 1995

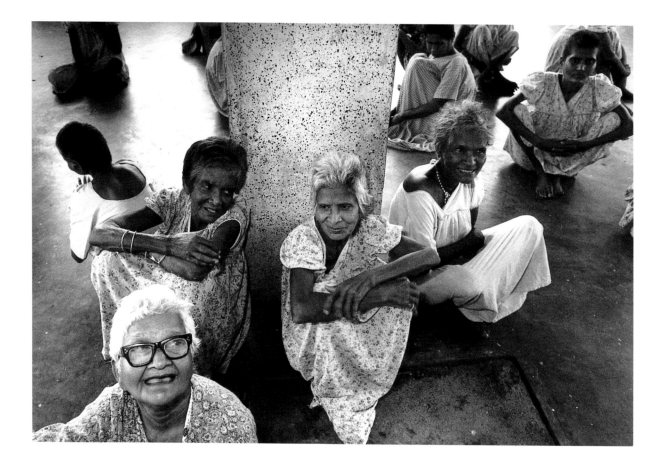

We will never know how much just a simple smile can do.

PREM DAN, 1995

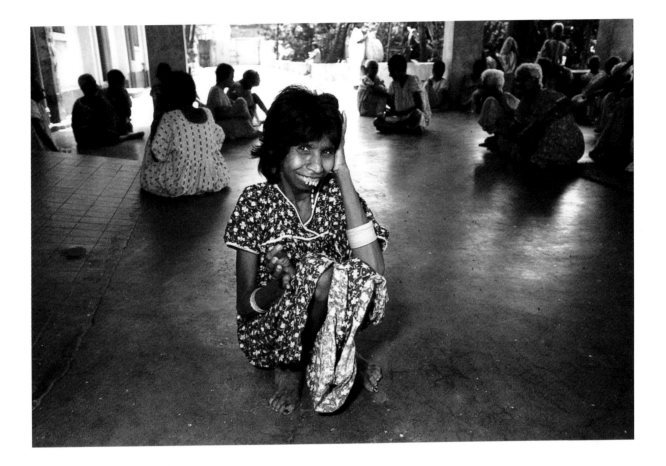

59

PREM DAN, 1995

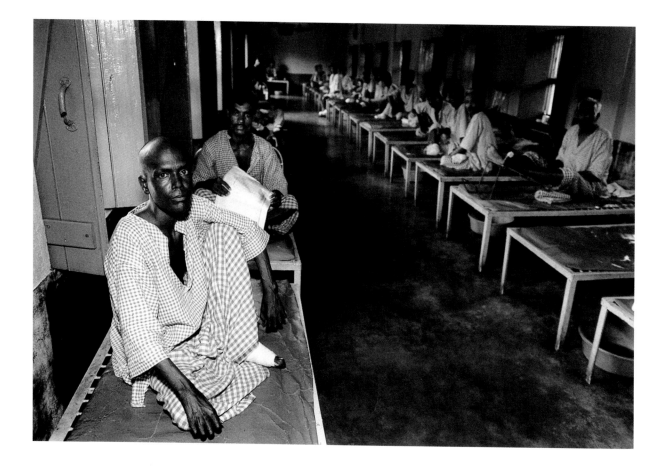

I saw a vast hall filled with men suffering from leprosy. Many of them were soaking their wounds. Although there were so many of them, the place was silent. There seemed to be little interaction among them. I wondered why and a Brother told me that theirs is a disease that isolates. That they are rejected by society and have no one to cry out to, so they don't even bother. It is hard for me to understand exactly what it is that they are going through. Still I am greeted with gracious nods. One man even walks up to me and kisses my feet—I feel entirely unworthy of such a greeting. — M. Collopy

TITAGARH, 1995

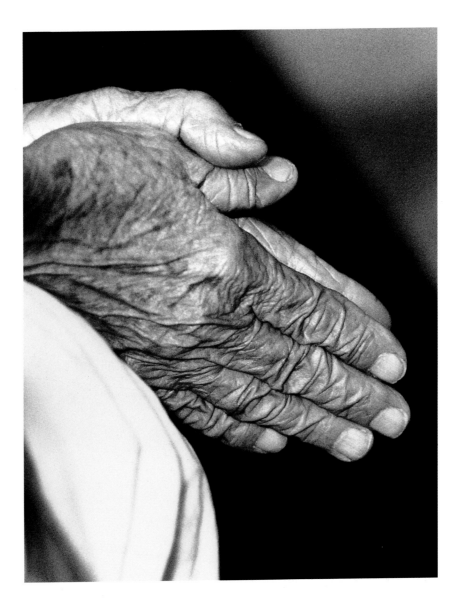

Be not afraid. God loves you and wants us to love one
another as He loves us. As miserable, weak and shameful
as we are, He loves us with an infinitely faithful love.

MOTHER TERESA IN PRAYER, 1995

62

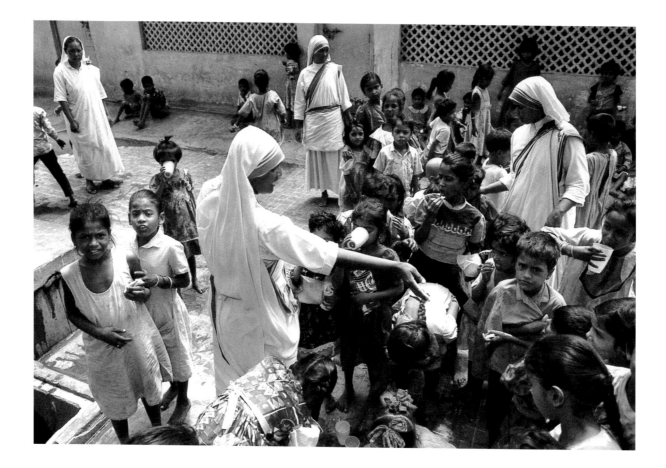

ORPHANED CHILDREN WITH SISTERS AT PREM DAN, 1995

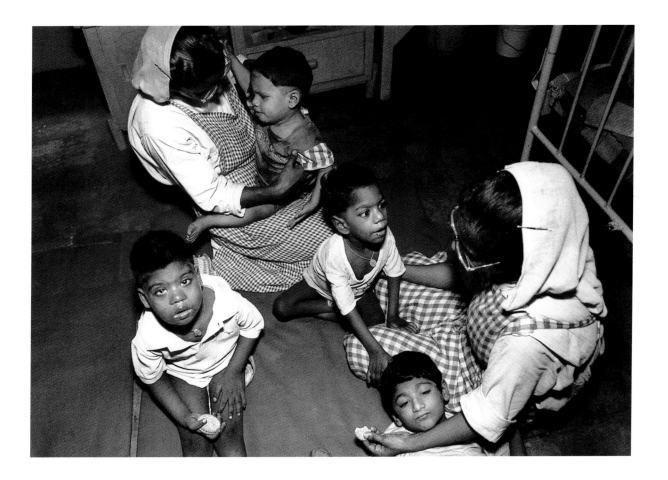

The life of every human being is sacred as the creation
of God, and is of infinite value because He created each
person, including the unborn child.

SHISHU BHAVAN, 1995

LET US ASK OUR LADY

to give us her heart,

so beautiful,

so pure,

so immaculate,

so full of love and humility,

that we may be able to receive Jesus in

the Bread of Life,

love Him as she loved Him,

and serve Him in the distressing disguise

of the poorest of the poor.

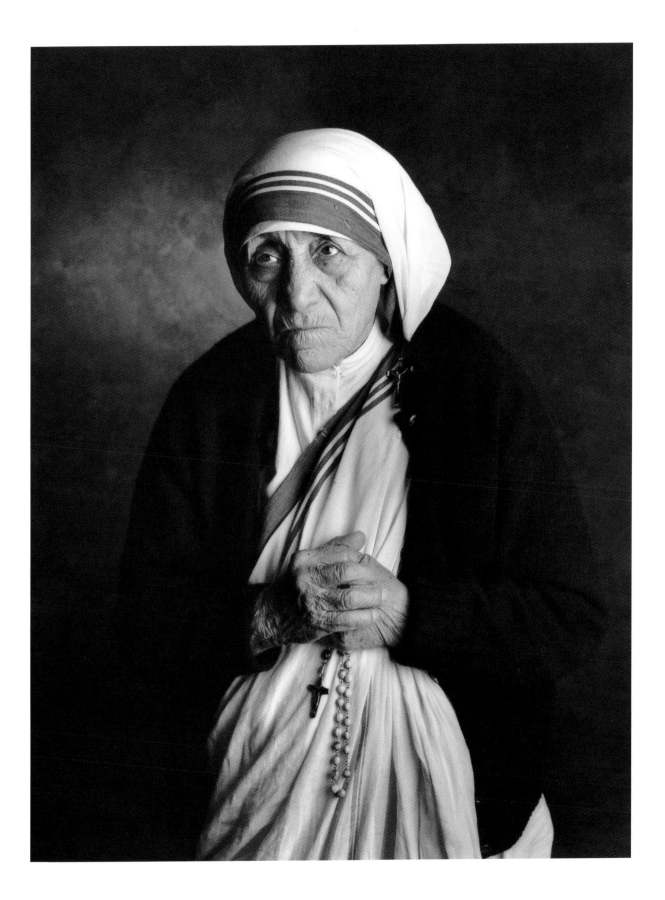

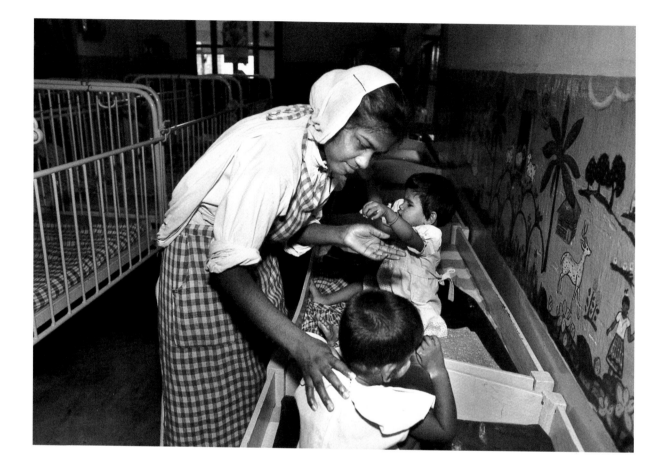

Jesus is the little one—to embrace Him. We will give
them not only our hands to serve, but our hearts to love.

SISTER HELPING TWO BLIND ORPHANS, SHISHU BHAVAN, 1995

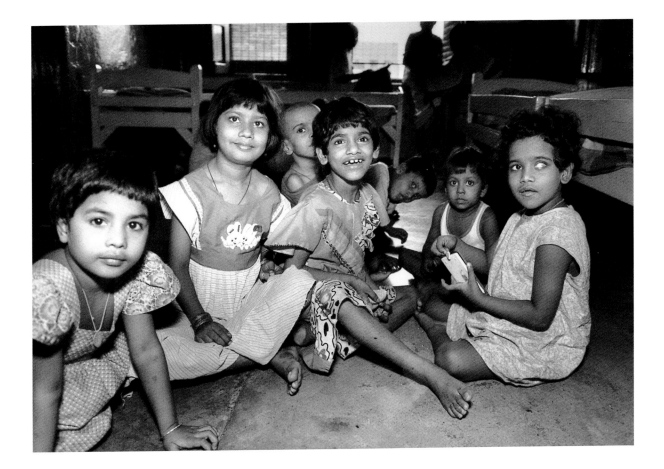

SHISHU BHAVAN, 1995

PREM DAN, 1995

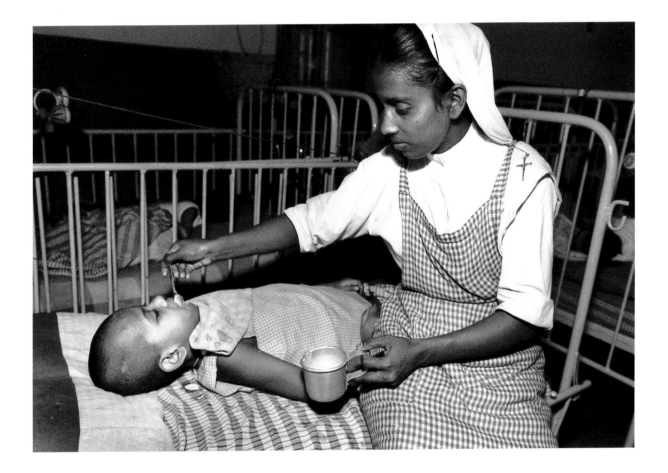

Shishu Bhavan, 1995

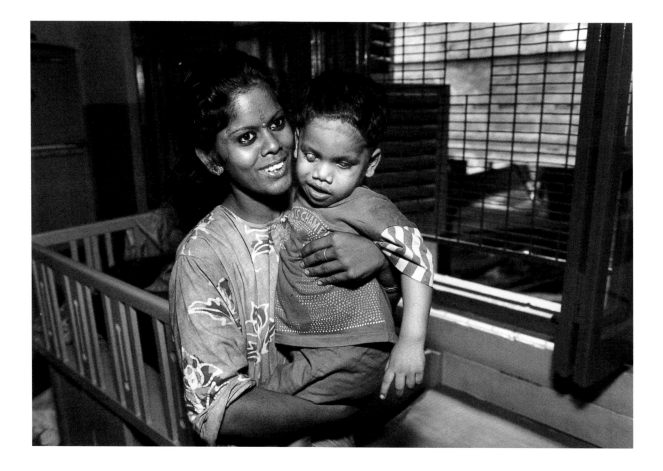

There was a blind boy at the home for orphans. There was something terribly wrong with his eyes. He received such tender love and affection from the Sisters and the volunteers. They would pick him up and talk to him and give him hugs. I remember his laugh being so infectious. — M. Collopy

SHISHU BHAVAN, 1995

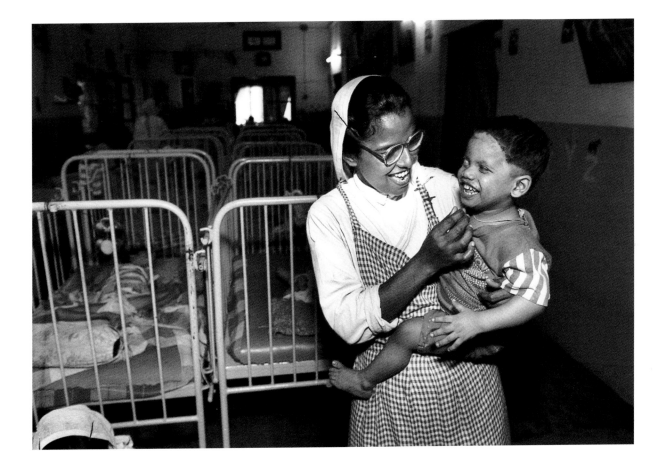

SHISHU BHAVAN, 1995

THE POOR MUST KNOW that we love them, that they are wanted. They themselves have nothing to give but love. We are concerned with how to get this message across. We are trying to bring peace to the world through our work. But the work is the gift of God.

WE DO NOTHING. He does everything. All glory must be returned to Him. God has not called me to be successful. He has called me to be faithful.

PRAY FOR US that we may not spoil God's work.

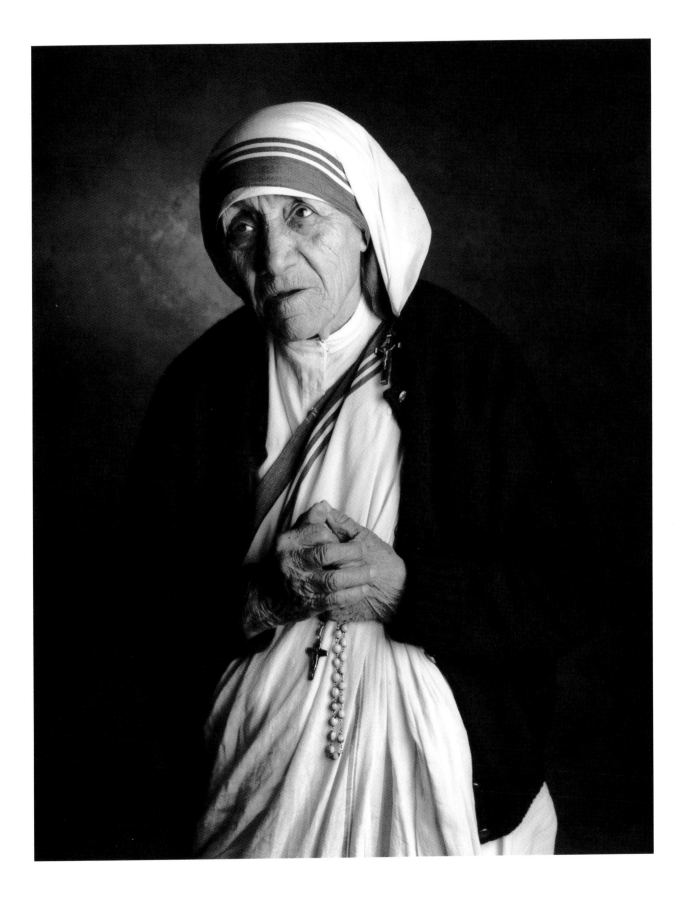

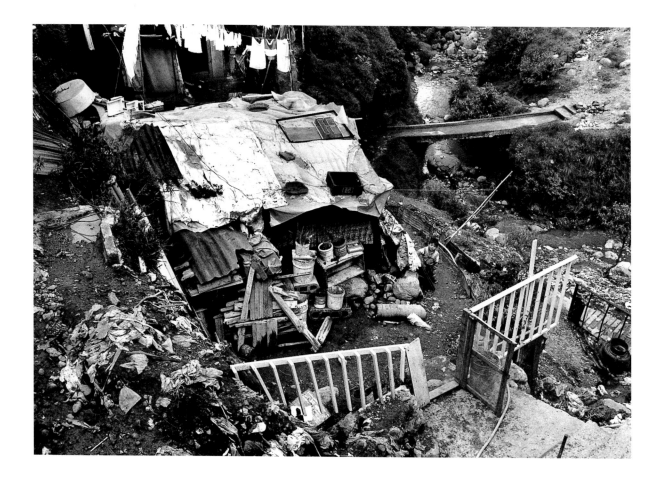

There was a place I saw in Mexico where the Sisters go—the most severe poverty I have seen in the West. It was a little city built up on a garbage dump. Houses were made out of anything people could find—tar, cardboard, scraps of rusting metal, etc. The soil was layered with decaying debris. The stench was nauseating. Bubbling liquids with a chemical odor oozed up from the ground. Amidst all this I notice a young boy in front of his home.

— M. Collopy

OUTSIDE MEXICO CITY, 1990

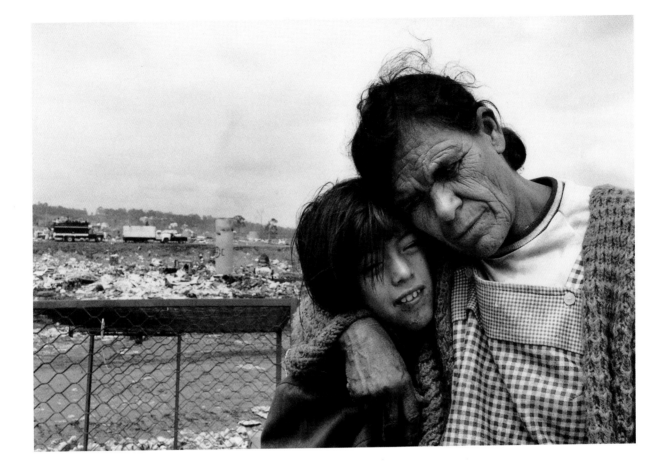

75

I met a woman living in the dump. She looked old beyond her years. She was worried about her daughter who had gone out to the dump to search for a doll to play with. The daughter hadn't been seen for a while so the mother went out to look for her. She was so relieved to find her safe and sound. — M. Collopy

OUTSIDE MEXICO CITY, 1990

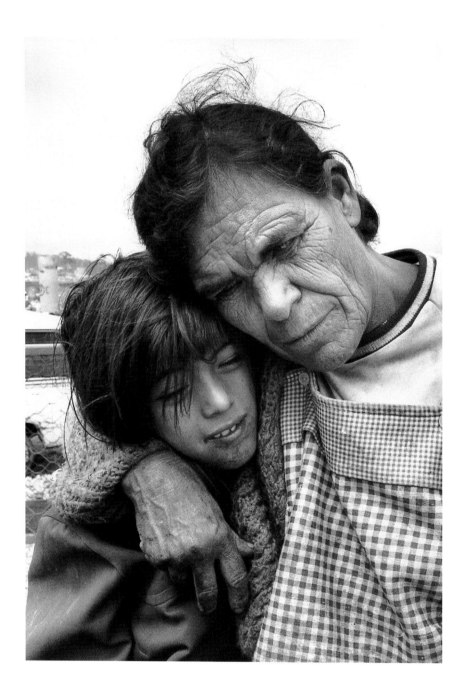

OUTSIDE MEXICO CITY, 1990

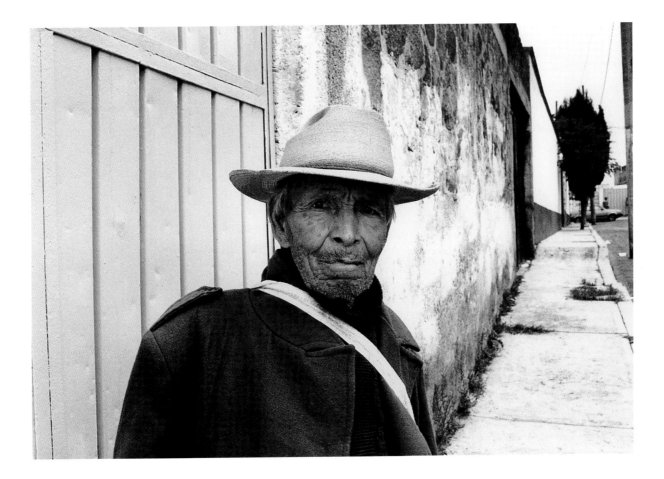

OUTSIDE MEXICO CITY, 1990

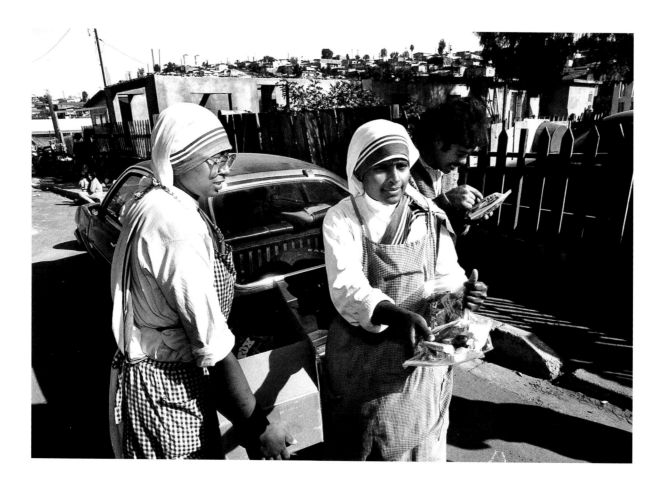

SISTERS DISTRIBUTING DONATED FOOD, TIJUANA, MEXICO, 1993

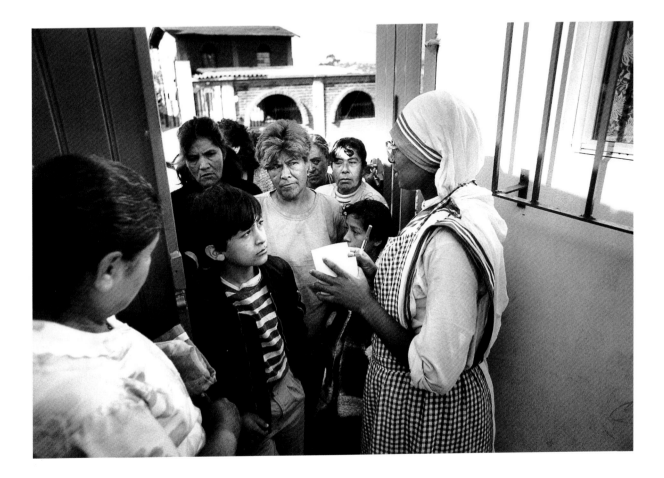

Dispensary Run by the Sisters, Tijuana, Mexico, 1993

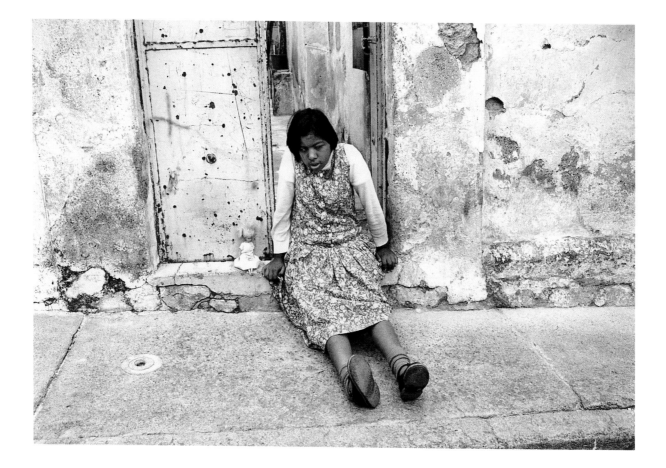

ON THE DOORSTEP OF THE SISTERS' HOUSE, MEXICO CITY, 1990

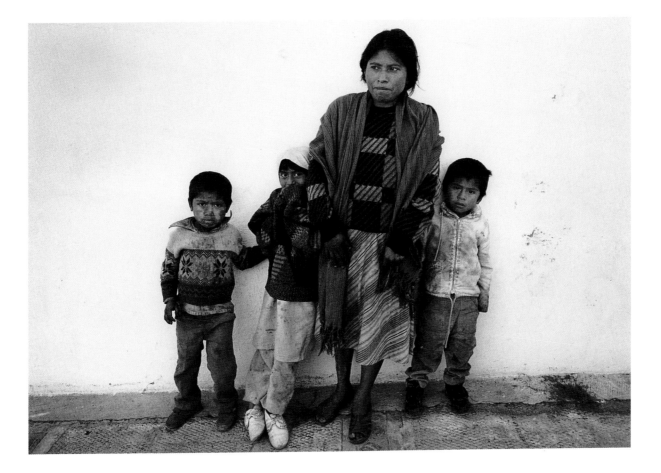

Many people are talking about the poor,
but very few people talk to the poor.

TIJUANA, MEXICO, 1993

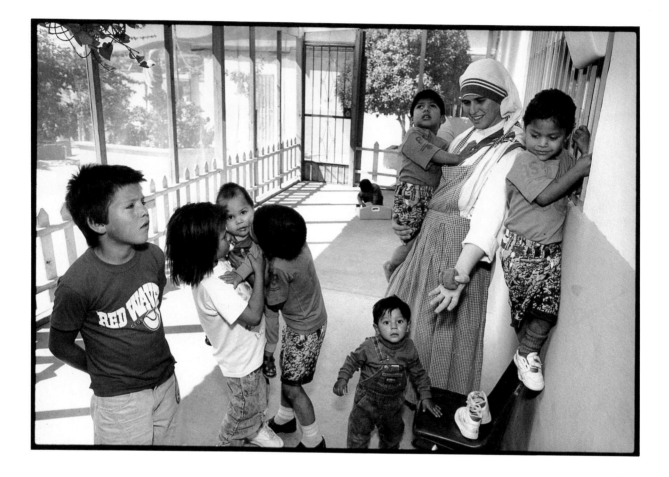

The Sisters run a home for orphaned children in Tijuana. The children there are full of energy. They seem so happy running around, laughing, rolling around in the dirt. They are precocious and playfully mischievous. I wonder how the Sisters are able to keep up with them all! — M. Collopy

T<small>IJUANA</small>, M<small>EXICO</small>, 1994

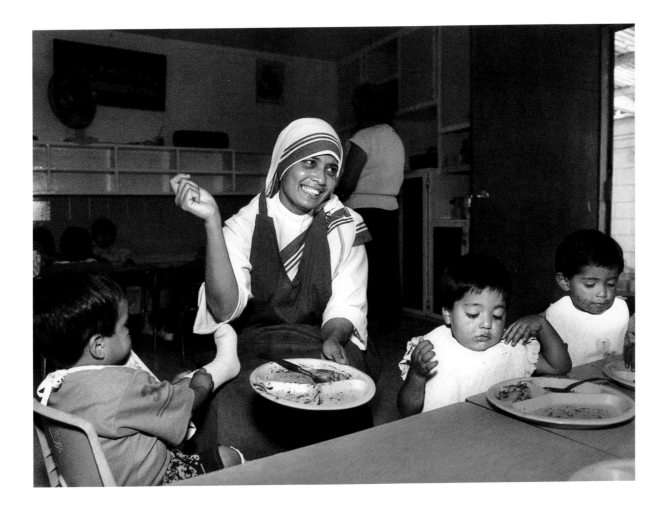

TIJUANA, MEXICO, 1994

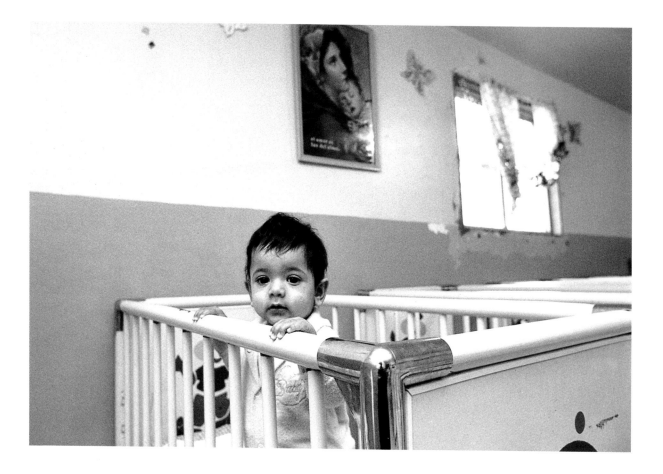

You did it to Me. These little neglected children must feel and realize that they too are the beloved children of the Heavenly Father.

TIJUANA, MEXICO, 1994

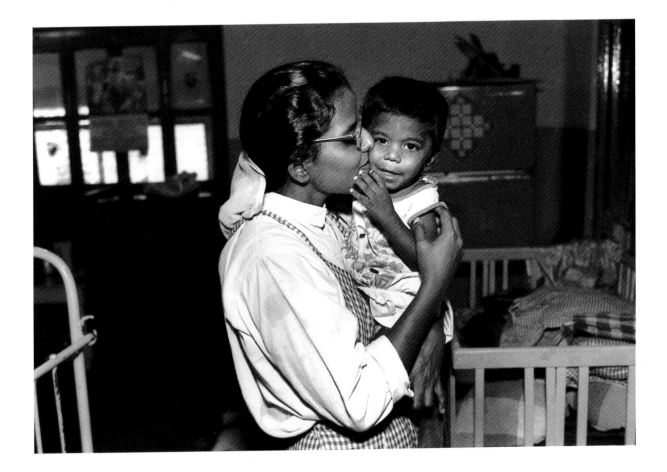

SISTER TAKING CARE OF AN ORPHANED CHILD, 1995

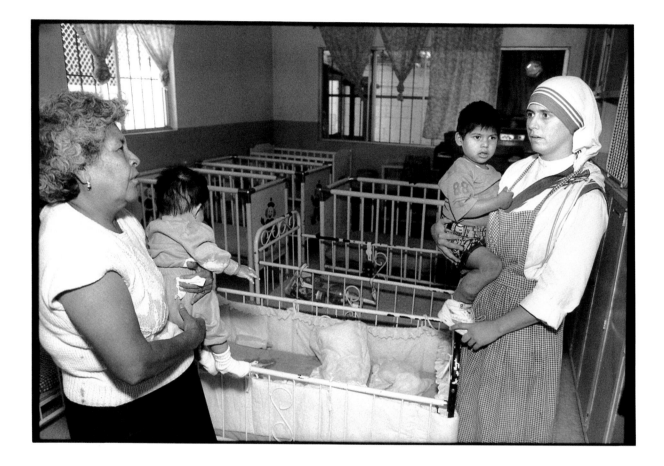

TIJUANA, MEXICO, 1994

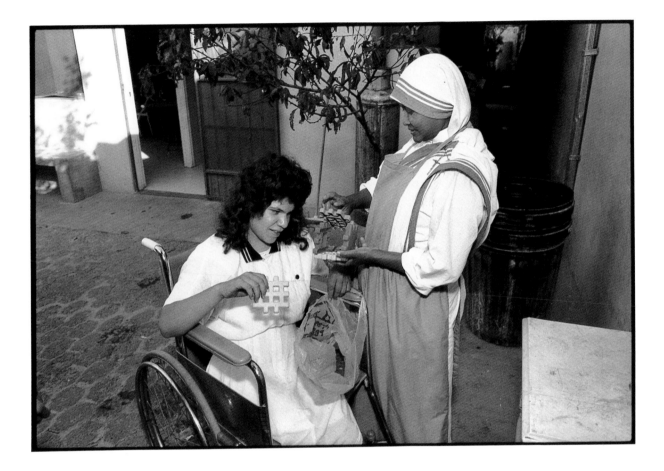

I met a girl who was mentally retarded and in a wheelchair. She had been with the Sisters for many years. She basically grew up with them. She was really part of the family there. — M. Collopy

Tijuana, Mexico, 1994

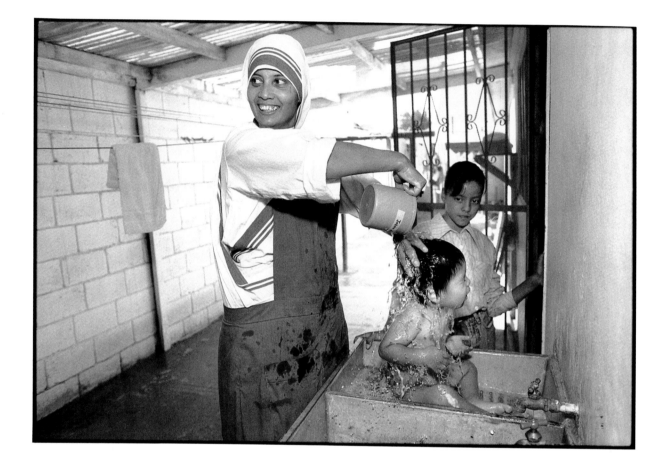

Every Sunday the Sisters bathe and dress the children up in their finest clothes to go to Mass. Afterwards, they have a breakfast and, when they're finished, the children all go out to play. Within an hour they are completely dirty and messy. The little guys are coated with mud. Again the Sisters bathe them and clean them up. This is repeated often throughout the day. The Sisters don't seem to mind at all. Their patience and cheerfulness really impresses me.

— M. Collopy

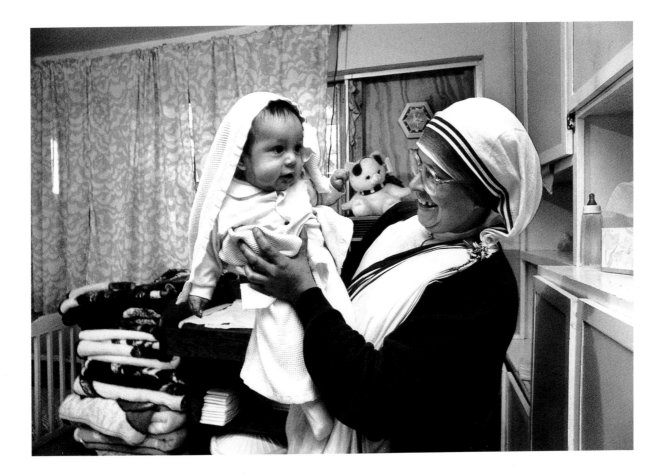

TIJUANA, MEXICO, 1993

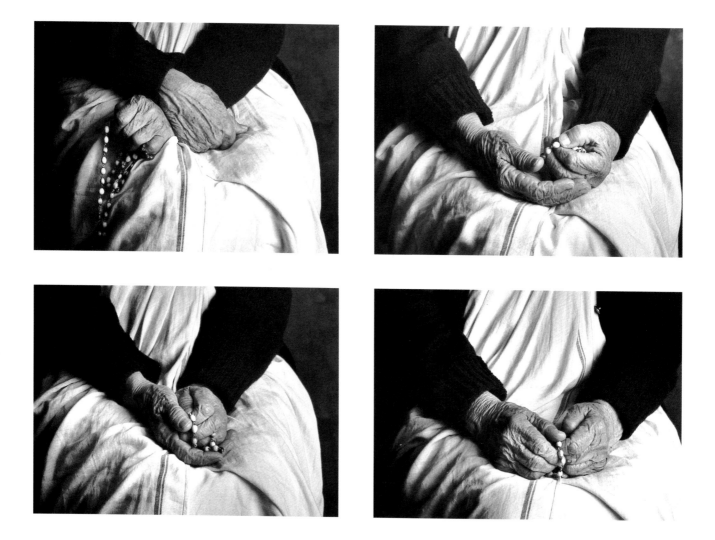

One day I came to the chapel and Mother motioned for me to come over by her. It was wonderful to be kneeling there next to her in prayer. There is an indescribable sense of peace in her presence. After Mass, she looked me in the eyes and said, "I will teach you something. If ever you feel distressed during your day—call upon our Lady—just say this simple prayer: Mary, Mother of Jesus, please be a mother to me now." I must admit—this prayer has never failed me. — M. Collopy

MOTHER PRAYING THE ROSARY, 1989

IMMACULATE HEART OF MARY, Cause of our Joy, bless your own Missionaries of Charity, help us to do all the good we can. Keep us in your most pure heart so that we may please Jesus through you, in you, and with you.

Sing: O Most Pure and Loving Heart
of my Mother and my Queen,
Grant that I may love Thee—
Love Thee daily more and more.
Grant that I may love Thee—
Love Thee daily more and more!

Immaculate Heart of Mary, Cause of our Joy, Pray for Us.

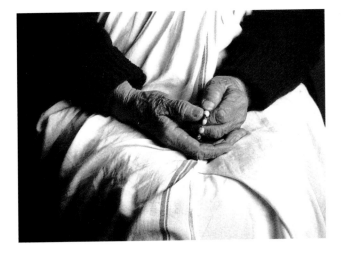
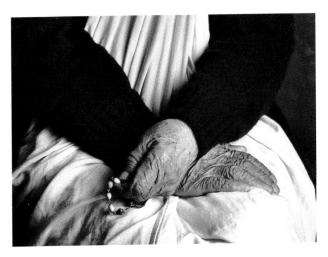

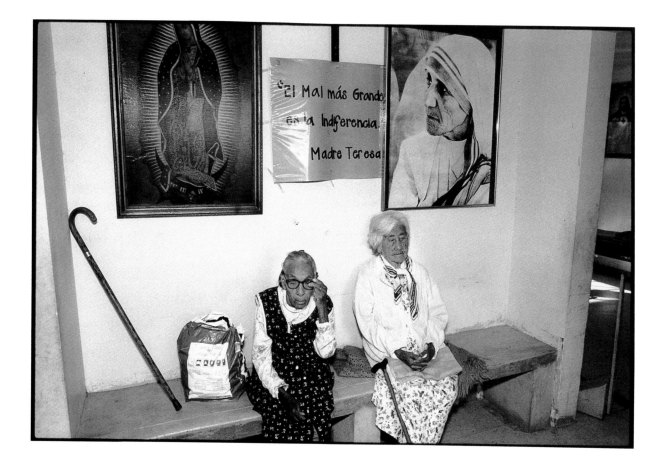

TIJUANA, MEXICO, 1993

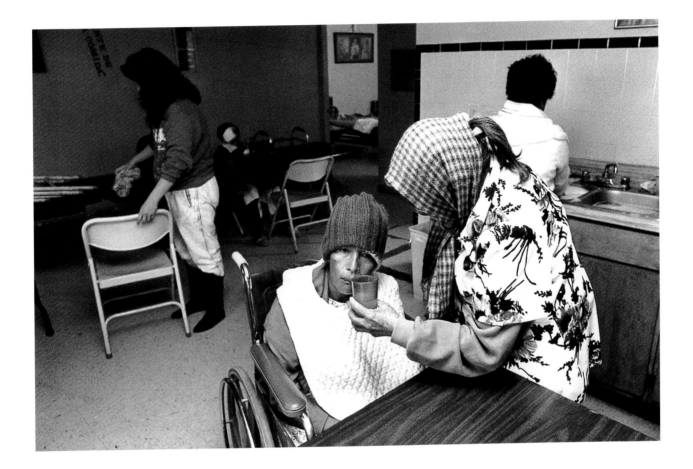

Thoughtfulness is the beginning of great sanctity.

TIJUANA, MEXICO, 1993

94

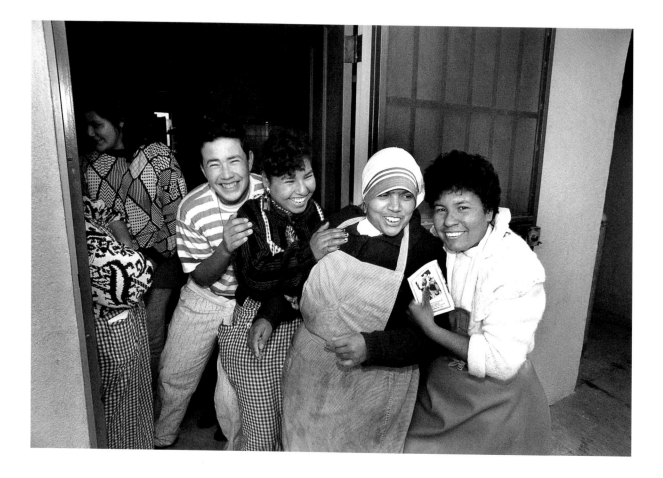

SISTER AND VOLUNTEERS AT THE SOUP KITCHEN, TIJUANA, 1993

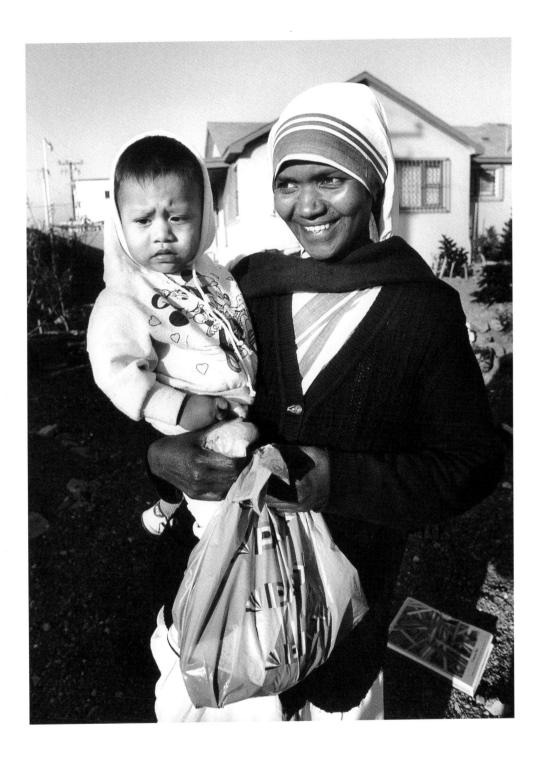

TIJUANA, MEXICO, 1993

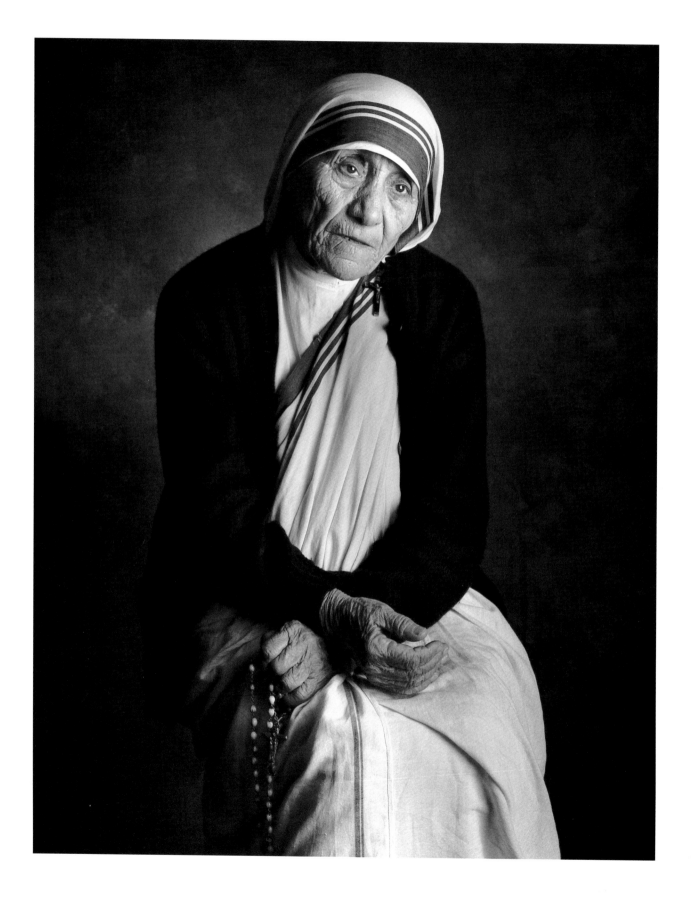

PRAYER FOR PEACE

LORD, make me a channel of your peace, that
where there is hatred,
 I may bring love;
where there is wrong,
 I may bring the spirit of forgiveness;
where there is discord,
 I may bring harmony;
where there is error,
 I may bring truth;
where there is doubt,
 I may bring faith;
where there is despair,
 I may bring hope;
where there are shadows,
 I may bring light,
where there is sadness,
 I may bring joy;
Lord, grant that I may seek rather
 to comfort than to be comforted;
to understand than to be understood;
 to love than to be loved;
for it is by forgetting self that one finds,
it is by forgiving that one is forgiven,
it is by dying that one awakens to eternal life.
Amen.

— SAINT FRANCIS OF ASSISI

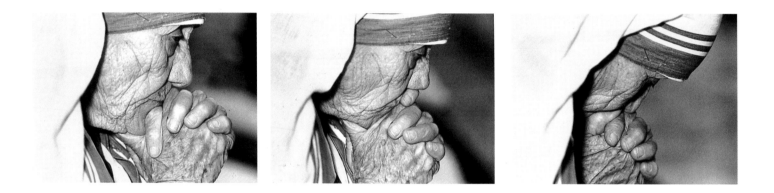

All we do—our prayer, our work, our suffering—is for Jesus.
Our life has no other reason or motivation.

This is a point many people do not understand.
I serve Jesus twenty-four hours a day. Whatever I do is for
Him. And He gives me the strength.

I love Him in the poor and the poor in Him, But always
the Lord comes first.

Whenever a visitor comes to our house, I take him to the
chapel to pray awhile.

I tell him, "Let us first greet the Master of the house.
Jesus is here."

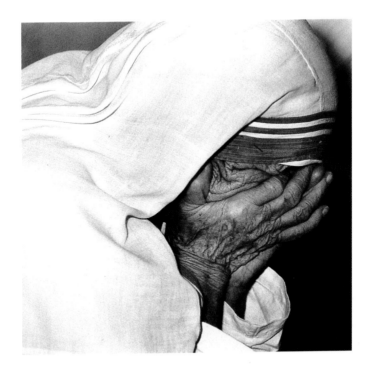

ANIMA CHRISTI

Soul of Christ, sanctify me,
Body of Christ, save me,
Blood of Christ, inebriate me,
Water from the side of Christ, wash me,
Passion of Christ, strengthen me,
O good Jesus, hear me,
Within Thy wounds hide me,
Suffer me not to be separated from Thee,
From the malicious enemy defend me,
In the hour of my death call me,
And bid me come unto Thee,
That with Thy Saints I may praise Thee,
For ever and ever. Amen.

—SAINT IGNATIUS OF LOYOLA

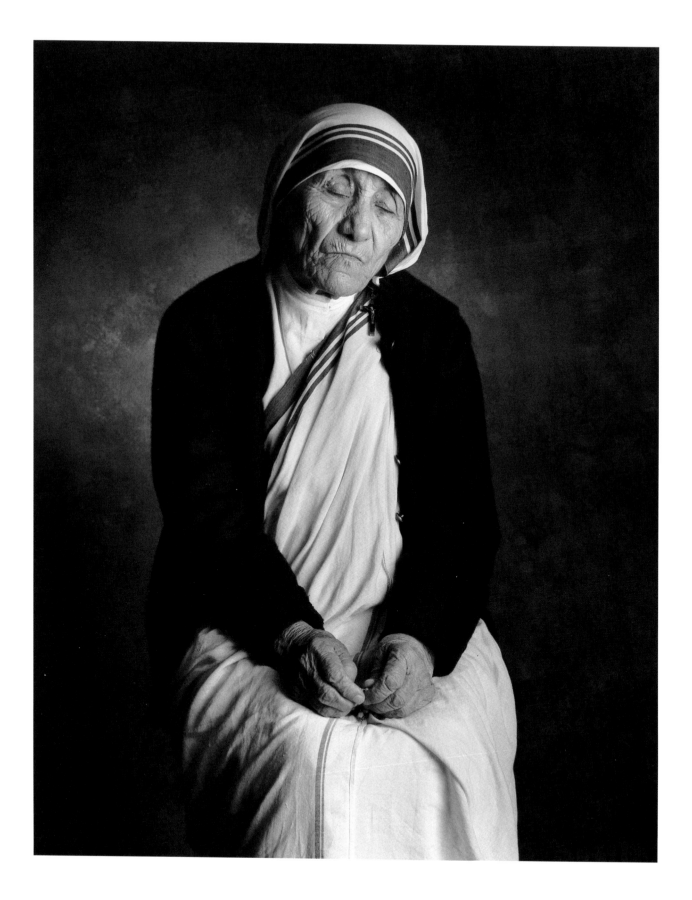

IN THE SILENCE of the heart God speaks.

Let God fill us, then only we speak.

Do small things with great love.

The Fruit of Silence…is prayer.

The Fruit of Prayer…is faith.

The Fruit of Faith…is love.

The Fruit of Love…is service.

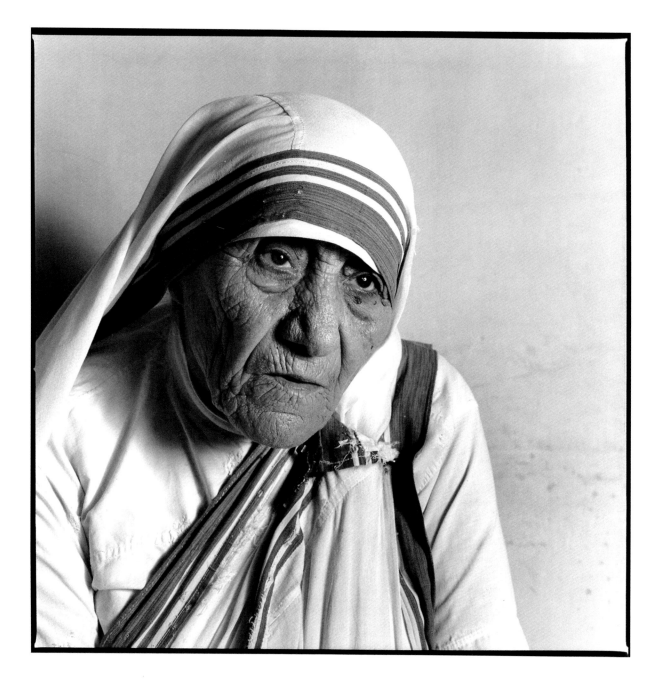

MOTHER, 1995

MY SECRET is quite simple—I pray!

YOU SHOULD SPEND at least half an hour in the morning and an hour at night in prayer. You can pray while you work. Work doesn't stop prayer, and prayer doesn't stop work. It requires only that small raising of mind to Him. "I love You, God, I trust You, I believe in You, I need you now." Small things like that. They are wonderful prayers.

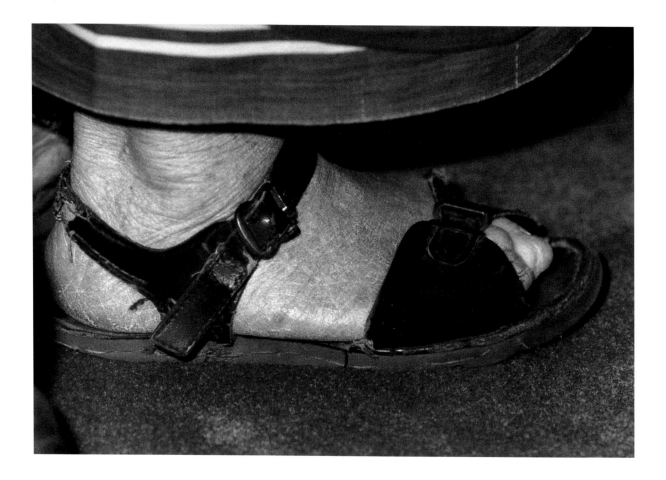

THE FOOT OF MOTHER TERESA, 1995

WE DID NOT COME TO BE SOCIAL WORKERS,
but to belong to Jesus. Pray with Jesus and Jesus will pray
through you.

WHEREVER GOD HAS PUT YOU, that is your vocation.
It is not what we do but how much love we put into it.

WHERE DOES LOVE BEGIN? It begins at home.
Let us learn to love in our family. In our own family we
may have very poor people, and we do not notice them.
We have no time to smile, no time to talk to each other.
Let us bring that love, that tenderness into our own home
and you will see the difference.

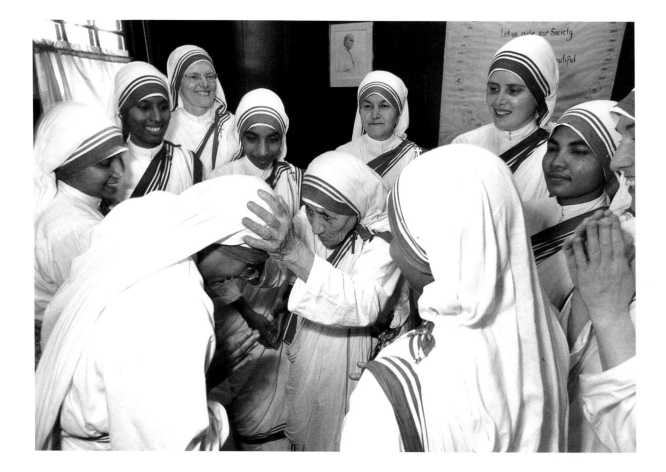

MOTHER GREETING AND BLESSING HER SISTERS, WASHINGTON, D.C., 1995

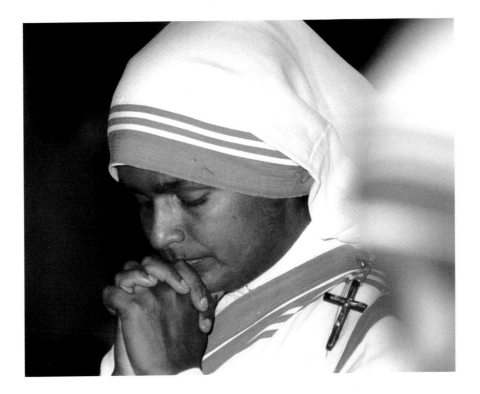

God has blessed our Society with many vocations. We have many, many young people who have consecrated their lives to serve Christ in the poorest of the poor—to give their all to Him. And it has been a wonderful gift of God to the whole world that through this work, the rich and poor have come to know each other, to love each other and to share with the joy of loving by putting their love, their understanding love, into living action.

SISTER, SAN FRANCISCO, 1988

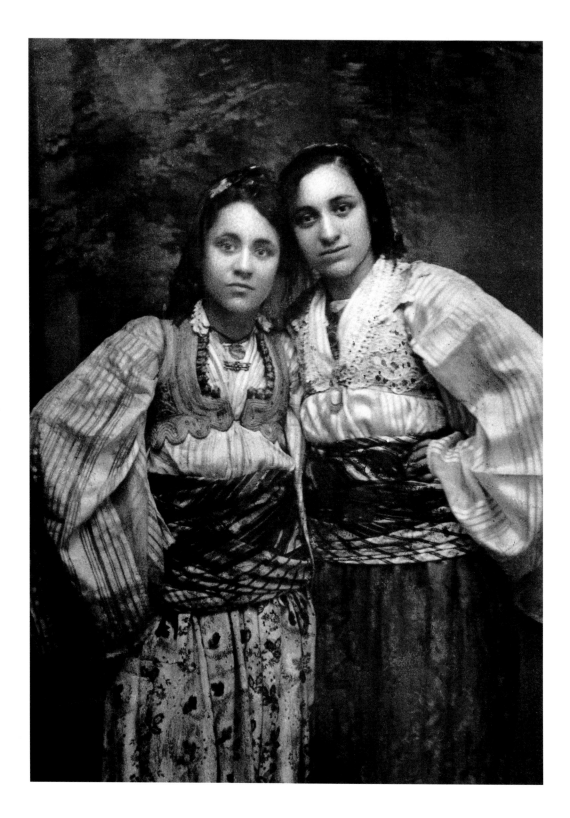

GANXHE AGNES BOJAXHIU (LEFT. NOW MOTHER TERESA OF CALCUTTA) AND HER SISTER AGA. CIRCA 1928.

I'LL NEVER FORGET MY OWN MOTHER. She used to be very busy the whole day, but as soon as the evening came, she used to move very fast to get ready to meet my father. At that time we didn't understand; we used to smile; we used to laugh; and we used to tease her; but now I remember what a tremendous, delicate love she had for him. Didn't matter what happened, but she was ready there with a smile to meet him.

I remember when I left home, my mother said to me— "Put your hand in His and walk all alone with Jesus."

I tell my Sisters, "We must more and more fall in love with God. Let it not be said that one single woman in the world loves her husband better than we do Christ."

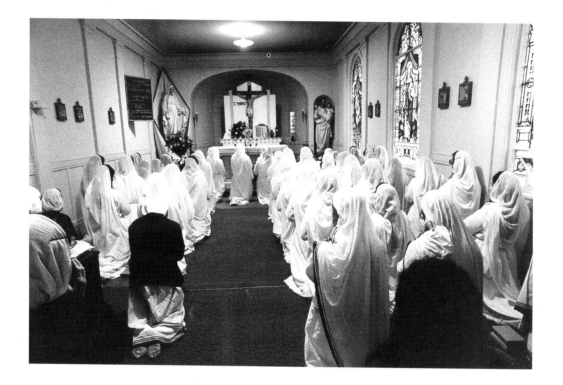

To me
> *Jesus is my God.*
> *Jesus is my Spouse.*
> *Jesus is my Life.*
> *Jesus is my only Love.*
> *Jesus is my All in All.*
> *Jesus is my Everything.*

Jesus, I love you with my whole heart,
with my whole being.

I have given Him all, even my sins, and He has
espoused me to Himself in tenderness and love.

Now and for life
I am the Spouse of my Crucified Spouse.

From Mother's meditation in the hospital, June 19, 1983.

PRAYER BEFORE JESUS IN THE BLESSED SACRAMENT (MOTHER IN THE BACK, LEFT) NOVITIATE, SAN FRANCISCO, 1986

FOR GOD'S BLESSING
ON OUR SOCIETY

We beseech You, O Lord, mercifully pour into
our Society, Thy Holy Spirit, by whose Wisdom
it was created, by whose Providence it is governed
and maintained, and whose love may enkindle in
the Society that same fire which Our Lord, Jesus
Christ sent down upon earth earnestly desiring
that it should burn mightily.

And so,

Breathe in me, O Holy Spirit,
 That my thoughts may all be holy.

Act in me, O Holy Spirit,
 That my work too may be holy.

Draw my heart, O Holy Spirit,
 That I love but what is holy.

Strengthen me, O Holy Spirit,
 To defend all that is holy.

Guard me, then, O Holy Spirit,
 That I always may be holy.

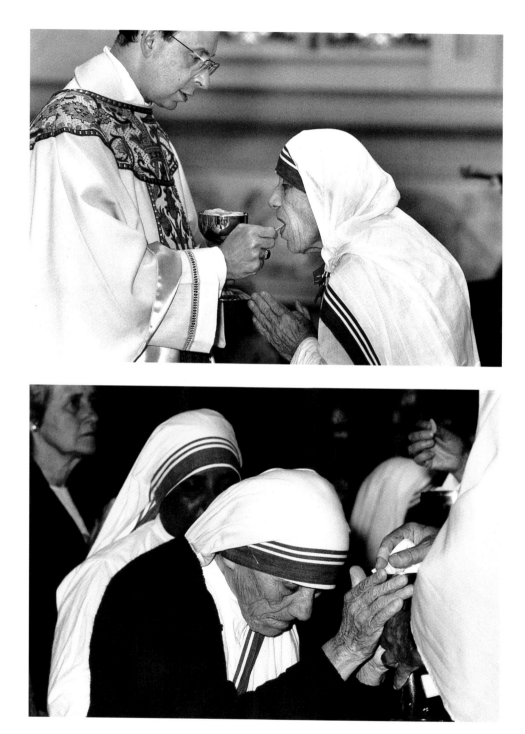

Holy Mass is the prayer of our day where we offer ourselves with Christ to be broken and given to the poorest of the poor. The Eucharist is our glory and joy and the mystery of our union with Christ.

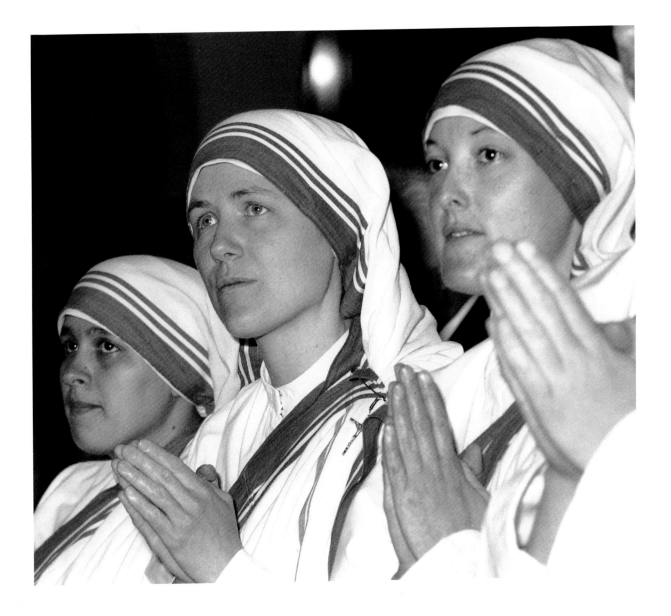

113

SISTERS' FIRST PROFESSION MASS, SAN FRANCISCO, 1989

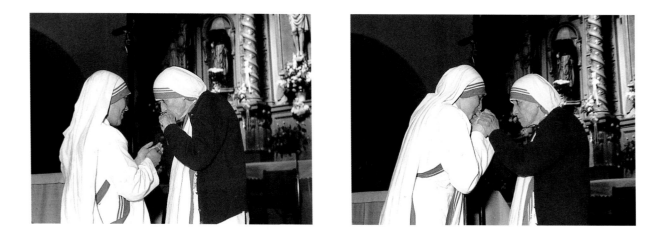

114

My child, receive the symbol of our crucified Spouse.
Spread the charity of His heart wherever you go and
so to satiate His thirst for souls. The reason for our
existence is to quench the infinite thirst of Jesus on
the cross for love of souls. Of my own free choice
I shall follow Christ in search of souls.

SISTERS RECEIVING CRUCIFIX FROM MOTHER DURING FIRST PROFESSION MASS, SAN FRANCISCO, 1987

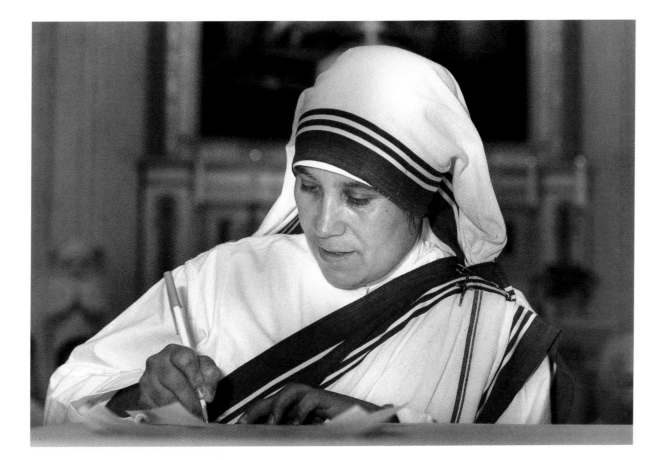

For the honor and glory of God and moved by a burning desire to quench the infinite thirst of Jesus on the Cross for love of souls by consecrating myself more fully to God, that I may follow Jesus more closely in my whole life in a spirit of loving trust, total surrender and cheerfulness, here and now, in the presence of my sisters, and into your hands, Mother (N.N.) Superior General of the Society of the Missionaries of Charity I vow for life: chastity, poverty, obedience and wholehearted and free service to the poorest of the poor according to the Constitutions of the Missionaries of Charity.

I give myself with my whole heart to this religious family so that by the grace of the Holy Spirit and the help of the Immaculate Heart of Mary, Cause of our Joy and Queen of the World, I may be led to the perfect love of God and neighbor and make the Church fully present in the world today.

SISTER MAKING HER FINAL PROFESSION BY SIGNING THE VOWS OF THE MISSIONARIES OF CHARITY, 1995

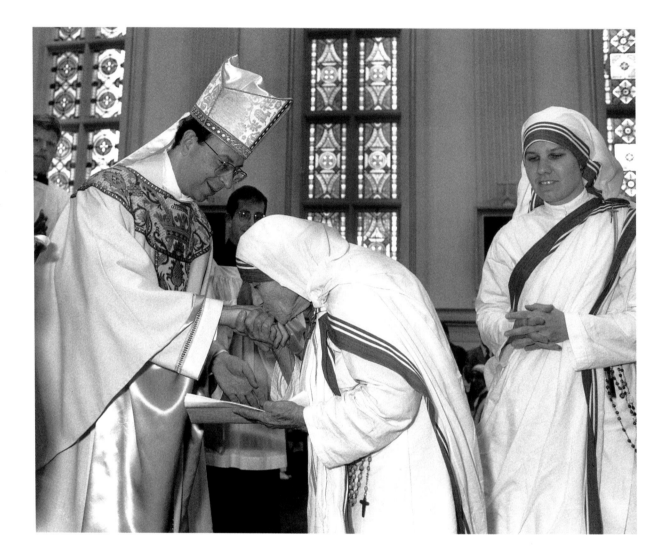

If Mother meets a bishop or a cardinal, she will kiss the bishop or cardinal's ring as a sign of respect for his authority.
— M. Collopy

PROFESSION MASS, WASHINGTON, D.C., 1995

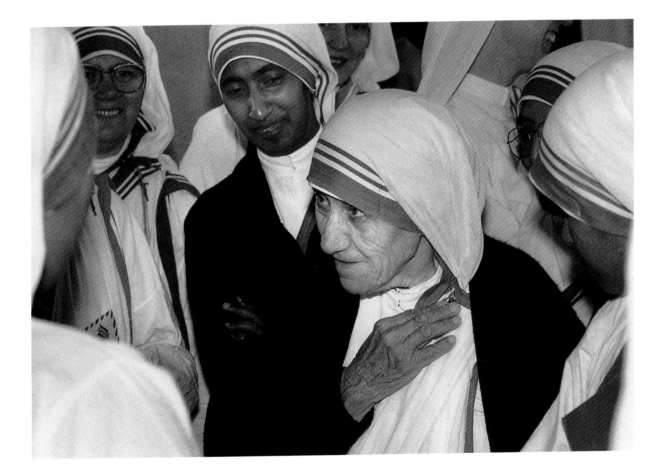

I once heard Mother tell a group of young Sisters that she does not need "numbers". If any of them is not willing to offer her free and wholehearted service to the poorest of the poor with love and joy—with the lepers, the old and lonely, the little ones, the AIDS patients—and others, then it's time to pack up their bags and go home. "No need to stay." — M. Collopy

MOTHER AND SISTERS, SAN FRANCISCO, 1986

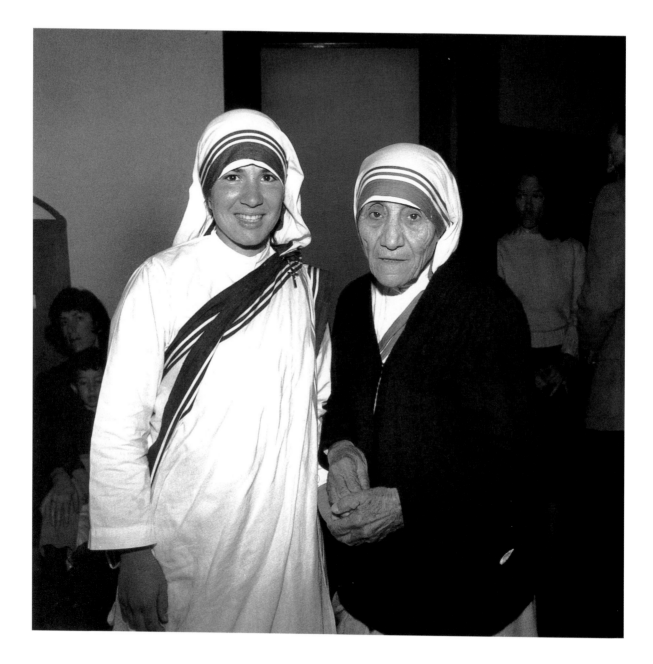

Every Sister is a branch on Christ the Vine.

Novitiate, San Francisco, 1987

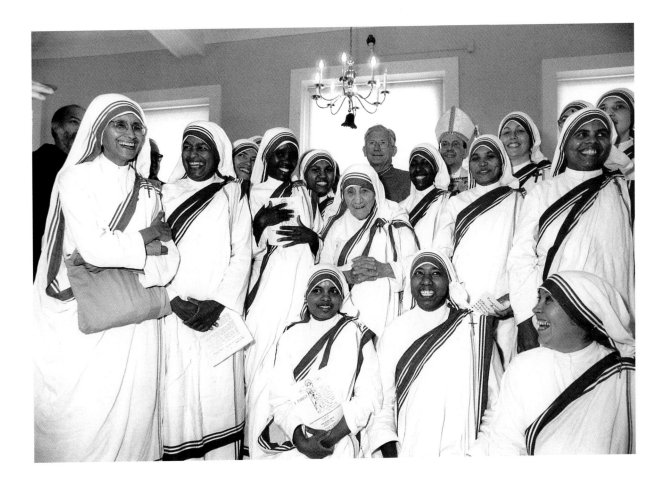

We pray together. We eat together. We work together.
And we fight together.

FINAL PROFESSIONS, WASHINGTON, D.C., 1995

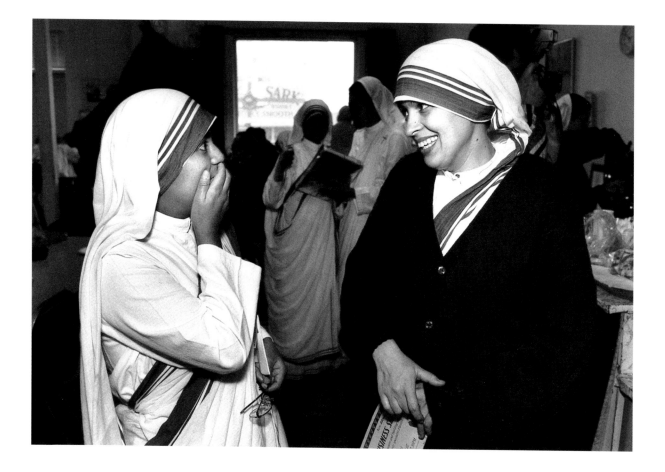

SISTERS, SAN FRANCISCO, 1993

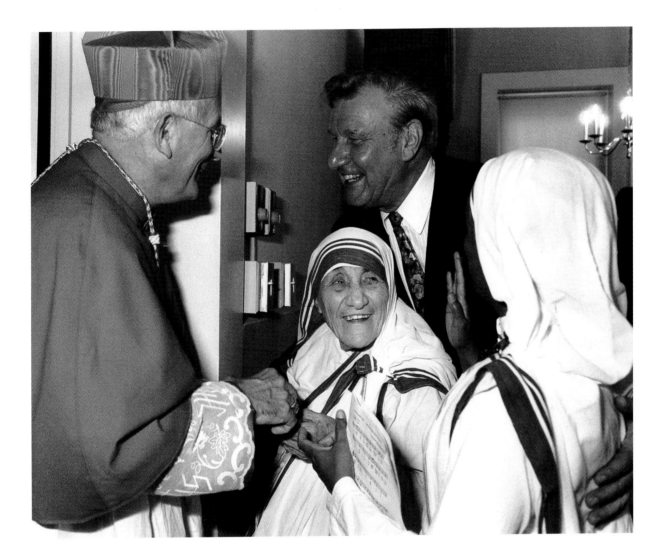

121

AFTER PROFESSION MASS, WASHINGTON, D.C., 1995

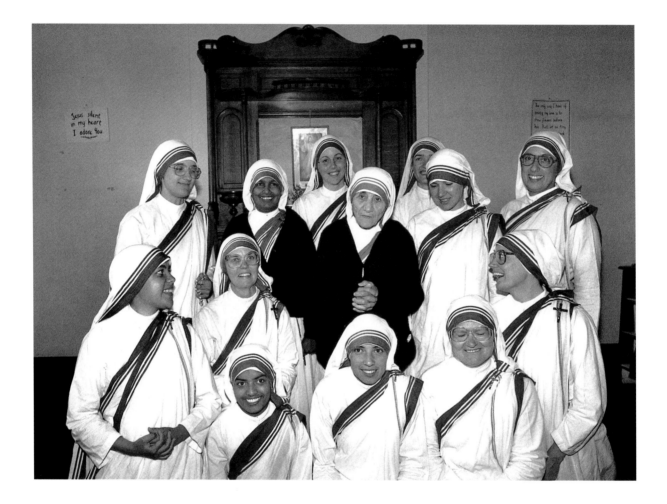

MOTHER TERESA AND SISTERS, SAN FRANCISCO, 1987

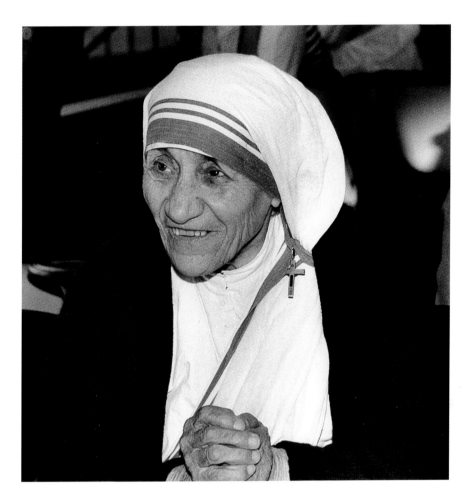

Let us not use bombs and guns to overcome the world. Let us use love and compassion. Peace begins with a smile— smile five times a day at someone you don't really want to smile at at all—do it for peace. So let us radiate the peace of God and so light His light and extinguish in the world and in the hearts of all men all hatred and love for power.

SAN FRANCISCO, 1985

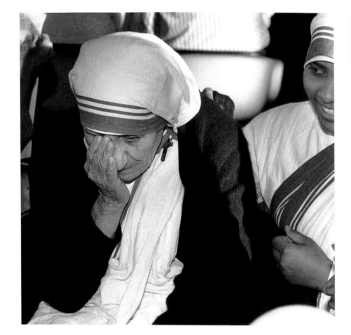
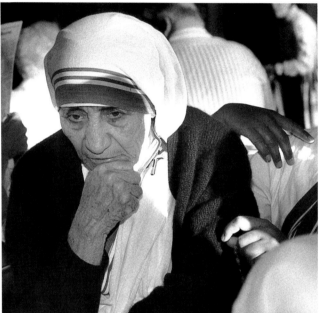

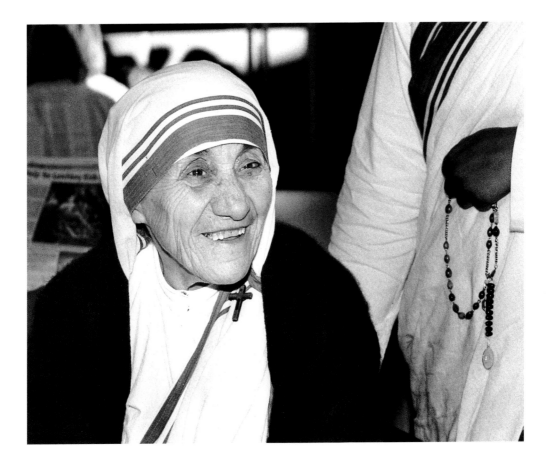

Smile at one another. It is not always easy. Sometimes I find it hard to smile at my Sisters, but then we must pray. Prayer begins at home and a family that prays together, stays together. We must give Jesus a home in our homes for only then can we give Him to others.

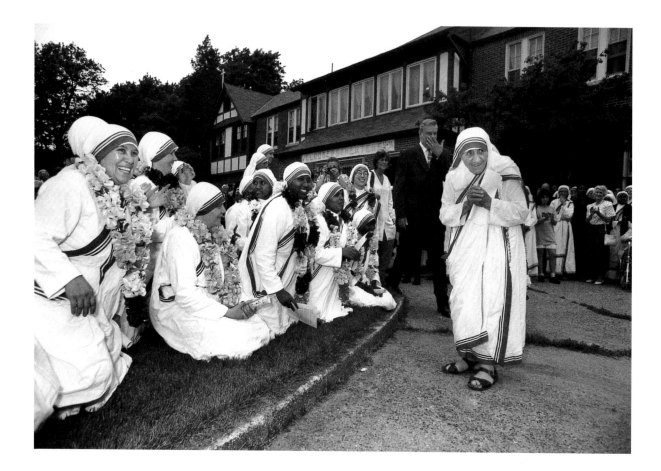

WASHINGTON, D.C., 1995

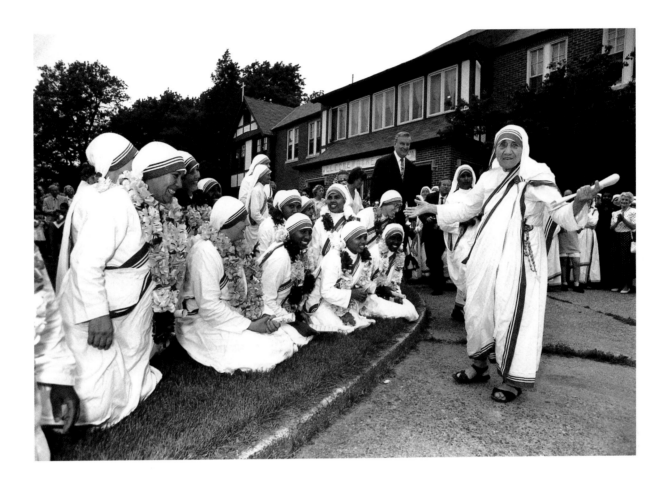

127

What could I have done without my Sisters ?!!!

WASHINGTON, D.C., 1995

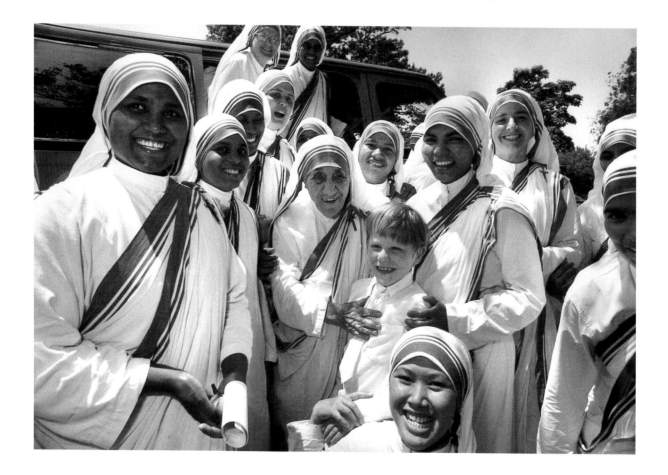

WASHINGTON, D.C., 1995

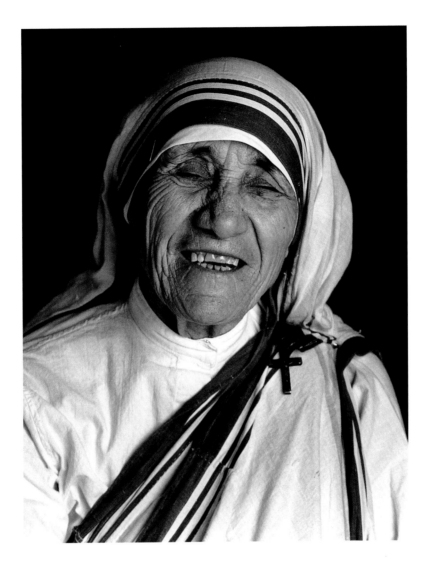

Once, a Jesuit priest (who was taller than average) met with Mother after a Mass he had said for the Sisters. The priest, who hadn't seen Mother in a while, jokingly teased her by saying, "Mother, every time I see you, you seem to be getting smaller and smaller. I think you must be shrinking!" Mother, who is only about 4'8" or so, came right back, "Oh yes—one must become very small to be able to enter into the Sacred Heart of Jesus!"

Another time, someone asked Mother, "What will you do when you are no longer Mother General?" Mother thought about this for a second and said with a smile, "I am good at cleaning toilets, you know!"

PRAYER BEFORE LEAVING
FOR APOSTOLATE

Dear Lord, the Great Healer, I kneel before You,
since every perfect gift must come from you. I pray,
give skill to my hands, clear vision to my mind,
kindness and meekness to my heart. Give me sin-
gleness of purpose, strength to lift up a part of the
burden of my suffering fellow men, and a true
realization of the privilege that is mine. Take from
my heart all guile and worldliness that with the
simple faith of a child, I may rely on You. Amen.

Sing: Be with us Mary along the way
 Guide every step we take
 Lead us to Jesus, your loving Son
 Come with us Mary, come.

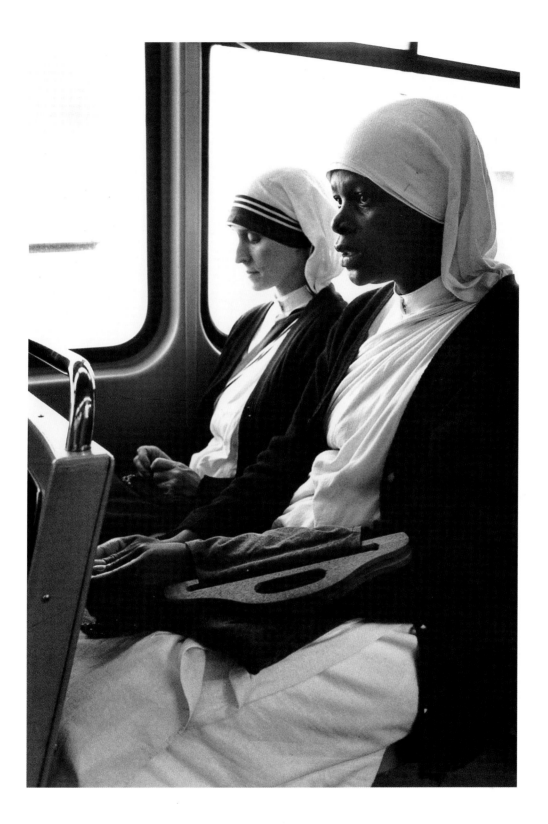

SISTERS GOING OUT ON HOME VISITS, SAN FRANCISCO, 1993

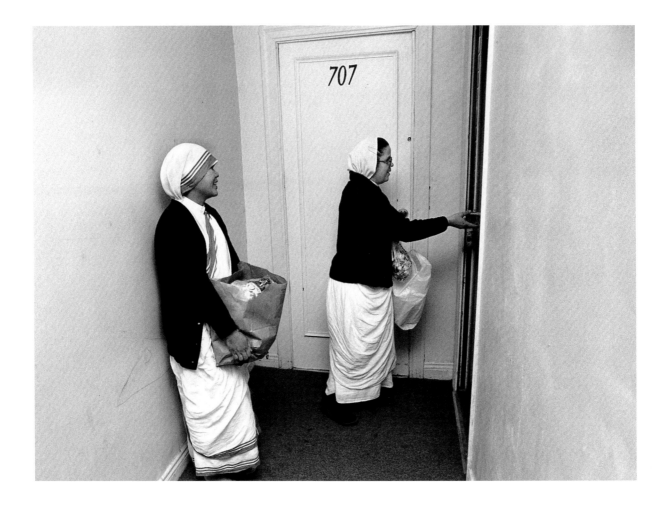

BRINGING GROCERIES TO SHUT-INS, SAN FRANCISCO, 1993

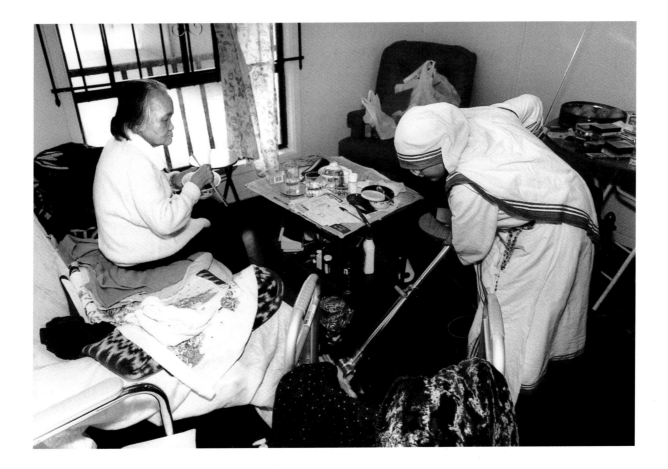

HELPING THE ELDERLY SHUT-INS, SAN FRANCISCO, 1994

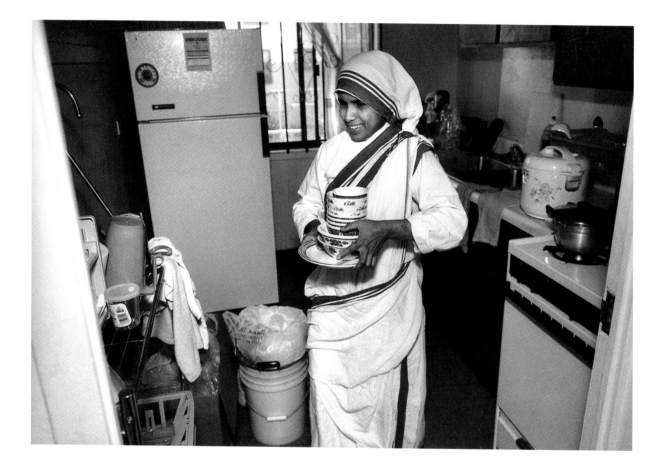

HELPING THE ELDERLY SHUT-INS, SAN FRANCISCO, 1994

WE MUST NOT DRIFT AWAY from the humble works, because these are the works nobody will do. It is never too small. We are so small and we look at things in a small way. But God, being Almighty, sees everything great. Therefore, even if you write a letter for a blind man or you just go and listen, or you take the mail for him, or you visit somebody or bring a flower to somebody—small things—or wash clothes for somebody, or clean the house—very humble work—that is where you and I must be. For there are many people who can do big things. But there are very few people who will do the small things.

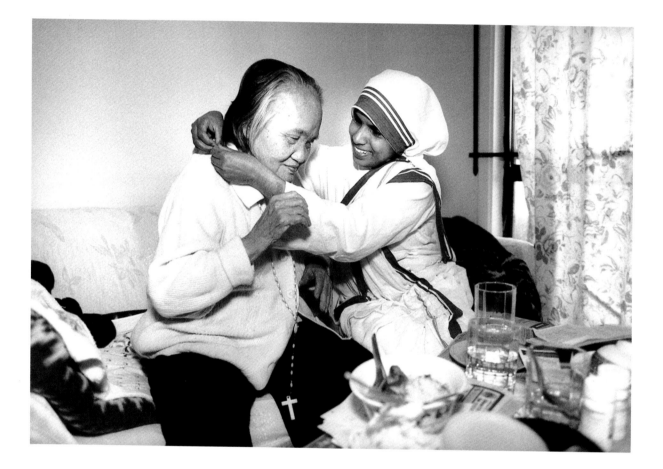

HOME VISIT, SAN FRANCISCO, 1994

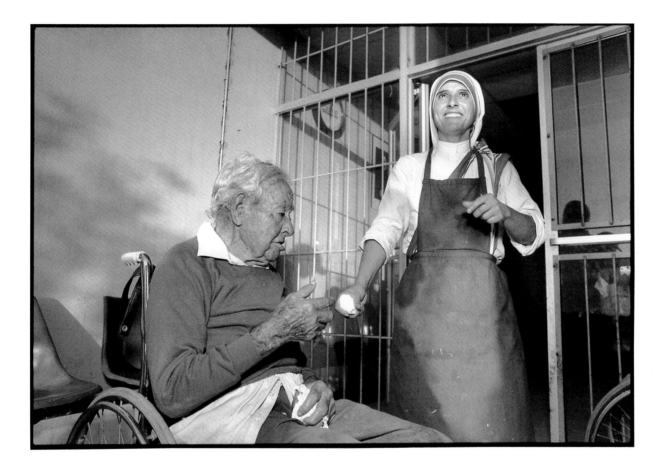

ON A VISIT, TIJUANA, MEXICO, 1994

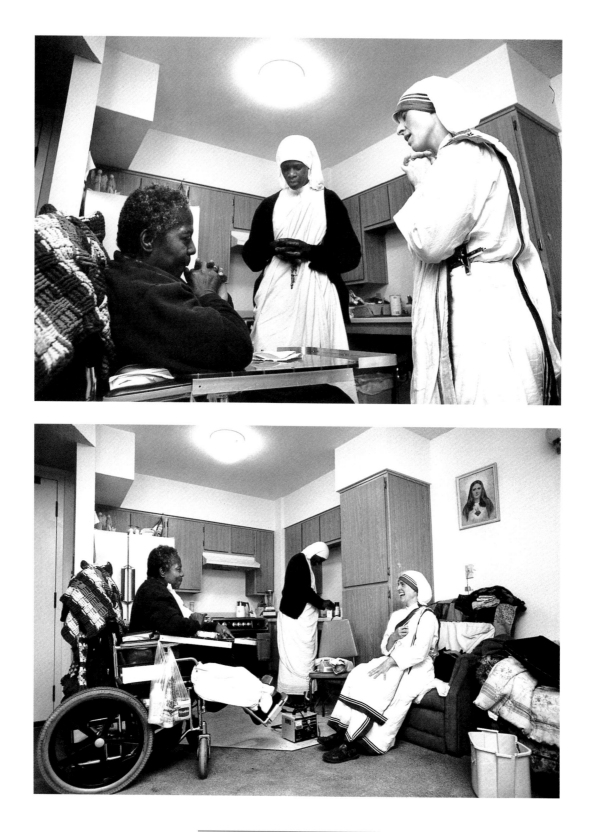

HOME VISIT, SAN FRANCISCO, 1994

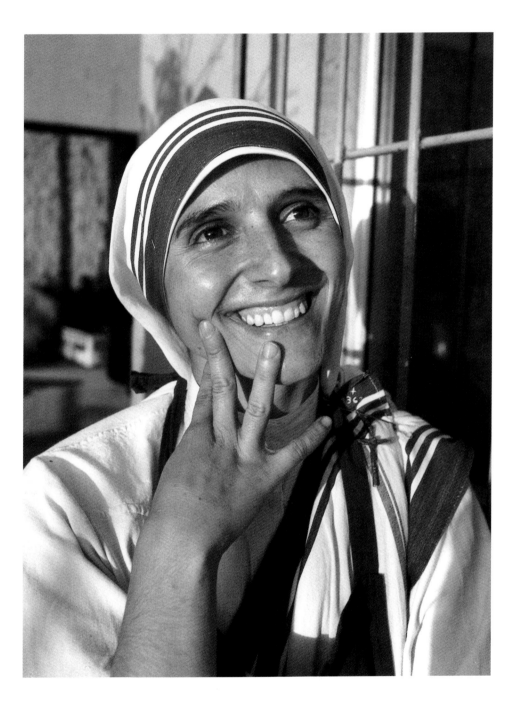

Joy is Prayer...
Joy is Love...
Joy is a net of Love by which we can catch souls.

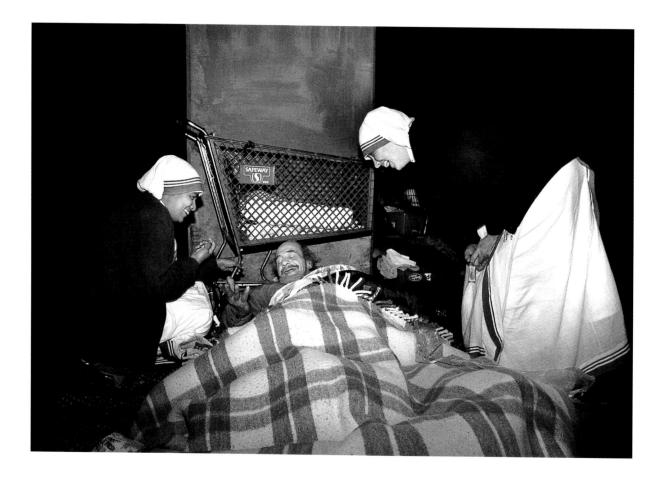

Around Christmas, one night, I drove around with the Sisters to hand out blankets and food to the homeless living underneath the freeways. There was a man that seemed well educated, and he and the Sisters started speaking in Italian. The official language of the Missionaries of Charity is English, but the Sisters come from all over the world and they are sent to serve all over the world, so it is not uncommon for the Sisters to know more than a couple of languages. — M. Collopy

WITH THE HOMELESS, SAN FRANCISCO, 1992

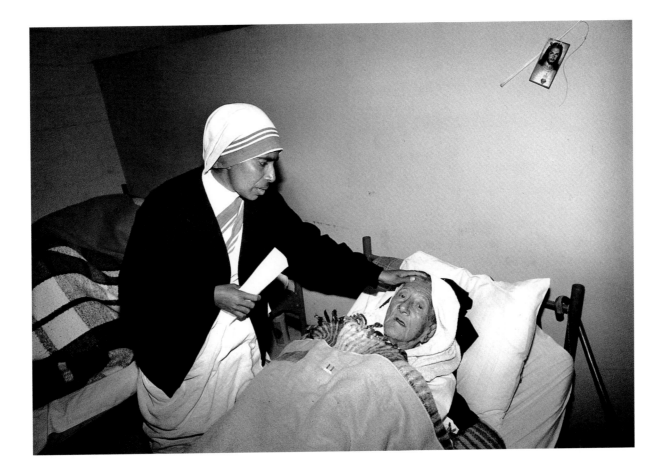

WITH THE SICK AND AGED, TIJUANA, 1993

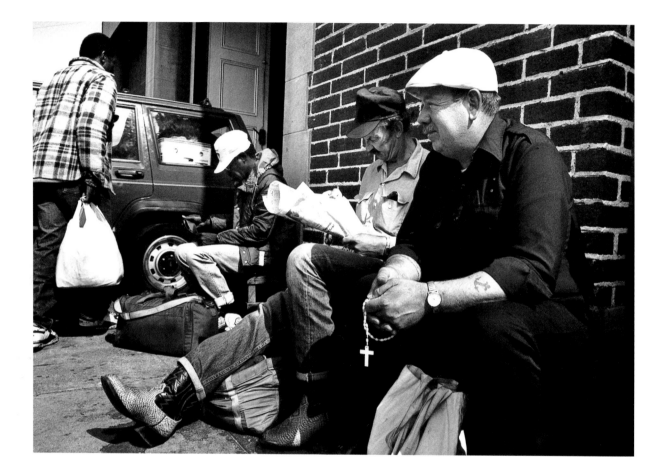

PRAYER OF POPE PAUL VI

Make us worthy Lord, to serve our fellow men through-
out the world who live and die in poverty and hunger.
Give them through our hands, this day their daily bread,
and by our understanding love, give peace and joy.

SOUP KITCHEN, SAN FRANCISCO, 1993

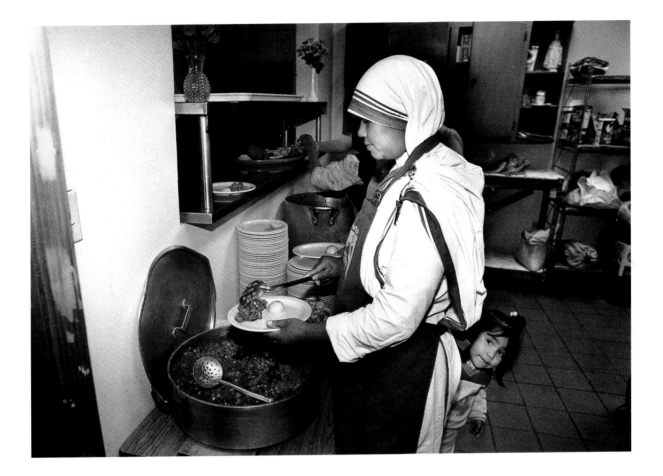

SOUP KITCHEN, 1993

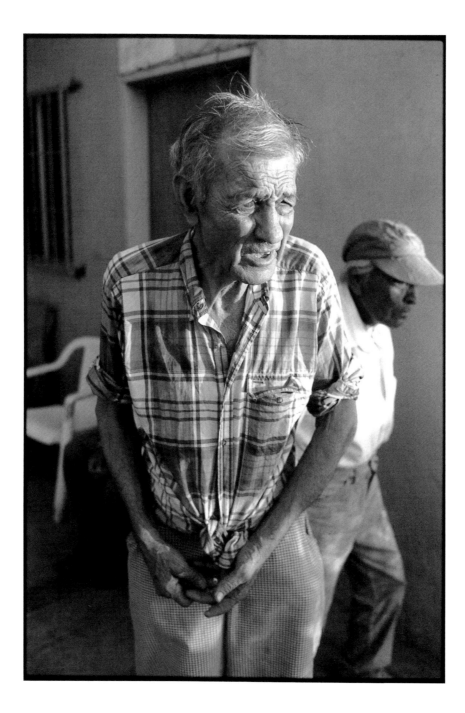

THERE IS MUCH SUFFERING in the world—very much.

And the material suffering is suffering from hunger, suffering

from homelessness, from all kinds of disease, but I still think

that the greatest suffering is being lonely, feeling unloved, just

having no one. I have come more and more to realize that it

is being unwanted that is the worst disease that any human

being can ever experience.

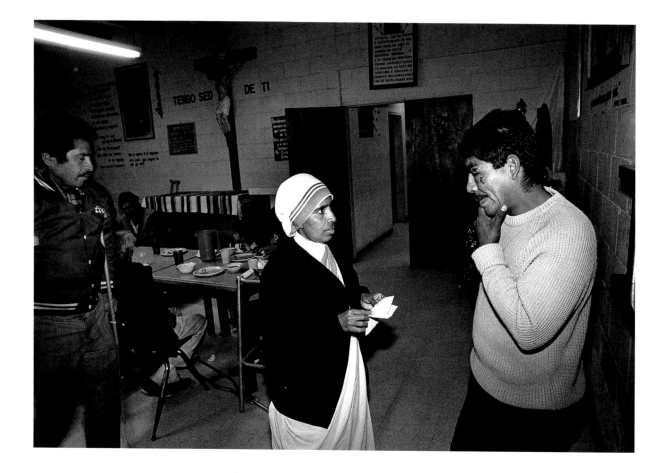

There was this man explaining to the Sister that he had been in a brawl. — M. Collopy

SOUP KITCHEN, 1993

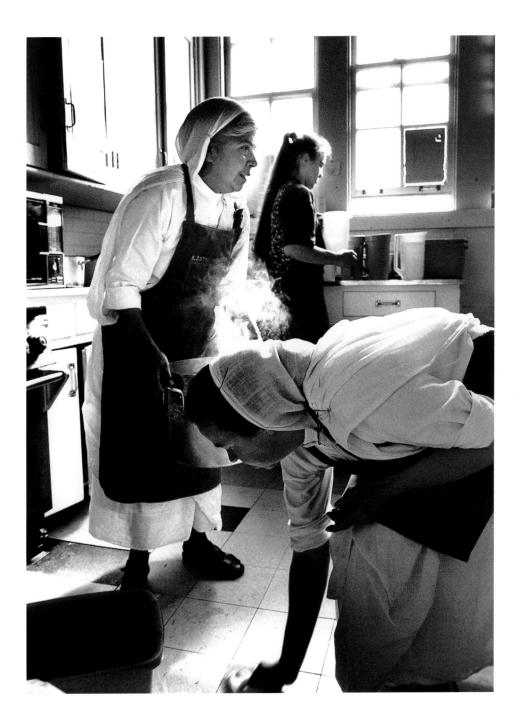

Soup Kitchen, 1992

148

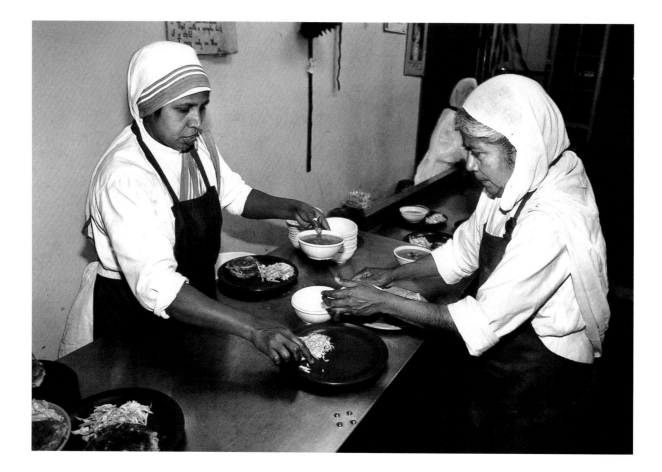

SOUP KITCHEN, 1992

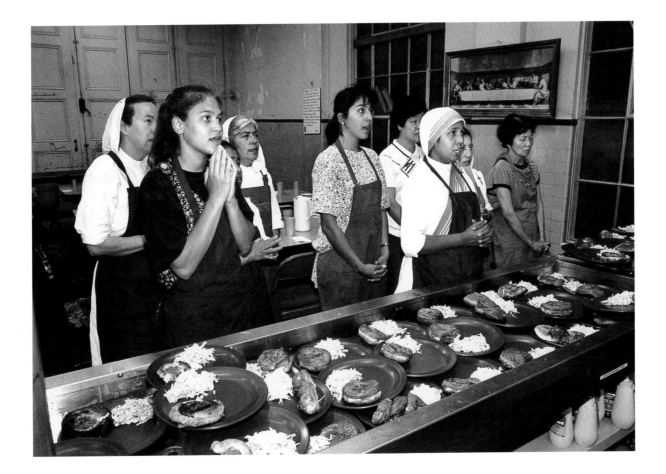

GRACE BEFORE THE MEAL, SOUP KITCHEN, 1992

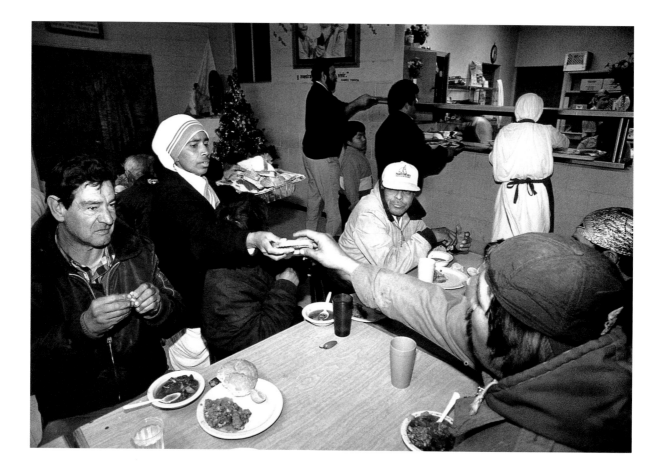

Soup Kitchen, 1992

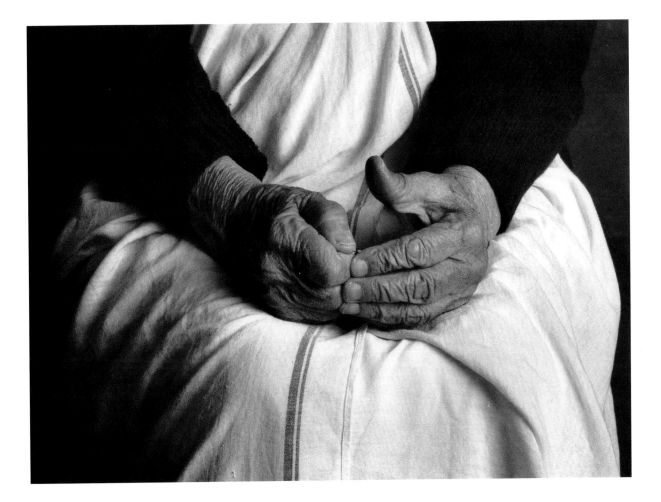

One day I was walking down the streets of London and I saw a man quite drunk. He was looking so sad and miserable I went right up to him and took his hand, shook it and asked, "How are you?" My hand is always warm—and he said, "Oh, after so long I feel the warmth of a human hand." And his face lit up. And his face was different. I only want to say that small things done in great love bring joy and peace.

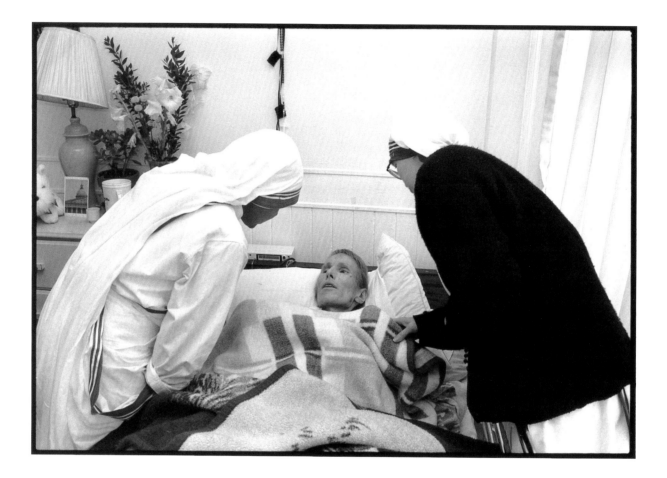

GIFT OF LOVE, AIDS HOSPICE, SAN FRANCISCO, 1996

WE HAVE OPENED A HOUSE in New York for those afflicted with AIDS, and now we are going to open one in Washington and San Francisco. What a change in those peoples' lives! I can't tell you! I can't believe that it's the people who had been rejected, unwanted, unloved, the rejects. Why? Because they have received love by the Sisters. Seven of them died a beautiful death and will go straight to heaven. A complete change in their lives. Why? That love, that care, to have somebody who loves them.

…Thousands, thousands of AIDS-diseased young people roaming the streets. Are we there? Do we know them: Do we do something?

…The other day I went to the hospital…and there one man, he said, "Mother Teresa, I want to speak to you privately." I said, "Is there something private you want to tell me?"

"I get terrible pains and I share my pain with the pain of Jesus which He had in the crown of thorns." A few months ago he was a man without love, without peace of mind, who for twenty years had not been to confession—something like that. But he found Jesus and to share.

"That day I share with the scourging, with the terrible pains Jesus had when they scourged Him. And when I get pain in my hands, I share it with the pain of Jesus when He was crucified."

And so he took every part of his body. See? He had found joy. Without even knowing, in his disease, he had found joy.

And when we brought him home and I took him to the chapel, and he bowed before the Blessed Sacrament. There was a big cross in their chapel. He was looking, looking, looking—and really I've never seen anybody even myself, I've never looked at the cross like that, like that man. Yet you could see the exchange of love between the two of them, between Jesus and him—really, I've never seen anything like that. I'm saying this just to give you something to think and to pray over because there is a great need in the world today.

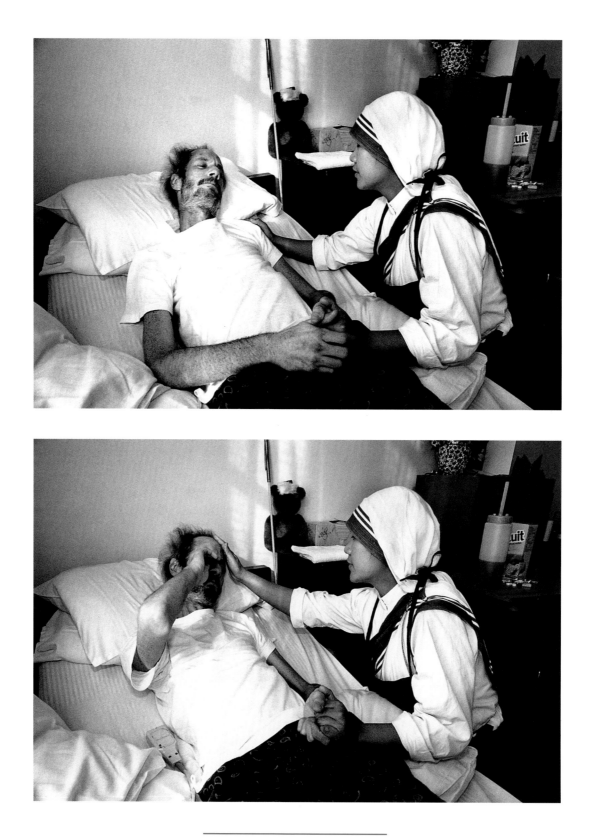

GIFT OF LOVE, AIDS HOSPICE, 1994

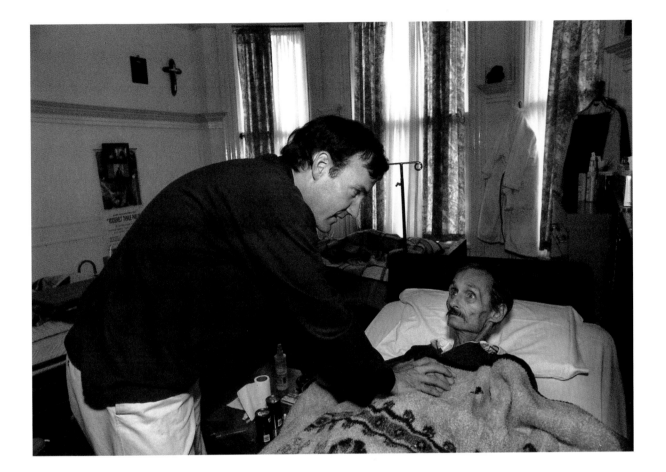

GIFT OF LOVE, AIDS HOSPICE, 1993

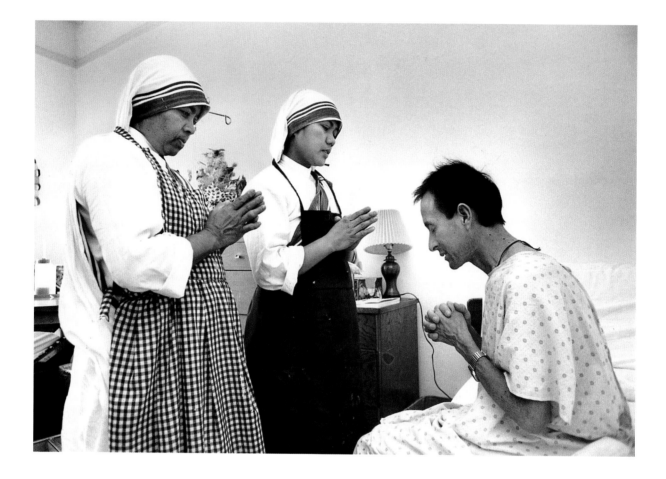

GIFT OF LOVE, AIDS HOSPICE, 1994

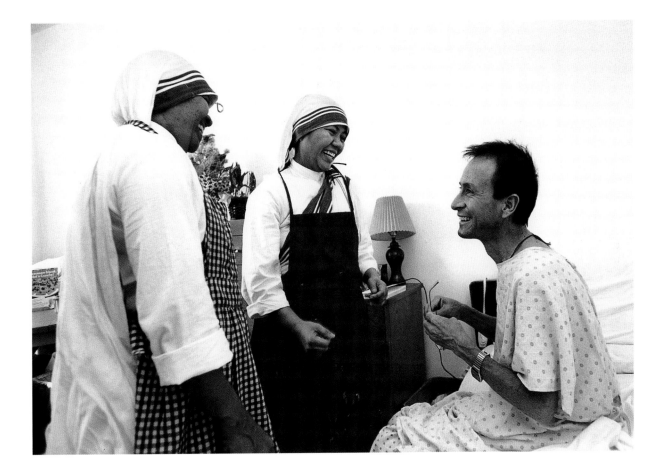

GIFT OF LOVE, AIDS HOSPICE, 1994

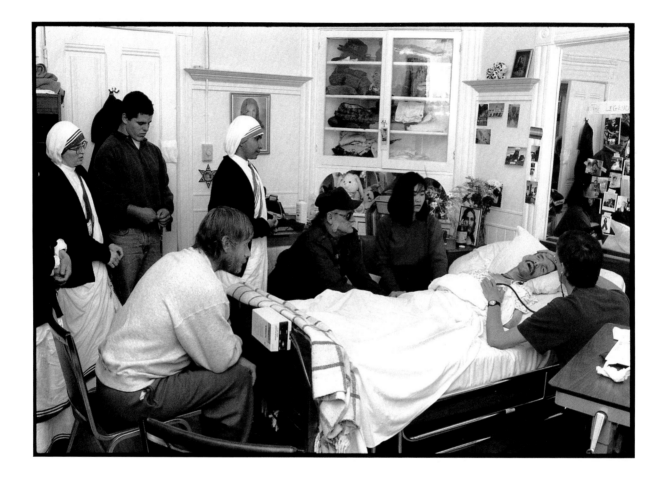

His name was David. Like the other men whose photographs appear in this section, when David found out about this book project, he wanted to be involved. So there we were at a most intimate and profound event—his death. As so many of the others who had come here to die, David had endured a difficult life and had suffered much. We thank these men for sharing the last moments of their lives with us and pray that they may experience a new life of joy and peace with God. —M. Collopy

GIFT OF LOVE, AIDS HOSPICE, 1996

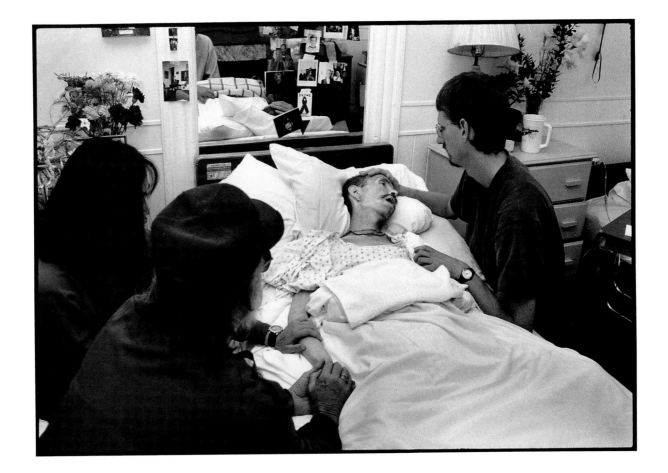

GIFT OF LOVE, AIDS HOSPICE, 1996

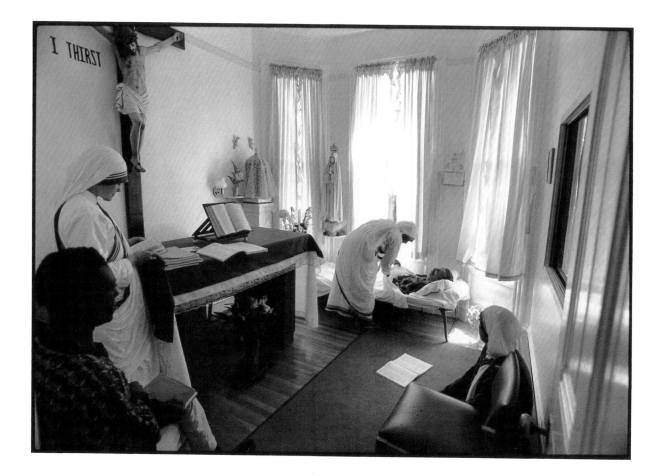

GIFT OF LOVE, AIDS HOSPICE, DAVID IN REPOSE, 1996

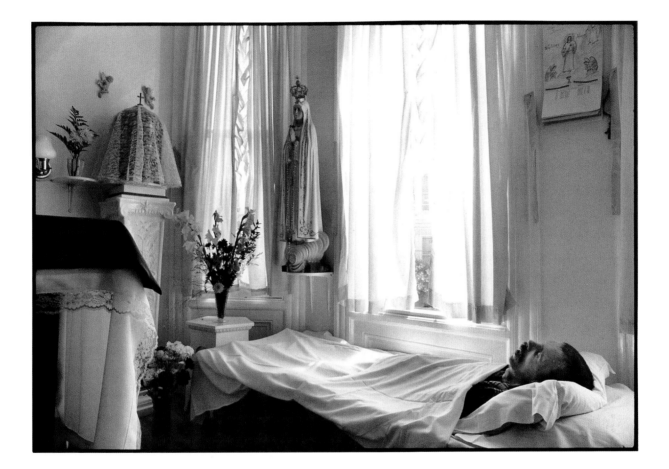

GIFT OF LOVE, AIDS HOSPICE, DAVID IN REPOSE, 1996

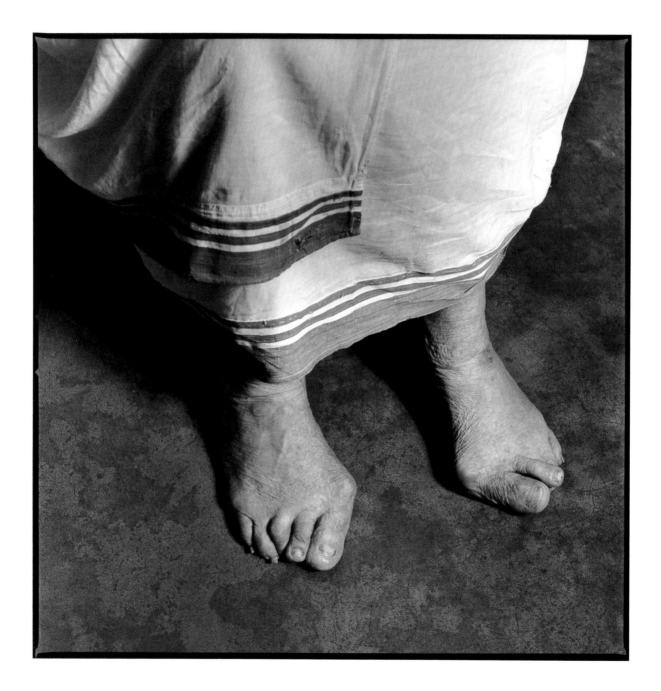

THE FEET OF MOTHER TERESA, 1995

SUFFERING IS INCREASING in the world today. People

are hungry for something more beautiful, for something

greater than people round about can give. There is a great

hunger for God in the world today. Everywhere there is much

suffering, but there is also great hunger for God and love for

each other.

Suffering in itself is nothing; but suffering shared with

Christ's Passion is a wonderful gift. Man's most beautiful gift

is that he can share in the Passion of Christ. Yes, a gift and a

sign of His love; because this is how His Father proved that

He loved the world—by giving His Son to die for us.

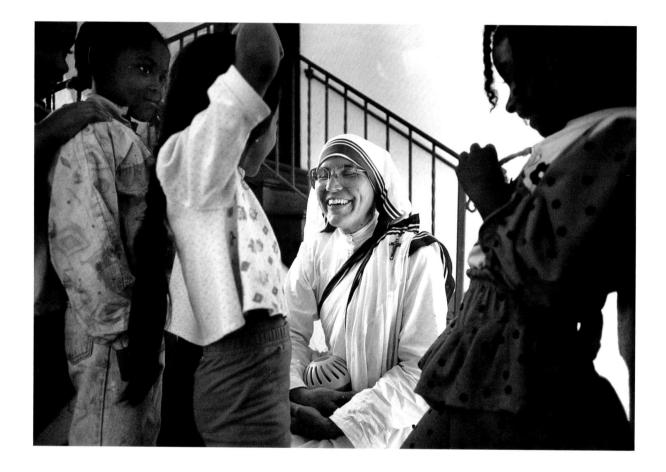

"And whoever receives one child such
as this in my name receives me."
—Matthew 18:5

CHILDREN'S SUMMER CAMP, OAKLAND, 1993

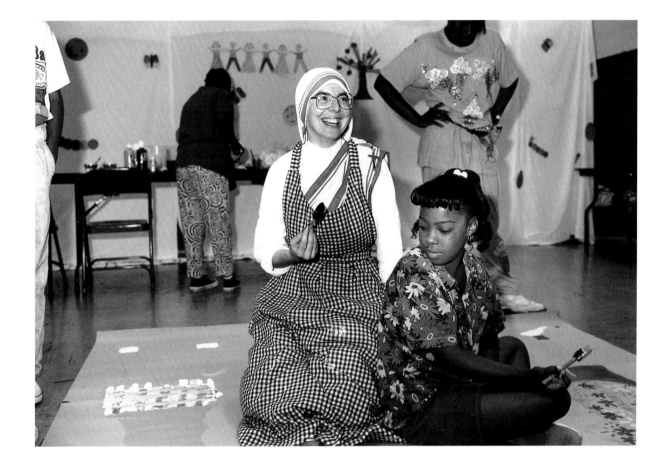

CHILDREN'S SUMMER CAMP, OAKLAND, 1993

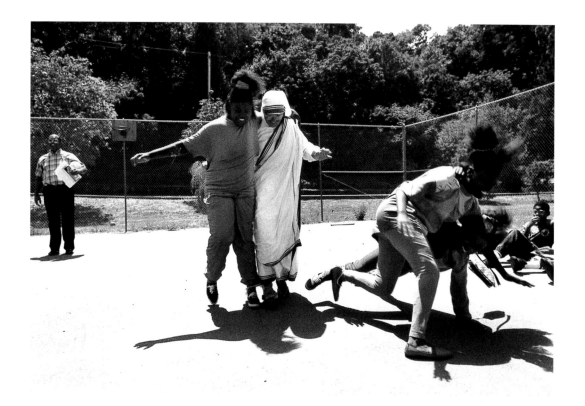

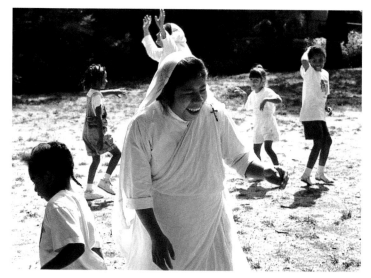

Sometimes it was hard to tell who was having more fun—the Sisters or the children. — M. Collopy

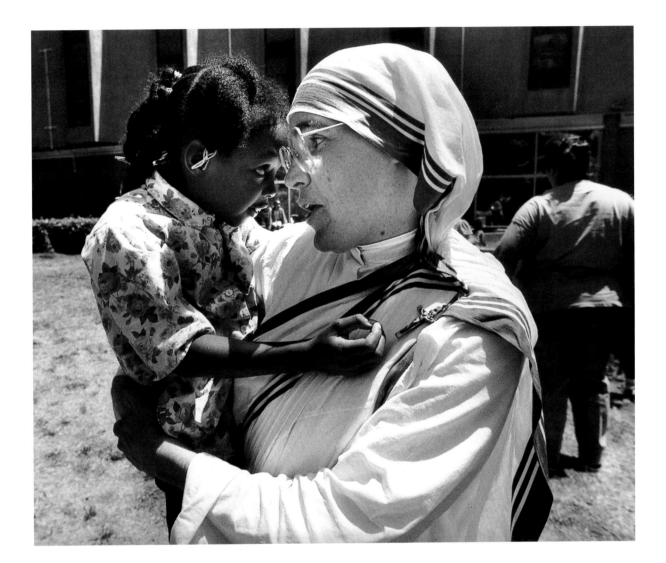

There was a little girl who was in tears all the time so the Sisters kept picking her up to comfort her. It turned out that there was a rare problem with her tear ducts so she couldn't help but shed tears all the time—even when she was quite happy and content. But of course she never minded the extra, loving attention of the Sisters! — M. Collopy

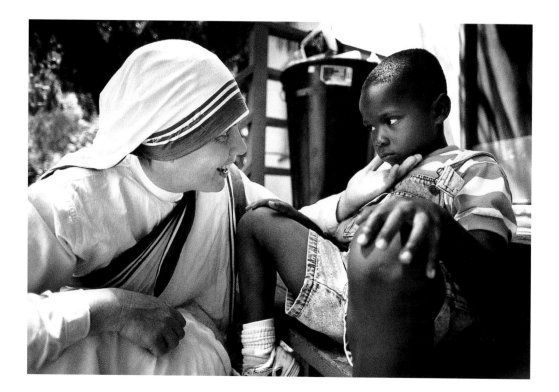

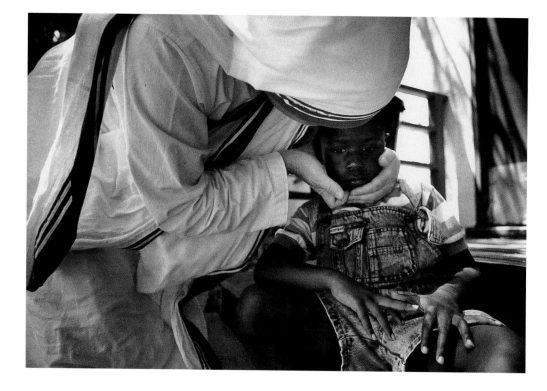

CHILDREN'S SUMMER CAMP, OAKLAND, 1993

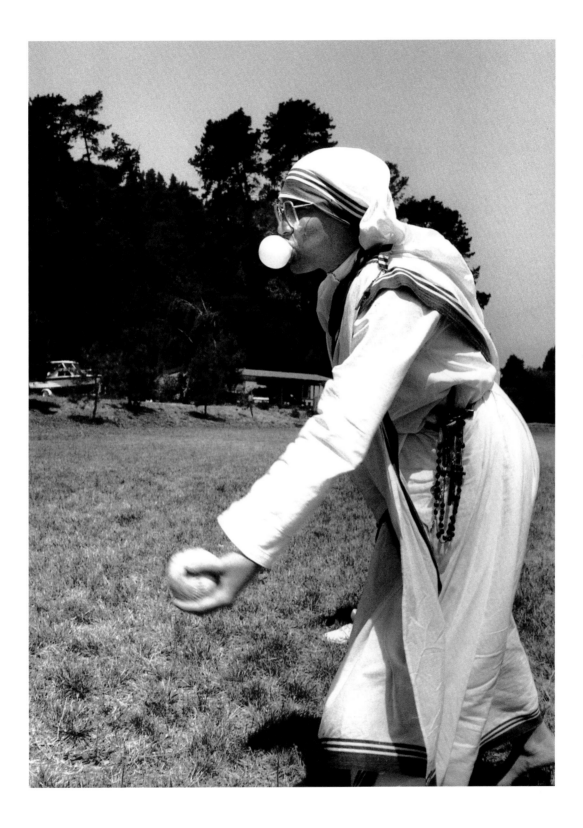

169

CHILDREN'S SUMMER CAMP, OAKLAND, 1993

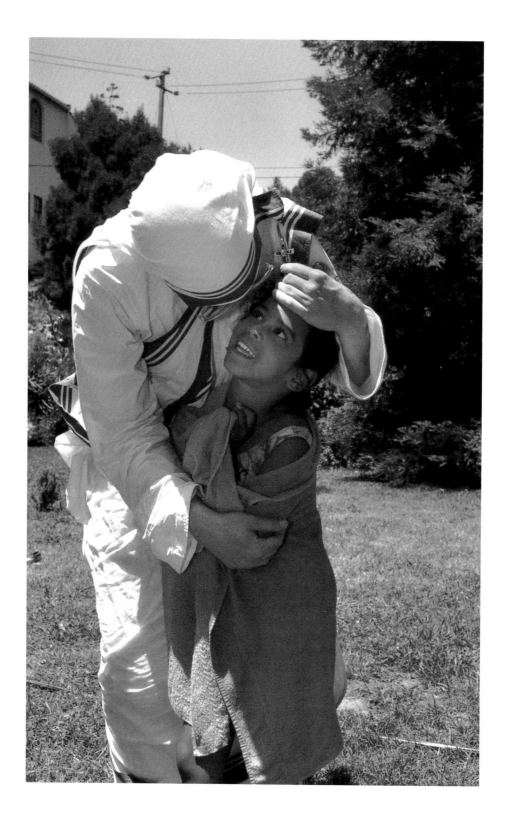

CHILDREN'S SUMMER CAMP, OAKLAND, 1993

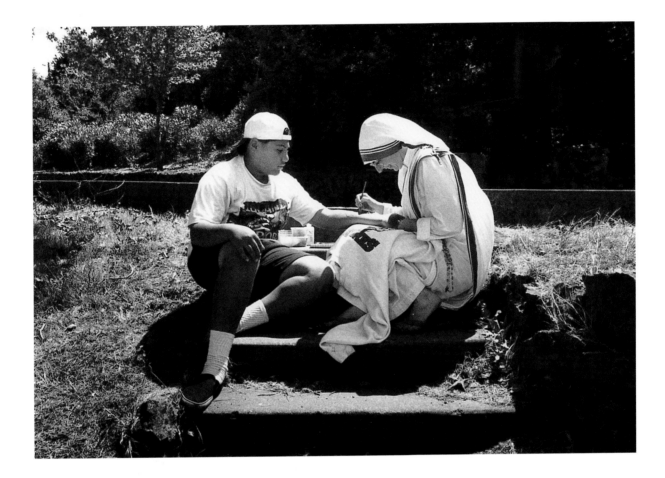

I watched a young boy sit patiently as one of the Sisters drew a tattoo (removable, of course) on his arm. Did it say "Mother"? — M. Collopy

CHILDREN'S SUMMER CAMP, OAKLAND, 1993

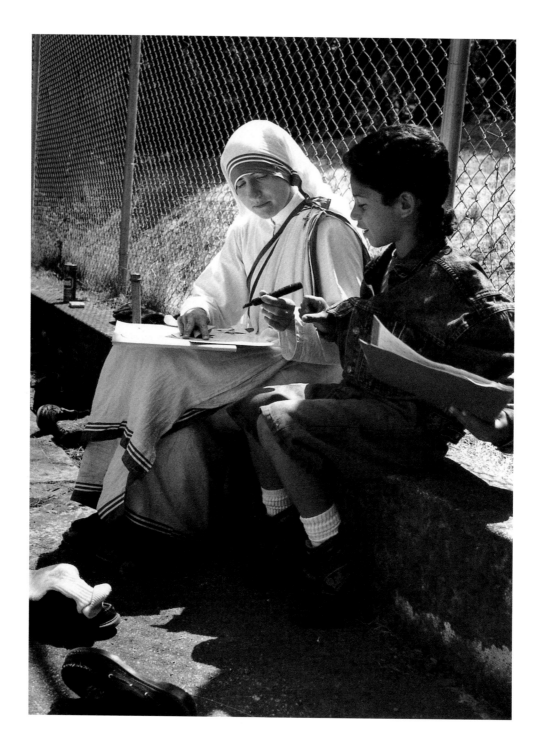

CHILDREN'S SUMMER CAMP, OAKLAND, 1993

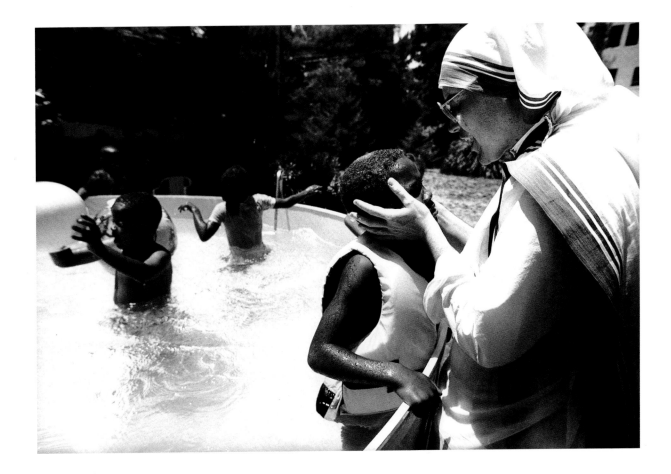

CHILDREN'S SUMMER CAMP, OAKLAND, 1993

CHILDREN'S SUMMER CAMP, OAKLAND, 1993

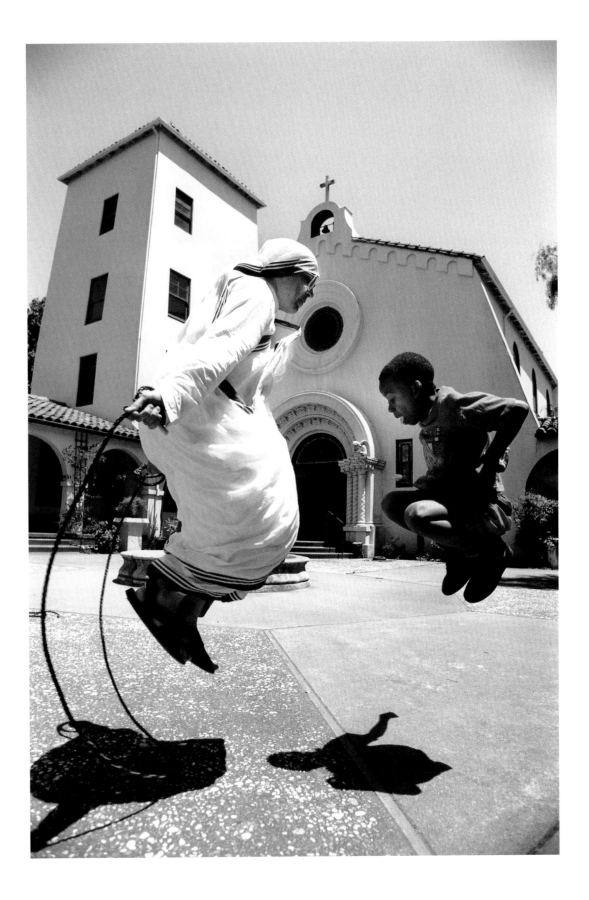

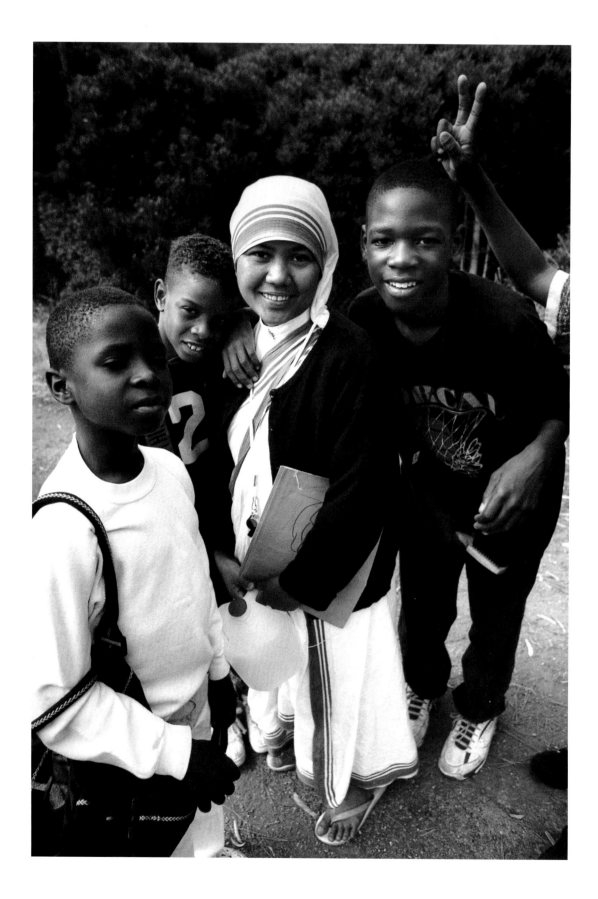

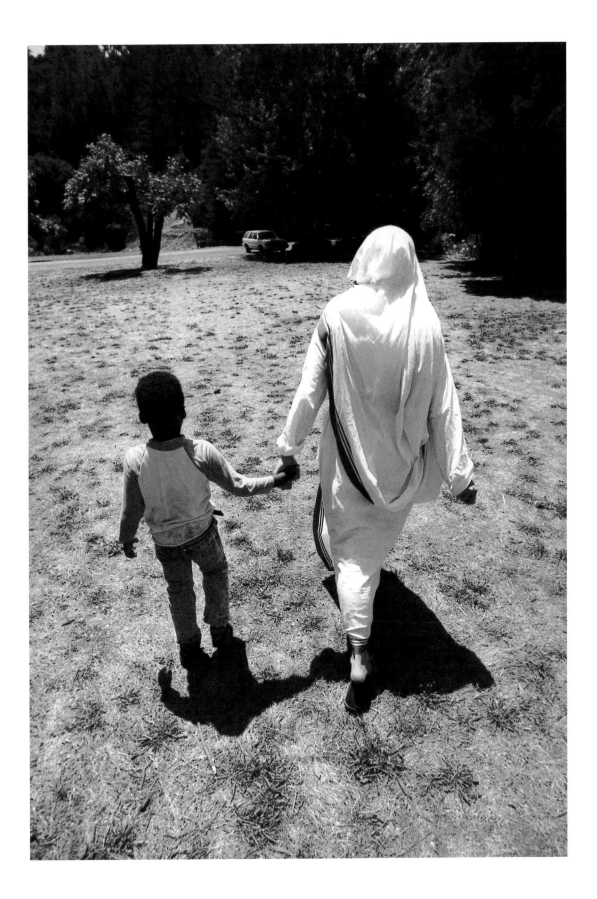

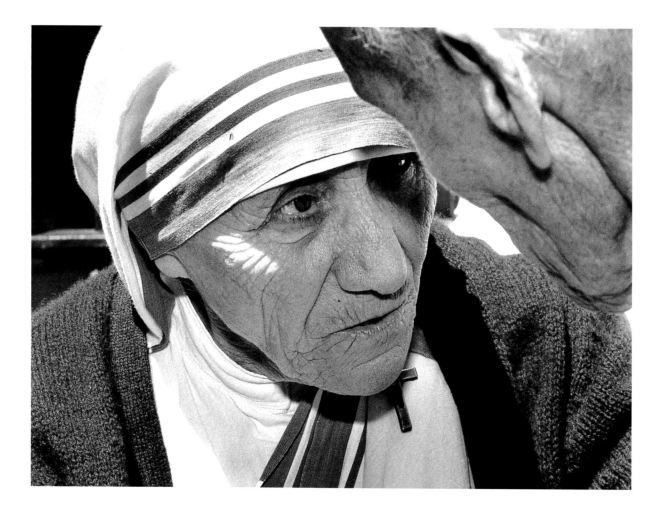

Never let anyone come to you without coming
away better and happier. Everyone should see
goodness in your face, in your eyes, in your smile.

SAN FRANCISCO, 1984

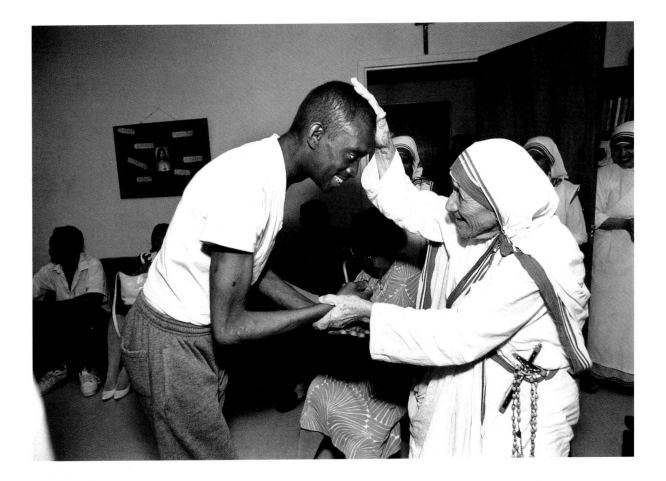

Welcome everyone as you welcome Christ Himself.
Show great love and respect.

WASHINGTON, D.C., 1995

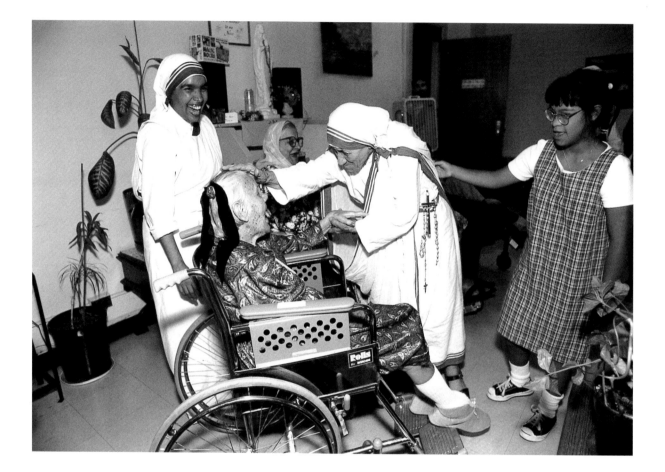

WASHINGTON, D.C., 1995

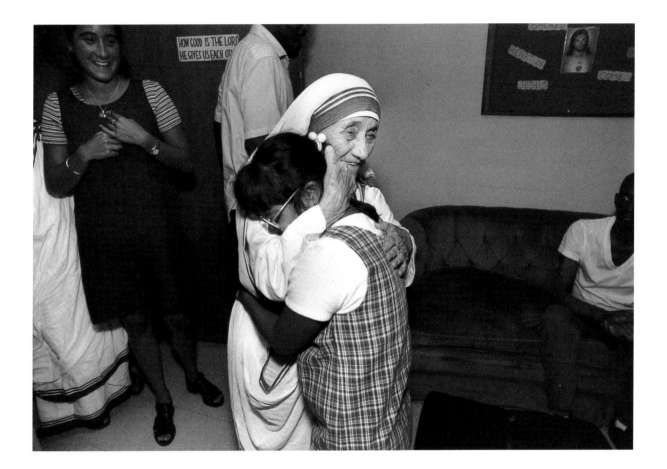

WASHINGTON, D.C., 1995

Today there were about three of us photographers taking pictures of Mother. After a while I could tell that she was uncomfortable with all the attention, feeling embarrassed and probably even a little annoyed. Still, she was very gracious about it all. But finally, I think it was really getting to her, and she walked up and said, with a little twinkle in her eye, "This is my deal with God: for every photo taken of me, a soul is released from Purgatory. And today—the place is cleaned out!" — M. Collopy

WASHINGTON, D.C., 1995

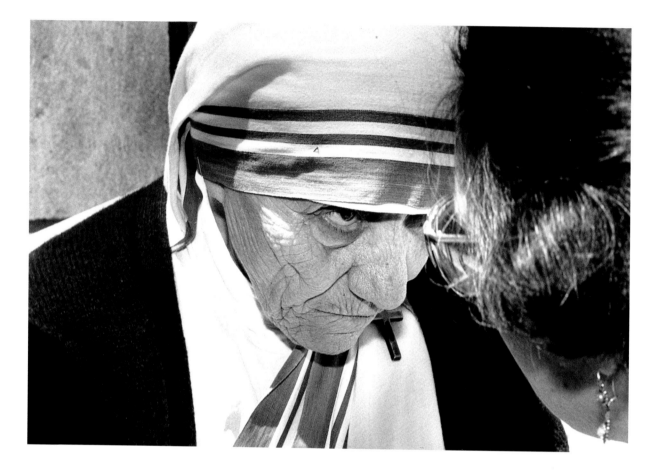

SAN FRANCISCO, 1984

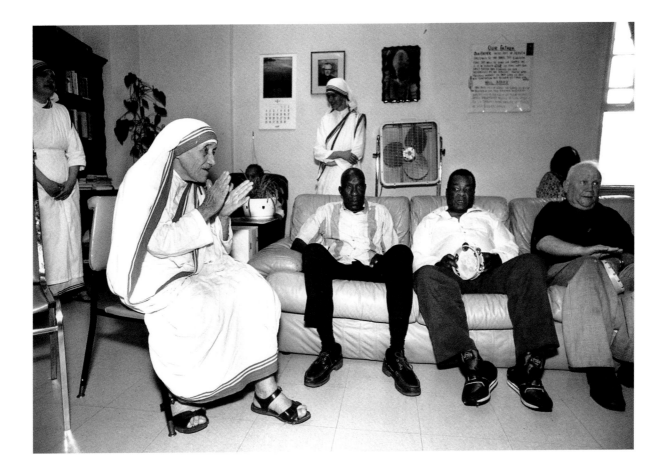

The men had been practicing to sing a song to Mother. I always find it interesting to see her reactions. She began singing along, tapping her feet and clapping to the music. Really getting into it. — M. Collopy

WASHINGTON, D.C., 1995

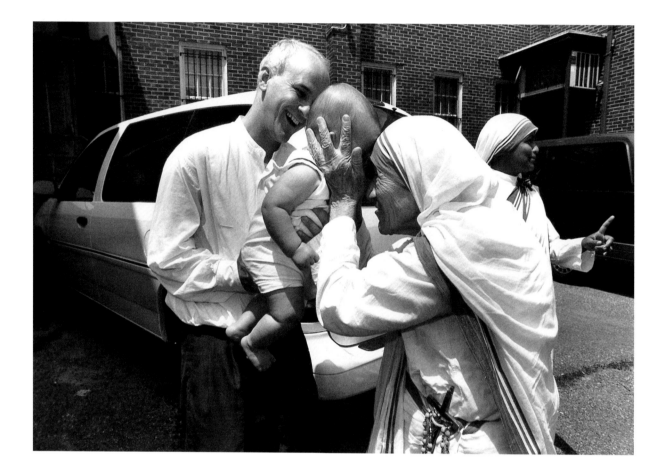

Washington, D.C., 1995

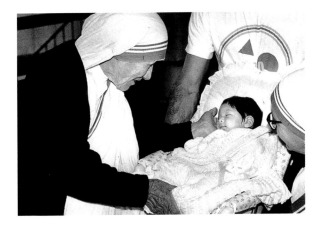
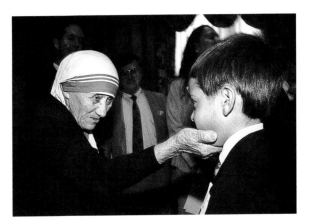
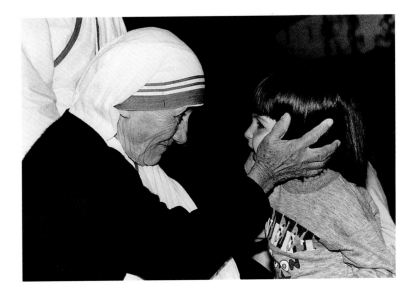

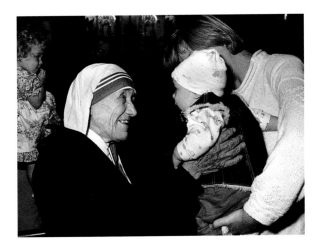
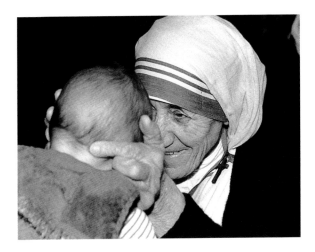

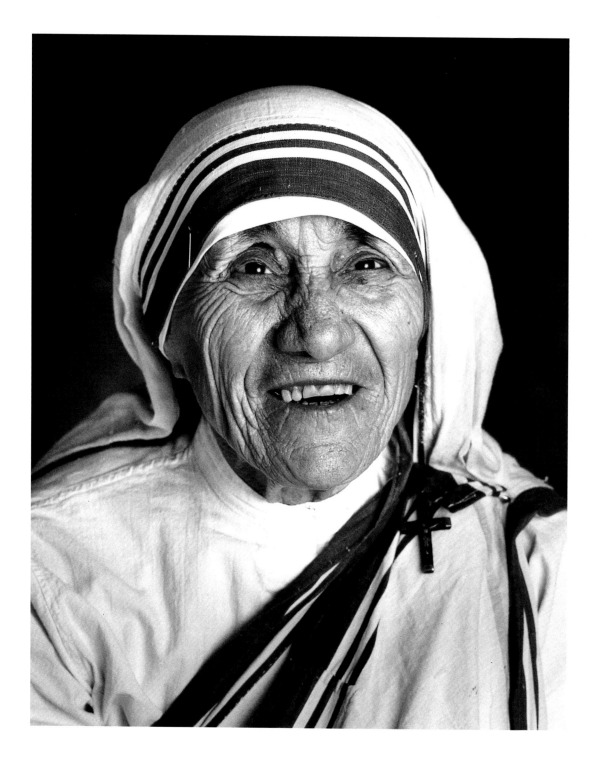

Love is the reason for my life.

MOTHER, 1987

189

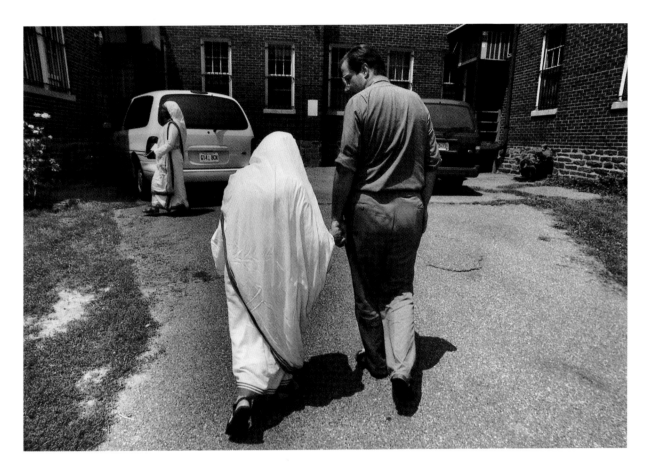

*Keep close
to Jesus
He loves you
Let us pray
God bless you
Mc Teresa mc*

MOTHER TERESA WITH FATHER JOSEPH, FATHER GENERAL OF THE MISSIONARIES OF CHARITY FATHERS, 1995

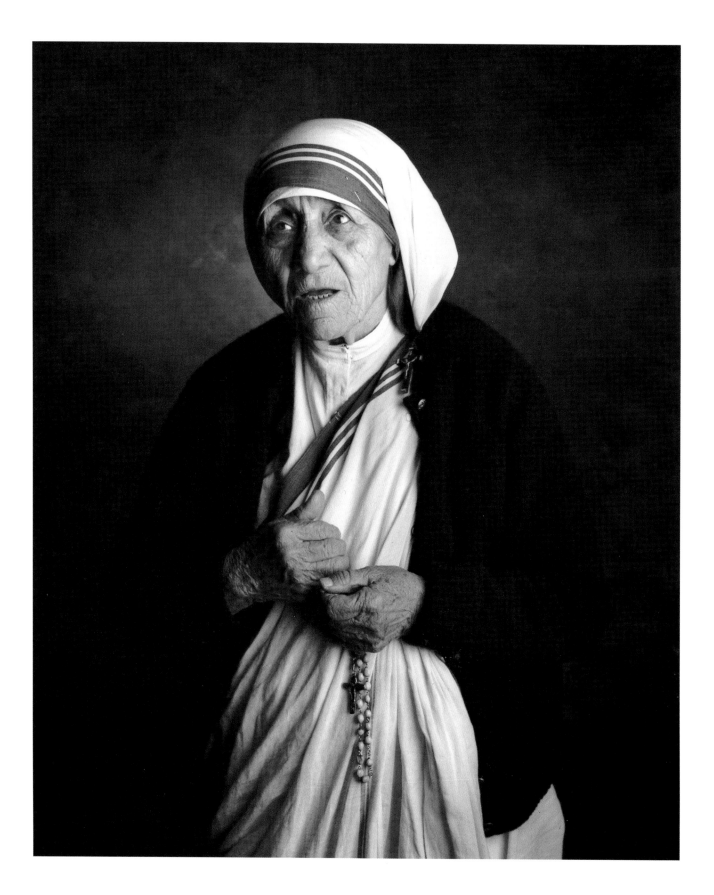

Whatever You Did unto One of the Least, You Did unto Me

Mother Teresa of Calcutta

ON THE LAST DAY, JESUS WILL SAY TO THOSE ON HIS RIGHT HAND, "Come, enter the Kingdom. For I was hungry and you gave me food, I was thirsty and you gave me drink, I was sick and you visited me." Then Jesus will turn to those on His left hand and say, "Depart from me because I was hungry and you did not feed me, I was thirsty and you did not give me to drink, I was sick and you did not visit me." These will ask Him, "When did we see You hungry or thirsty or sick and did not come to Your help?" And Jesus will answer them, "Whatever you neglected to do unto one of the least of these, you neglected to do unto Me!"

As we have gathered here to pray together, I think it will be beautiful if we begin with a prayer that expresses very well what Jesus wants us to do for the least. St. Francis of Assisi understood very well these words of Jesus, and his life is very well expressed by a prayer. And this prayer, which we say every day after Holy Communion, always surprises me very much, because it is very fitting for each one of us. And I always wonder whether eight hundred years ago when St. Francis lived, they had the same difficulties that we have today. I think that some of you already have this prayer of peace—so we will pray it together…

Let us thank God for the opportunity He has given us today to have come here to pray together. We have come here especially to pray for peace, joy, and love. We are reminded that Jesus came to bring the good news to the poor. He had told us what is that good news when He said: "My peace I leave with you, My peace I give unto you." He came not to give the peace of the world, which is only that we don't bother each other. He came to give the peace of heart that comes from loving—from doing good to others.

And God loved the world so much that He gave His Son—it was giving. God gave His Son to the Virgin Mary, and what did she do with Him? As soon as Jesus came into the house of her cousin, Elizabeth, Scripture tells us that the unborn child—the child in the womb of Elizabeth—leapt with joy. While still in the womb of Mary, Jesus brought peace to John the Baptist, who leapt for joy in the womb of Elizabeth.

And as if that were not enough, as if it were not enough that God the Son should become one of us and bring peace and joy while still in the womb of Mary, Jesus also died on the Cross to show that greater love. He died for you and for me, and for that leper and for that man dying of hunger and that naked person lying in the street, not only of Calcutta, but of Africa and everywhere. Our Sisters serve these poor people in 105 countries throughout the world. Jesus insisted that we love one another as He loves each one of us. Jesus gave His life to love us, and He tells us that we also have to give whatever it takes to do good to one another. And in the Gospel Jesus says very clearly: "Love as I have loved you."

Jesus died on the Cross because that is what it took for Him to do good to us—to save us from our selfishness in sin. He gave up everything to do the Father's will—to show us that we too must be willing to give up everything to do God's will, to love one another as He loves each of us. If we are not willing to give whatever it takes to do good to one another, sin is still in us. That is why we too must give to each other until it hurts.

It is not enough for us to say: "I love God", but I also have to love my neighbor. St. John says that you are a liar if you say you love God and you don't love your neighbor whom you see, whom you touch, with whom you live. And so it is very important for us to realize that love, to be true, has to hurt. I must be willing to give whatever it takes not to harm other people and, in fact, to do good to them. This requires that I be willing to give until it hurts. Otherwise, there is no true love in me and I bring injustice, not peace, to those around me.

It hurt Jesus to love us. We have been created in His image for greater things, to love and to be loved. We must "put on Christ", as Scripture tells us. And so, we have been created to love as He loves us. Jesus makes Himself the hungry one, the naked one, the homeless one, the unwanted one, and He says, "You did it to Me." On the last day He will say to those on His right, "Whatever you did to the least of these you did to Me", and He will also say to those on His left, "Whatever you neglected to do for the least of these you neglected to do it for Me."

When He was dying on the Cross, Jesus said, "I thirst." Jesus is thirsting for our love, and this is the thirst of everyone, poor and rich alike. We all thirst for the love of others, that they go out of their way to avoid harming us and to do good to us. This is the meaning of true love, to give until it hurts.

I can never forget the experience I had in visiting a home where they kept all these old parents of sons and daughters who had just put them into an institution and forgotten them—maybe. I saw that in that home these people had everything—good food, a comfortable place, television, everything, but everyone was looking toward the door. And I did not see a single smile on the face. I turned to Sister and asked: "Why do these people who have every comfort here, why are they all looking toward the door? Why are they not smiling?"

I am so used to seeing the smiles on our people, even the dying ones smile. And Sister said: "This is the way it is nearly every day. They are expecting, they are hoping that a son or daughter will come to visit them. They are hurt because they are forgotten." And see, this neglect to love brings spiritual poverty. Maybe in our own family we have somebody who is feeling lonely, who is feeling sick, who is feeling worried. Are we there? Are we willing to give until it hurts in order to be with our families, or do we put our own interests first? These are the questions we must ask ourselves, especially as we begin this year of the family. We must remember that love begins at home, and we must also remember that the future of humanity passes through the family.

I was surprised in the West to see so many young boys and girls given to drugs. And I tried to find out why? Why is it like that, when those in the West have so many more things than those in the East? And the answer was: "Because there is no one in the family to receive them." Our children depend on us for everything—their health, their nutrition, their security, their coming to know and love God. For all of this, they look to us

with trust, hope, and expectation. But often father and mother are so busy they have no time for their children, or perhaps they are not even married or have given up on their marriage. So the children go to the streets and get involved in drugs or other things. We are talking of love of the child, which is where love and peace must begin. These are the things that break peace.

But I feel that the greatest destroyer of peace today is abortion, because it is a war against the child, a direct killing of the innocent child, murder by the mother herself. And if we accept that a mother can kill even her own child, how can we tell other people not to kill one another? How do we persuade a woman not to have an abortion? As always, we must persuade her with love, and we remind ourselves that love means to be willing to give until it hurts. Jesus gave even His life to love us. So, the mother who is thinking of abortion should be helped to love, that is, to give until it hurts, her plans, or her free time, to respect the life of her child. The father of that child, whoever he is, must also give until it hurts.

By abortion, the mother does not learn to love but kills even her own child to solve her problems. And, by abortion, the father is told that he does not have to take any responsibility at all for the child he has brought into the world. That father is likely to put others in the same trouble. So abortion just leads to more abortion. Any country that accepts abortion is not teaching its people to love, but to use any violence to get what they want. This is why the greatest destroyer of love and peace is abortion.

Many people are very, very concerned with the children of India, with the children of Africa, where quite a few die of hunger, and so on. Many people are also concerned about all the violence in this great country of the United States. These concerns are very good. But often these same people are not concerned with the millions who are being killed by the deliberate decision of their own mothers. And this is what is the greatest destroyer of peace today—abortion, which brings people to such blindness.

And for this I appeal in India and I appeal everywhere: "Let us bring the child back." This child is God's gift to the family. Each child is created in the special image and likeness of God for greater things—to love and to be loved. In this year of the family we must bring the child back to the center of our care and concern. This is the only way that our world can survive, because our children are the only hope for the future. As older people are called to God, only their children can take their places.

But what does God say to us? He says: "Even if a mother could forget her child, I will not forget you. I have carved you in the palm of my hand." We are carved in the palm of His hand; that unborn child has been carved in the hand of GOD from conception and is called by God to love and to be loved, not only now in this life, but forever. God can never forget us.

I will tell you something beautiful. We are fighting abortion by adoption—by care of the mother and adoption for her baby. We have saved thousands of lives. We have sent word to the clinics, to the hospitals and police stations: "Please don't destroy the child; we will take the child." So we always have someone tell the mothers in trouble: "Come, we will take care of you, we will get a home for your child." And we have a tremendous demand from couples who cannot have a child—but I never give a child to a couple who have done something not to have a child. Jesus said, "Anyone who receives

a child in my name, receives me." By adopting a child, these couples receive Jesus, but by aborting a child, a couple refuses to receive Jesus.

Please don't kill the child. I want the child. Please give me the child. I am willing to accept any child who would be aborted and give that child to a married couple who will love the child and be loved by the child. From our children's home in Calcutta alone, we have saved over three thousand children from abortion. These children have brought such love and joy to their adopting parents and have grown up so full of love and joy.

I know that couples have to plan their family, and for that there is natural family planning, not contraception. In destroying the power of giving life, through contraception, a husband or wife is doing something to self. This turns the attention to self and so destroys the gift of love in him or her. In loving, the husband and wife must turn the attention to each other, as happens in natural family planning, and not to self, as happens when we tell people to practice contraception and abortion.

The poor are very great people. They can teach us so many beautiful things. Once one of them came to thank us for teaching her natural family planning and said: "You people who have practiced chastity, you are the best people to teach us natural planning because it is nothing more than self-control out of love for each other." And what this poor person said is very true. These poor people maybe have nothing to eat, maybe they have not a home to live in, but they can still be great people when they are spiritually rich.

When I pick up a person from the street, hungry, I give him a plate of rice, a piece of bread. But a person who is shut out, who feels unwanted. unloved, terrified, the person who has been thrown out from society—that spiritual poverty is much harder to overcome. And abortion, which often follows from contraception, brings a people to be spiritually poor, and that is the worst poverty and the most difficult to overcome.

Those who are materially poor can be very wonderful people. One evening we went out and we picked up four people from the street. And one of them was in a most terrible condition. I told the Sisters: "You take care of the other three; I will take care of the one who looks worst." So I did for her all that my love can do. I put her in bed, and there was such a beautiful smile on her face. She took hold of my hand, as she said one thing only: "Thank you", and she died.

I could not help but examine my conscience before her. And I asked: "What would I say if I were in her place?" And my answer was very simple. I would have tried to draw a little attention to myself. I would have said: "I am hungry, I am dying, I am cold, I am in pain", or something. But she gave me much more—she gave me her grateful love. And she died with a smile on her face. Then there was the man we picked up from the drain, half eaten by worms, and, after we had brought him to the home, he only said, "I have lived like an animal in the street, but I am going to die as an angel, loved and cared for." Then, after we had removed all the worms from his body, all he said, with a big smile, was: "Sister, I am going home to God", and he died. It was so wonderful to see the greatness of that man who could speak like that without blaming anybody, without comparing anything. Like an angel—this is the greatness of people who are spiritually rich even when they are materially poor.

We are not social workers. We may be doing social work in the eyes of some people, but we must be contemplatives in the heart of the world. For we must bring that presence of God into your family, for the family that prays together, stays together. There is so much hatred, so much misery, and we with our prayer, with our sacrifice, are beginning at home. Love begins at home, and it is not how much we do but how much love we put into what we do.

If we are contemplatives in the heart of the world with all its problems, these problems can never discourage us. We must always remember what God tells us in Scripture: Even if a mother could forget the child in her womb—something impossible, but even if she could forget—I will never forget you.

And so here I am talking with you. I want you to find the poor here, right in your own home first. And begin love there. Be that good news to your own people first. And find out about your next-door neighbors. Do you know who they are?

I had the most extraordinary experience of love of neighbor with a Hindu family. A gentleman came to our house and said: "Mother Teresa, there is a family who have not eaten for so long. Do something." So I took some rice and went there immediately. And I saw the children—their eyes shining with hunger. I don't know if you have ever seen hunger. But I have seen it very often. And the mother of the family took the rice I gave her and went out. When she came back, I asked her "Where did you go? What did you do?" And she gave a simple answer: "They were hungry also." What struck me was that she knew—and who are they? A Muslim family—and she knew. I didn't bring any more rice that evening because I wanted them, Hindus and Muslims, to enjoy the joy of sharing.

But there were those children, radiating joy, sharing the joy of peace with their mother because she had the love to give until it hurts. And you see, this is where love begins—at home in the family.

So, as the example of this family shows, God will never forget us, and there is something you and I can always do. We can keep the joy of loving Jesus in our hearts and share that joy with all we come in contact with.

Let us make that one point—that no child will be unwanted, unloved, uncared for, or killed and thrown away. And give until it hurts—with a smile.

Because I talk so much of giving with a smile, once a professor from the United States asked me: "Are you married?" And I said: "Yes, and I find it sometimes very difficult to smile at my spouse, Jesus, because He can be very demanding—sometimes." This is really something true. And there is where love comes in—when it is demanding, and yet we can give it with joy.

One of the most demanding things for me is traveling everywhere—and with publicity. I have said to Jesus that if I don't go to heaven for anything else, I will be going to heaven for all the traveling with all the publicity, because it has purified me and sacrificed me and made me really ready to go to heaven.

If we remember that God loves us, and that we can love others as He loves us, then America can become a sign of peace for the world. From here, a sign of care for the weakest of the weak—the unborn child—must go out to the world. If you become a burning light of justice and peace in the world, then really you will be true to what the founders of this country stood for. God bless you!

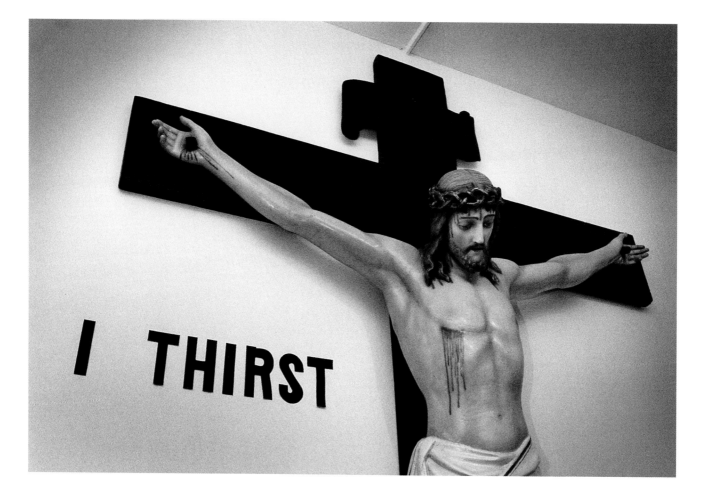

"I Thirst"

25 March, 1993
Varanasi

My Dearest Children, Sisters, Brothers, and Fathers,

THIS LETTER BEING VERY PERSONAL, I wanted to write in my own hand—but there are so many things to say. Even if not in Mother's hand, still it comes from Mother's heart.

Jesus wants me to tell you again, specially in this Holy Week, how much love He has for each one of you—beyond all you can imagine. I worry some of you still have not really met Jesus—one to one—you and Jesus alone. We may spend time in chapel—but have you seen with the eyes of your soul how He looks at you with love? Do you really know the living Jesus—not from books but from being with Him in your heart? Have you heard the loving words He speaks to you? Ask for the grace, He is longing to give it. Until you can hear Jesus in the silence of your own heart, you will not be able to hear Him saying "I thirst" in the hearts of the poor. Never give up this daily intimate contact with Jesus as the real living person—not just the idea. How can we last even one day without hearing Jesus say "I love you"—impossible. Our soul needs that as much as the body needs to breathe the air. If not, prayer is dead—meditation only thinking. Jesus wants you each to hear Him—speaking in the silence of your heart.

Be careful of all that can block that personal contact with the living Jesus. The Devil may try to use the hurts of life, and sometimes our own mistakes—to make you feel it is impossible that Jesus really loves you, is really cleaving to you. This is a danger for all of us. And so sad, because it is completely opposite of what Jesus is really wanting, waiting to tell you. Not only that He loves you, but even more—He longs for you. He misses you when you don't come close. He thirsts for you. He loves you always, even when you don't feel worthy. When not accepted by others, even by yourself sometimes—He is the one who always accepts you. My children, you don't have to be different for Jesus to love you. Only believe—You are precious to Him. Bring all you are suffering to His feet—only open your heart to be loved by Him as you are. He will do the rest.

You all know in your mind that Jesus loves you—but in this letter Mother wants to touch your heart instead. Jesus wants to stir up our hearts, so not to lose our early love, specially in the future after Mother leaves you. That is why I ask you to read this letter before the Blessed Sacrament, the same place it was written, so Jesus himself can speak to you each one.

Why is Mother saying these things? After reading the Holy Father's letter on "I thirst", I was struck so much—I cannot tell you what I felt. His letter made me realize more than ever how beautiful is our vocation. How great God's love for us in choosing our Society to satiate that thirst of Jesus, for love, for souls—giving us our special place in the Church. At the same time we are reminding the world of His thirst, something that was being forgotten. I wrote the Holy Father to thank him. The Holy Father's letter is a sign for our whole society—to go more into this great thirst of Jesus for each one. It is also a sign for Mother, that the time has come for me to speak openly of the gift God gave Sept. 10[1]—to explain as fully as I can what it means for me—the thirst of Jesus.

For me Jesus' thirst is something so intimate—so I have felt shy until now to speak to you of Sept. 10—I wanted to do as Our Lady who "kept all these things in her heart". That is why Mother hasn't spoken so much of "I Thirst", especially outside. But still, Mother's letters and instructions always point to it—showing the means to satiate His thirst through prayer, intimacy with Jesus, living our vows—specially our 4th vow.[2] For me it is so clear—everything in MC exists only to satiate Jesus. His words on the wall of every MC chapel, they are not from the past only, but alive here and now, spoken to you. Do you believe it? If so, you will hear, you will feel His presence. Let it become as intimate for each of you, just as for Mother—this is the greatest joy you could give me. Mother will try to help you understand—but Jesus himself must be the one to say to you "I Thirst." Hear your own name. Not just once. Every day. If you listen with your heart, you will hear, you will understand.

Why does Jesus say "I Thirst"? What does it mean? Something so hard to explain in words—if you remember anything from Mother's letter, remember this—"I thirst" is something much deeper than Jesus just saying "I love you." Until you know deep inside that Jesus thirsts for you—you can't begin to know who He wants to be for you. Or who He wants you to be for Him.

The heart and soul of MC is only this—the thirst of Jesus' Heart, hidden in the poor. This is the source of every part of MC life. It gives us our Aim, our 4th vow, the Spirit of our Society. Satiating the living Jesus in our midst is the Society's only purpose for existing. Can we each say the same for ourselves—that it is our only reason for living? Ask yourself—would it make any difference in my vocation, in my relation to Jesus, in my work, if Jesus' thirst were no longer our Aim—no longer on the chapel wall? Would anything change in my life? Would I feel any loss? Ask yourself honestly, and let this be a test for each to see if His thirst is a reality, something alive—not just an idea.

"I Thirst" and "You did it to me"—Remember always to connect the two, the means with the Aim. What God has joined together let no one split apart. Do not underestimate our practical means—the work for the poor, no matter how small or humble—that make our life something beautiful for God. They are the most precious gifts of God to our Society—Jesus' hidden presence so near, so able to touch. Without the work for the

[1] *Inspiration Day. On her way to Darjeeling by train, Mother Teresa heard a "call within a call" to leave Loreto convent and go to work with the poor in the slums. 1946.*

[2] *The first three vows are the evangelical vows of poverty, chastity, and obedience. The fourth vow taken by the Missionaries of Charity is one of "wholehearted and free service to the poorest of the poor".*

poor the Aim dies—Jesus' thirst is only words with no meaning, no answer. Uniting the two, our MC vocation will remain alive and real, what Our Lady asked.

...The thirst of Jesus is the focus of all that is MC. The Church has confirmed it again and again—"Our charism is to satiate the thirst of Jesus for love and souls—by working at the salvation and sanctification of the poorest of the poor." Nothing different. Nothing else. Let us do all we can to protect this gift of God to our Society.

Believe me, my dear children—pay close attention to what Mother is saying now—only the thirst of Jesus, hearing it, feeling it, answering it with all your heart, will keep the Society alive after Mother leaves you. If this is your life, you will be all right. Even when Mother leaves you, Jesus' thirst will never leave you. Jesus thirsting in the poor you will have with you always.

That is why I want the Active Sisters and Brothers, the Contemplative Sisters and Brothers, and the Fathers to each one aid the other in satiating Jesus with their own special gift—supporting, completing each other and this precious Grace as one Family, with one Aim and purpose. Do not exclude the Coworkers and Lay MCs from this—this is their call as well, help them to know it.

Because the first duty of a priest is the ministry to preach, some years back I asked our Fathers to begin speaking about "I Thirst", to go more deeply into what God gave the Society Sept. 10. I feel Jesus wants this of them, also in the future—so pray that Our Lady keeps them in this special part of their 4th vow. Our Lady will help all of us in this, since she was the first person to hear Jesus' cry "I Thirst" with St. John, and I am sure Mary Magdalen. Because Our Lady was there on Calvary, she knows how real, how deep is His longing for you and for the poor. Do we know? Do we feel as She? Ask her to teach—you and the whole Society are hers. Her role is to bring you face to face, as John and Magdalen, with the love in the Heart of Jesus crucified. Before it was Our Lady pleading with Mother, now it is Mother in her name pleading with you—"listen to Jesus' thirst." Let it be for each what Holy Father said in his letter—a Word of Life.

How do you approach the thirst of Jesus? Only one secret—the closer you come to Jesus, the better you will know His thirst. "Repent and believe", Jesus tells us. What are we to repent? Our indifference, our hardness of heart. What are we to believe? Jesus thirsts even now, in your heart and in the poor—He knows your weakness, He wants only your love, wants only the chance to love you. He is not bound by time. Whenever we come close to Him—we become partners of Our Lady, St. John, Magdalen. Hear Him. Hear your own name. Make my joy and yours complete.

Let us pray.

God bless you
M. Teresa, M.C.

Missionaries of Charity Prayers

This section contains all the prayers of the M.C. Prayer Book, the official prayer book of the Order.

MORNING PRAYERS

O God, we believe you are here; / we adore and love you with our whole heart and soul.

You have created us, / redeemed us by the death of your Son, / sanctified us by the grace of your Holy Spirit, / and preserved us this past night. / We give you most humble thanks for these and all the other benefits you have poured on us. / We offer you all our thoughts, words, actions, and sufferings, / and implore you to give us grace not to offend you this day, / but to do your holy Will in all things. / May all the angels and saints pray for us, / and you, / O Holy Mother of God, / give us your blessing.

O Jesus, through the most pure heart of Mary, / we offer you the prayers, works, and sufferings of this day / for all the intentions of your Divine Heart.

We offer all in union with your prayers, works, joys, and sufferings when on earth, / to the praise and glory of your divine Majesty, / in thanksgiving for all the graces bestowed on the Immaculate Heart of Mary, / Cause of our Joy, / and to obtain fervent souls for our Society.

In your boundless Mercy, O Sacred Heart of Jesus, / you have mercifully chosen us as your own. In return for this blessing, we consecrate ourselves unreservedly and forever to your service. / Accept now, and at every moment of our lives, / the offering of all our thoughts, labours, joys, and sorrows. / Infuse into this Community the spirit of prayer, regularity, self-denial, and charity. / Give us the grace to live united and to be nourished by your holy love, / so that we may be enabled to possess you eternally in Heaven.

Blessed be the holy and undivided Trinity, now and forevermore. Amen.

ACT OF FAITH
We firmly believe all the sacred truths / the Holy Catholic Church believes and teaches, / because they have been revealed by you, the sovereign Truth, / who neither can deceive nor be deceived, / and by the assistance of your holy grace / we are resolved to live and die in the communion of this your Church.

ACT OF HOPE
Relying upon your Goodness, Power, and promises / we hope to obtain pardon of our sins and life everlasting, / through the merits of your Son Jesus Christ, our only Redeemer, / and by the intercession of His blessed Mother and all the Saints.

ACT OF LOVE
We love you with our whole heart and soul, because you, O God, are most worthy of all our love. / We desire to love you as the Blessed do in heaven, / we adore all the designs of your divine Providence, / resigning ourselves entirely to your Will. / We also love our neighbour for your sake as we love ourselves; / we sincerely forgive all who have injured us, / and ask pardon of all whom we have injured.

ACT OF CONTRITION
O God, I love you with my whole heart and above all things. I am heartily sorry for having offended you, because you are so good. I firmly resolve not to offend you any more. And I shall do whatever you ask of me.

ACT OF DESIRE
May the burning and most sweet power of your love, / O Lord Jesus Christ / we implore you, absorb our minds, / that we may die through love of you, who were graciously pleased to die through love of us.

Immaculate Heart of Mary, Cause of our Joy, / bless your own Missionaries of Charity, / help us to do all the good we can, / keep us in your most pure Heart, / so that we may please Jesus through you, in you, and with you.

O God, we recommend to your fatherly care, / the Pope, Cardinals, Bishops, Priests, and all religious, / all those who have asked our prayers and for whom we should pray.

THE ANGELUS
The Angel of the Lord declared unto Mary
And she conceived by the power of the Holy Spirit.

(Hail Mary)

Behold the handmaid of the Lord
Be it done to me according to your word.

(Hail Mary)

And the Word was made flesh
And dwells among us.

(Hail Mary)

Pray for us, O Holy Mother of God.
That we may be made worthy of the promises of Christ.

Let us pray

Pour forth we beseech you, O Lord, your grace into our hearts / that we to whom the incarnation of Christ your Son was made known by the message of an angel, / may by His passion and cross / be brought to the glory of His resurrection / through the same Christ our Lord. Amen.

REGINA COELI
(From Holy Saturday till Pentecost)
Queen of heaven Rejoice, Alleluia,
For He whom you merited to bear, Alleluia,
Has risen as He said, Alleluia.
Pray for us to God, Alleluia.
Rejoice and be glad O Virgin Mary, Alleluia.
For the Lord has risen indeed, Alleluia.

Let us pray

O God, who gave joy to the world through the resurrection of your son Our Lord Jesus Christ, / grant we implore you / that / through your Mother the Virgin Mary / we may obtain the joys of everlasting life / through the same Christ our Lord. Amen.

BEFORE MEDITATION

O God, we firmly believe that we are in your most holy presence, / we believe that you see us / —and that at this moment you behold even the inmost recesses of our hearts. / Penetrated with this your divine presence, we adore you, / O God, / with all the powers of our soul. / We are unworthy to appear before you / and more unworthy to hold communion with you. / We are heartily sorry for having offended you, / and we beseech of you pardon of our sins / and grace to make a good and fruitful meditation. / We offer you all the thoughts of our minds, / the affections of our hearts, / and the operations of our souls, / imploring you to fill them with your divine Spirit. / Speak to us, O Lord, / let us

hear your voice and attend to your holy inspirations. / Speak, Lord, for your servants are listening.

O Jesus! / grant that you may be the object of our thoughts and affections, / the subject of our conversations, / the end of our actions, / the model of our life, / our support in death, and our reward eternally in your heavenly Kingdom. Amen.

AFTER MEDITATION

O holy Mother of God, / throw your mantle of purity over our souls, / and present us to your divine Son Jesus, / and give Jesus to us. / Mary, our dearest Mother, we confidently turn to you, / holiest Mother, / we beg you lend us your heart so beautiful, so pure, so immaculate, / your heart so full of love and humility, / that we may be able to receive and carry Jesus / with the same sentiments with which you received and carried Him.

Come, O Mary, / our Queen and our Mother, / come and receive Jesus in us.

Take, O Lord, and receive all our liberty, / our memory, our understanding, and our whole will, / whatever we have and possess. / You have given us all these; / to you, O Lord, we restore them; / all are yours, dispose of them in any way according to your Will. / Give us your love and your grace, / for this is enough for us.
(St. Ignatius)

OUR LADY'S OFFICE, p. 220, (opening prayer, p. 220 and the verse and response from "Morning", p. 221.)

PRAYERS AFTER COMMUNION

RADIATING CHRIST
Dear Jesus, help us to spread your fragrance everywhere we go. / Flood our souls with your spirit and life. / Penetrate and possess our whole being, /so utterly, /that our lives may only be a radiance of yours. / Shine through us, / and be so in us, / that every soul we come in contact with / may feel your presence in our soul. / Let them look up and see no longer us / but only Jesus! / Stay with us, / and then we shall begin to shine as you shine; / so to shine as to be a light to others; / the light, O Jesus, will be all from you, / none of it will be ours; / it will be you, shining on others through us. / Let us thus praise you in the way you love best / by shining on

those around us. / Let us preach you without preaching, / not by words but by our example, / by the catching force, / the sympathetic influence of what we do, / the evident fullness of the love our hearts bear / to you. Amen.

PRAYER FOR PEACE
Lord, make me a channel of your peace, that where there is hatred,
 I may bring love;
where there is wrong,
 I may bring the spirit of forgiveness;
where there is discord,
 I may bring harmony;
where there is error,
 I may bring truth;
where there is doubt,
 I may bring faith;
where there is despair,
 I may bring hope;
where there are shadows,
 I may bring light;
where there is sadness,
 I may bring joy;
Lord, grant that I may seek rather
 to comfort than to be comforted;
to understand than to be understood;
to love than to be loved;
for it is by forgetting self that one finds,
it is by forgiving that one is forgiven,
it is by dying that one awakens to eternal life. Amen.

ANIMA CHRISTI
Soul of Christ, sanctify me,
Body of Christ, save me,
Blood of Christ, inebriate me,
Water from the side of Christ, wash me,
Passion of Christ, strengthen me,
O Good Jesus, hear me,
Within Thy wounds hide me,
Suffer me not to be separated from Thee,
From the malicious enemy defend me,
In the hour of my death call me,
And bid me come unto Thee,
That with Thy Saints I may praise Thee,
For ever and ever. Amen.

PRAYER OF POPE PAUL VI
 Make us worthy, Lord, / to serve our fellow men throughout the world / who live and die in poverty and hunger. / Give them through our hands this day their daily bread, / and by our understanding love, give peace and joy.

PRAYER BEFORE LEAVING FOR APOSTOLATE
 Dear Lord, the Great Healer, I kneel before You, since every perfect gift must come from You. I pray, give skill to my hands, clear vision to my mind, kindness and meekness to my heart. Give me singleness of purpose, strength to lift up a part of the burden of my suffering fellow men, and a true realization of the privilege that is mine. Take from my heart all guile and worldliness that with the simple faith of a child, I may rely on You. Amen.

Sing: Be with us Mary along the way
 Guide every step we take
 Lead us to Jesus, your loving Son
 Come with us, Mary, come.

MID-DAY EXAMEN PRAYERS

VENI CREATOR
(On Thursdays and Sundays)
Creator spirit all divine
Come visit every soul of Thine
And fill with Thy celestial flame
The hearts which Thou, Thyself, didst frame.

O gift of God Thine is the sweet
Consoling name of paraclete
And spring of life, and fire of love
And unction flowing from above.

The mystic sevenfold gifts are Thine
Finger of God's right hand divine
And Father's promise sent to teach
The tongue a rich and heavenly speech.

Kindle with fire brought from above
Each sense, and fill our hearts with love
And grant our flesh so weak and frail
The strength of Thine which cannot fail.

Drive far away our deadly foe
And grant us Thy true peace to know
So we led by Thy guidance still
May safely pass through every ill.

To us through Thee the grace be shown
To know the Father and the Son
And spirit of them both may we
Forever rest our faith in Thee.

To Father, Son be praises meet,
And to the Holy Paraclete
And may Christ send us from above
That Holy Spirit's gift of love.

VENI CREATOR
(Daily, except Thursday and Sunday)
Come Holy Spirit Creator Blest
And in our souls take up your rest,
Come with your grace and heavenly aid
To fill the hearts which you have made.

To you the comforter we cry
To you the gift of God Most High,
The fount of life and fire of love
And souls anointing from above.

Make to us the Father known
Teach us the eternal Son to own,
Be this our never changing creed
That you from them both proceed.

To God the Father let us sing
To God the Son our risen King
And equally let us adore
The spirit God forevermore.

V. Send forth your Spirit and they shall be created.

R. And thou shalt renew the face of the earth.

Let us pray

O God, / you teach the hearts of the faithful by sending them the light of the Holy Spirit, / grant us / by the same spirit / to have a right judgment in all things / and ever more to rejoice in His holy comfort. Amen.

(in thanksgiving for our vocation, for our parents and benefactors)
MEMORARE
Remember, O most gracious Virgin Mary, that never was it known / that any one who fled to your protection, / implored your help, / or sought your intercession, / was left unaided. / Inspired with this confidence, / we fly to you, / O Virgin of virgins, our mother; / to you we come, / before you we stand, / sinful and sorrowful; / O Mother of the Word Incarnate, / despise not our petitions, / but in your clemency hear and answer us. Amen.

Litanies for each day of the week and according to Liturgical Seasons.

LITANY OF THE HOLY NAME OF JESUS
SUNDAY
(and daily from Easter to Trinity Sunday)
Lord, have mercy on us.
Christ, have mercy on us.
Lord, have mercy on us.
Jesus, hear us.
Jesus, graciously hear us.
God the Father of Heaven, HAVE MERCY ON US.
God, the Son, Redeemer of the world,
God the Holy Spirit,
Holy Trinity, one God,
Jesus, Son of the living God,
Jesus, splendour of the Father,
Jesus, brightness of eternal light,
Jesus, King of glory,
Jesus, Son of justice,
Jesus, Son of the Virgin Mary,
Jesus, most amiable,
Jesus, most admirable,
Jesus, mighty God,
Jesus, father of the world to come,
Jesus, angel of great counsel,
Jesus, most powerful,
Jesus, most patient,
Jesus, most obedient,
Jesus, meek and humble of heart,
Jesus, lover of chastity,
Jesus, lover of us,
Jesus, the God of peace,
Jesus, the Author of life,
Jesus, example of virtues,
Jesus, zealous lover of souls,
Jesus, our God,
Jesus, our refuge,
Jesus, the Father of the poor,
Jesus, treasure of the faithful,
Jesus, the Good Shepherd,
Jesus, the true light,
Jesus, eternal wisdom,
Jesus, infinite goodness,
Jesus, our way and our life,
Jesus, the joy of angels,
Jesus, the King of Patriarchs,
Jesus, the master of the Apostles,
Jesus, the teacher of the Evangelists,
Jesus, the strength of martyrs,
Jesus, the light of confessors,

Jesus, the purity of virgins,
Jesus, the crown of all Saints,
Be merciful unto us.
Jesus, spare us.

Be merciful unto us.
Jesus, hear us.
From all evil, JESUS DELIVER US.
From all sin,
From your wrath,
From the snares of the devil,
From the spirit of uncleanness,
From everlasting death,
From the neglect of your inspirations,
Through the mystery of Your holy Incarnation,
Through Your nativity,
Through Your infancy,
Through Your most divine life,
Through Your labours,
Through Your agony and passion,
Through Your Cross and dereliction,
Through Your faintness and weariness,
Through Your death and burial,
Through Your Resurrection,
Through Your Ascension,
Through Your institution of the most Holy Eucharist,
Through Your joys,
Through Your glory,
Lamb of God, You take away the sins of the world,
spare us, O Jesus.
Lamb of God, You take away the sins of the world,
graciously hear us, O Jesus.
Lamb of God, You take away the sins of the world,
have mercy on us, O Jesus.
Jesus, hear us.
Jesus, graciously hear us.

Let us pray

O Lord Jesus Christ, who said:
Ask and you shall receive, seek and you shall find,
knock and it shall be opened unto you, grant we
beseech You to us Your supplicants, the gift of Your
most divine love, that we may love You with our whole
hearts and in all our words and works and never cease
from praising You.

O Lord, give us a perpetual fear as well as love of Your
Holy Name, for You never cease to govern those You
founded upon the solidity of Your love, Who live and
reign world without end. Amen.

LITANY OF THE HOLY SPIRIT
MONDAY
Lord, have mercy on us.
Christ have mercy on us.
Lord, have mercy on us.
Christ, hear us,
Christ, graciously hear us.
God the Father of heaven, HAVE MERCY ON US.
God, the Son, Redeemer of the world,
God, the Holy Spirit,
Holy Spirit, who proceeds from the Father and the Son,
Holy Spirit, co-equal with the Father and the Son,
Promise of the Father, most loving and most bounteous,
Gift of the Most High God,
Ray of heavenly light,
Author of all good,
Source of living water,
Consuming fire,
Burning love,
Spiritual unction,
Spirit of truth and power,
Spirit of wisdom and understanding,
Spirit of counsel and fortitude,
Spirit of knowledge and piety,
Spirit of the fear of the Lord,
Spirit of compunction and penance,
Spirit of grace and of prayer,
Spirit of charity, peace, and joy,
Spirit of patience, longanimity, and goodness,
Spirit of benignity, continence, and chastity,
Spirit of the adoption of the sons of God,
Holy Spirit, the Comforter,
Holy Spirit, the Sanctifier,
Who in the beginning moved over the waters,
By whose inspiration spoke the holy men of God,
Who did cooperate in the miraculous conception of the
Son of God,
Who did descend upon Him at His Baptism,
Who on the day of Pentecost did appear in fiery tongues
upon the disciples of our Lord,
By whom we also are born,
Who dwells in us,
Who governs the Church,
Who fills the whole world,
Holy Spirit, hear us.
That You write Your law in our hearts, WE BESEECH
YOU HEAR US.
That You shed abroad Your light in our hearts,
That You inflame us with the fire of Your love,
That You open to us the treasures of Your grace,
That You teach us to ask for them according to Your Will,

That You enlighten us with Your heavenly inspirations,
That You lead us in the way of Your commandments,
That You keep us to Yourself by Your powerful attractions,
That You grant us the knowledge that alone is necessary,
That You make us obedient to Your inspirations,
That You teach us to pray, and Yourself pray with us.
That You clothe us with love towards our brethren,
That You inspire us with horror of evil,
That You direct us in the practice of good,
That You give us the grace of all virtues,
That You cause us to persevere in justice,
That You be Yourself our everlasting reward,
Lamb of God, who takes away the sins of the world, spare us, O Lord.
Lamb of God, who takes away the sins of the world, graciously hear us, O Lord.
Lamb of God, who takes away the sins of the world, have mercy on us, O Lord.
Holy Spirit, hear us.
Holy Spirit, graciously hear us.
Lord, have mercy on us.
Christ, have mercy on us.
Create in us a clean heart, O God.
And renew a right spirit in us.

Let us pray

Grant, O Merciful Father, that Your divine Spirit may enlighten, inflame, and cleanse our hearts, that He may penetrate us with His heavenly dew and make us fruitful in good works, through Jesus Christ, Our Lord. Amen.

LITANY OF HUMILITY
TUESDAY
Lord, have mercy on us.
Christ, have mercy on us.
Lord, have mercy on us.
Christ, hear us.
Christ, graciously hear us.
God the Father of Heaven, HAVE MERCY ON US.
God the Son, Redeemer of the world,
God, the Holy Spirit,
Holy Trinity, One God,
O Jesus, meek and humble of heart,
Make our hearts like Yours.
From the desire of being esteemed, DELIVER ME, O JESUS.
From the desire of being loved,
From the desire of being extolled,

From the desire of being honored,
From the desire of being praised,
From the desire of being preferred,
From the desire of being consulted,
From the desire of being approved,
From the desire of being popular,
From the fear of being humiliated,
From the fear of being despised,
From the fear of suffering rebukes,
From the fear of being calumniated,
From the fear of being forgotten,
From the fear of being wronged,
From the fear of being ridiculed,
From the fear of being suspected,

That others may be loved more than I,
JESUS, GRANT ME THE GRACE TO DESIRE IT.
That others may be esteemed more than I,
That in the opinion of the world, others may increase and I may decrease,
That others may be chosen and I set aside,
That others may be praised and I unnoticed,
That others may be preferred to me in everything,
That others may become holier than I, provided that I may become as holy as I should,

Lamb of God, who takes away the sins of the world, spare us, O Lord.
Lamb of God, who takes away the sins of the world, graciously hear us, O Lord.
Lamb of God, who takes away the sins of the world, have mercy on us, O Lord.

Let us pray

O Lord Jesus Christ, who said: Ask and you shall receive, seek and you shall find, knock and it shall be opened unto you, grant we beseech You to us Your supplicants, the gift of Your most divine love, that we may love You with our whole hearts and in all our words and works, and never cease from praising You.

O Lord, give us a perpetual fear as well as love of Your Holy Name, for You never cease to govern those You founded upon the solidity of Your love, who live and reign world without end, Amen.

LITANY OF ST. JOSEPH
WEDNESDAY
Lord, have mercy on us.
Christ, have mercy on us.

Lord, have mercy on us.
Christ, hear us.
Christ, graciously hear us.
God the Father of Heaven, HAVE MERCY ON US.
God the Son, Redeemer of the world,
God the Holy Spirit,
Holy Trinity, One God,
Holy Mary, PRAY FOR US.
Saint Joseph,
Illustrious Scion of David,
Light of Patriarchs,
Spouse of the Mother of God,
Chaste guardian of the Virgin,
Foster father of the Son of God,
Diligent defender of Christ,
Head of the Holy Family,
Joseph most just,
Joseph most chaste,
Joseph most prudent,
Joseph most obedient,
Joseph most faithful,
Mirror of patience,
Lover of poverty,
Model of workers,
Ornament of domestic life,
Guardian of virgins,
Safeguard of families,
Consolation of the poor,
Hope of the sick,
Patron of the dying,
Terror of demons,
Protector of Holy Church,

Lamb of God, who takes away the sins of the world,
spare us, O Lord.
Lamb of God who takes away the sins of the world,
graciously hear us, O Lord.
Lamb of God, who takes away the sins of the world,
have mercy on us.

V. He has placed him Lord of His house.
R. And prince of all His possessions.

Let us pray

O God, who by an ineffable providence was pleased to
elect the Blessed Joseph as spouse of thy Mother, grant,
we beseech Thee, that as we venerate him as protector
on earth, we may deserve to have him as intercessor in
heaven, who lives and reigns world without end.
Amen.

LITANY OF THE SACRED HEART
THURSDAY
Lord, have mercy on us.
Christ, have mercy on us.
Lord, have mercy on us.
Christ, hear us.
Christ, graciously hear us.
God the Father of Heaven, HAVE MERCY ON US.
God the Son, Redeemer of the world,
God the Holy Spirit,
Holy Trinity, One God,
Heart of Jesus, Son of the eternal Father,
Heart of Jesus, formed by the Holy Spirit in the Virgin
Mother's womb,
Heart of Jesus, substantially united to the word of God,
Heart of Jesus of infinite majesty,
Heart of Jesus, Holy Temple of God,
Heart of Jesus, tabernacle of the Most High,
Heart of Jesus, house of God and gate of heaven,
Heart of Jesus, glowing furnace of charity,
Heart of Jesus, vessel of justice and love,
Heart of Jesus, full of goodness and mercy,
Heart of Jesus, abyss of all virtues,
Heart of Jesus, most worthy of all Praise,
Heart of Jesus, king and center of all hearts,
Heart of Jesus, containing all the treasures of wisdom
and knowledge,
Heart of Jesus, having all the fullness of the Godhead,
Heart of Jesus in whom the Father is well pleased,
Heart of Jesus, of whose fullness we have received,
Heart of Jesus, desire of the everlasting hills,
Heart of Jesus, patient and rich in mercy,
Heart of Jesus, enriching all who call upon Thee,
Heart of Jesus, fount of life and holiness,
Heart of Jesus, propitiation of our offenses,
Heart of Jesus, overwhelmed with reproaches,
Heart of Jesus, bruised for our iniquities,
Heart of Jesus, obedient even unto death,
Heart of Jesus, pierced with a lance,
Heart of Jesus, source of all consolation,
Heart of Jesus, our life and resurrection,
Heart of Jesus, our peace and reconciliation,
Heart of Jesus, victim for our sins,
Heart of Jesus, salvation of those who hope in You,
Heart of Jesus, hope of those who die in You,
Heart of Jesus, delight of all saints,

Lamb of God, who takes away the sins of the world,
spare us, O Lord.
Lamb of God, who takes away the sins of the world,
graciously hear us, O Lord.

Lamb of God, who takes away the sins of the world, have mercy on us.

Let us pray

Almighty and everlasting God, look on the Heart of Your Son and the praise and satisfaction He offers You for sinners. In Your goodness, pardon those who ask your mercy in the name of Your Son, Jesus Christ, who lives and reigns with You forever and ever. Amen.

LITANY OF THE PASSION OF OUR LORD FRIDAY
(and daily from Ash Wednesday to Holy Saturday)
Lord, have mercy on us.
Christ, have mercy on us.
Lord, have mercy on us.
Christ, hear us.
Christ, graciously hear us.
God the Father of heaven, HAVE MERCY ON US.
God the Son, Redeemer of the world,
God the Holy Spirit,
Holy Trinity, One God,
Jesus Christ, who for our redemption came down from heaven,
Jesus Christ, who was born of the glorious Virgin Mary,
Jesus Christ, who for us took the form of a servant,
Jesus Christ, who lay in the manger,
Jesus Christ who did not disdain to weep,
Jesus Christ, who macerated Your body with hunger and thirst,
Jesus Christ, who for us continued in prayer, even unto a bloody sweat,
Jesus Christ, who suffered Yourself to be betrayed with a kiss by Judas,
Jesus Christ, who was taken and cast down upon the ground,
Jesus Christ, who suffered Yourself to be led with Your hands bound behind Your back,
Jesus Christ, who was brought before the chief priests and falsely accused,
Jesus Christ, who was smitten on the face with blows and stripes,
Jesus Christ, who was mocked with diverse reproaches,
Jesus Christ who was delivered to Pilate,
Jesus Christ, who was tied to the pillar and scourged, even unto blood,
Jesus Christ, who was clothed with a purple garment by the soldiers,
Jesus Christ, who was crowned with hard and sharp thorns,

Jesus Christ, who so often heard those most cruel words: Away with Him, crucify Him,
Jesus Christ, who being wearied and burdened, bore the hard wood of the Cross,
Jesus Christ, who being lifted up on the Cross was made the companion of thieves,
Jesus Christ, who having Your hands and feet nailed to the Cross, was blasphemed by those who passed by,
Jesus Christ, whose beautiful face was made as it were leprous,
Jesus Christ, who prayed to Your Father for those that crucified You, and graciously heard the thief upon the cross,
Jesus Christ, who recommended Your most dear Mother to St. John,
Jesus Christ, who was pierced with a spear and redeemed the world with Your own Blood,
Jesus Christ, who was laid in a sepulchre,
Jesus Christ, who rose from the dead the third day,
Jesus Christ, who forty days afterwards ascended into heaven,
Jesus Christ, who sits at the right hand of the Father,
Jesus Christ, who will come to judge the living and the dead,

Lamb of God, You take away the sins of the world, spare us, O Lord.
Lamb of God, You take away the sins of the world, graciously hear us, O Lord.
Lamb of God, You take away the sins of the world, have mercy on us, O Lord.
Christ, hear us.
Christ, graciously hear us.
Lord, have mercy on us.
Christ, have mercy on us.
Lord, have mercy on us.
Our Father

Let us pray

We beseech You, O Lord Jesus Christ, that the Blessed Virgin Mary may intercede for us with Your clemency, both now and at the hour of our death, who at the hour of Your Passion had her most holy soul pierced through with the sword of sorrow. Amen.

STABAT MATER DOLOROSA
1. At the cross, her station keeping,
 Stood the mournful Mother weeping
 Close to Jesus to the last.

2. Through her heart His sorrow sharing,
 All His bitter anguish bearing,
 Now at length the sword has passed.

3. Oh, how sad and sore distressed,
 Was that Mother highly blest,
 Of the sole-begotten One!

4. Christ above in torment hangs;
 She beneath beholds the pangs,
 Of her dying glorious Son.

5. Is there one who would not weep,
 Whelmed in miseries so deep,
 Christ's dear Mother to behold?

6. Can the human heart refrain
 From partaking in her pain,
 In that Mother's pain untold?

7. Bruised, derided, cursed, defiled,
 She beheld her tender Child,
 All with bloody scourges rent.

8. For the sins of His own nation,
 Saw Him hang in desolation,
 Til His Spirit forth He sent.

9. O thou Mother, fount of love!
 Touch my spirit from above,
 Make my heart with thine accord:

10. Make me feel as thou hast felt;
 Make my soul to glow and melt,
 With the love of Christ my Lord.

11. Holy Mother, pierce me through;
 In my heart each wound renew
 Of my Saviour Crucified:

12. Let me share with thee His pain,
 Who for all my sins was slain,
 Who for me in torments died.

13. Let me mingle tears with thee,
 Mourning Him who mourned for me,
 All the days that I may live:

14. By the cross with thee to stay;
 There with thee to weep and pray,
 Is all I ask of thee to give.

15. Virgin of all virgins blest!
 Listen to my fond request:
 Let me share your grief with thee;

16. Let me to my latest breath
 In my body bear the death
 Of that dying Son of thine.

17. Wounded with His every wound,
 Steep my soul till it has swooned
 In His very blood away!

18. Be to me, O Virgin, nigh,
 Lest in flames I burn and die,
 In His awful judgment day.

19. Christ, when thou shalt call me hence,
 Be thy Mother my defence,
 Be thy cross my victory.

20. While my body here decays,
 May my soul thy goodness praise
 Safe in Paradise with thee. Amen.

We beseech you, O Lord Jesus Christ, / that the Blessed Virgin Mary may intercede for us with your clemency, / both now and at the hour of our death; / who / at the hour of your passion / had her most holy soul pierced through with the sword of sorrow.

LITANY OF OUR LADY
SATURDAY
Lord, have mercy on us.
Christ, have mercy on us.
Lord, have mercy on us.
Christ, hear us.
Christ, graciously hear us.
God the Father of Heaven, HAVE MERCY ON US.
God the Son, Redeemer of the world,
God the Holy Spirit,
Holy Trinity, One God,

Holy Mary, PRAY FOR US.
Holy Mother of God,
Holy Virgin of Virgins,
Mother of Christ,
Mother of divine grace,
Mother most pure,
Mother most chaste,
Mother inviolate,
Mother undefiled,

Mother most amiable,
Mother most admirable,
Mother of good counsel,
Mother of our Creator,
Mother of our Savior,
Virgin most prudent,
Virgin most venerable,
Virgin most renowned,
Virgin most powerful,
Virgin most merciful,
Virgin most faithful,
Mirror of justice,
Seat of wisdom,
Cause of our joy,
Spiritual vessel,
Vessel of honor,
Vessel of singular devotion,
Mystical rose,
Tower of David,
Tower of ivory,
House of gold,
Ark of the Covenant,
Gate of Heaven,
Morning star,
Health of the sick,
Refuge of sinners,
Comforter of the afflicted,
Help of Christians,
Queen of Angels,
Queen of patriarchs,
Queen of prophets,
Queen of apostles,
Queen of martyrs,
Queen of confessors,
Queen of virgins,
Queen of all saints,
Queen conceived without original sin,
Queen of the most Holy Rosary,
Queen assumed into Heaven,
Queen of Peace.

Lamb of God, who takes away the sins of the world,
spare us, O Lord.
Lamb of God, who takes away the sins of the world,
graciously hear us, O Lord.
Lamb of God, who takes away the sins of the world,
have mercy on us.
V. Pray for us, O Holy Mother of God.
R. That we may be made worthy of the promises
of Christ.

Let us pray

Pour forth, We beseech You, O Lord, Your grace into
our hearts, that we, to whom the Incarnation of Christ
Your Son was made known by the message of an angel
may by His Passion and Cross be brought to the glory
of His resurrection through the same Christ Our Lord.
Amen.

LITANY

FROM CHRISTMAS TO EPIPHANY
Lord, have mercy on us.
Christ, have mercy on us.
Lord, have mercy on us.
Christ, hear us.
Christ, graciously hear us.
God the Father of heaven, HAVE MERCY ON US,
God the Son, Redeemer of the world,
God the Holy Spirit,
Holy Trinity, One God,
Infant, Son of the Virgin Mary,
Infant, begotten before the morning star,
Infant, Word made Flesh,
Infant, our God,
Infant, our Brother,
Infant, possessing all things, yet divested of all,
Infant, who wept in a cradle,
Infant, desired by the Magi,
Infant, overthrower of idols,
Infant, filled with zeal for God, Your Father,
Infant, powerful in weakness,
Infant, treasure of grace,
Infant, who established in bliss the lost sons of Adam,
Infant, Lord of the Angels,
Infant, Joy of the Shepherds,
Infant, Light of the Wise Men,
Infant, Salvation of Infants,
Infant, Expectation of the Just,
Infant, First-fruit of all Saints,
Infant, Light of the world,
Be favourable to us, and pardon us, O Infant Jesus,
From the slavery of the children of Adam, DELIVER US,
 O INFANT JESUS.
From the captivity of the devil,
From the malice of the world,
From the concupiscence of the flesh,
From the concupiscence of the eyes,
From the pride of life,
From the disorderly passion for knowledge,

From the blindness of the understanding,
From the malice of the will,
From all our offences,
By Your Pure Conception,
By Your poor and humble Nativity,
By Your painful Circumcision,
By Your glorious Manifestation,
By Your holy Presentation,
By Your infant conversation,
By Your fatiguing journey,
By Your poverty,
By Your tears,

Lamb of God, You take away the sins of the world,
spare us, O Infant Jesus.
Lamb of God, You take away the sins of the world,
graciously hear us, O Infant Jesus.
Lamb of God, You take away the sins of the world,
have mercy on us, O Infant Jesus.

Let us pray

 O Lord, / who for the love of us / has been pleased to pass through / all the infirmities and vicissitudes of infancy, / mercifully grant that, being filled with the spirit of that holy infancy, /we may be recognized as children of God / Your brethren / who with the Father and the Holy Spirit / lives and reigns, one God world without end. Amen.

 O Blessed parents of the Infant Jesus, / Mary and Joseph, / we humbly and earnestly implore you to beg for us, / at the crib of your Infant Son, / that like Him / and as His true and faithful followers / we may love to live in true humility, / disengagement from creatures / contempt of the world and its vanities, / constant recollection of the holy presence of God, / fervour and fidelity in all our duties, / and in the practice of the tenderest charity to all persons. / May we never blush at the humility of the crib, / nor at the poverty and simplicity of Bethlehem. / May we ever rejoice at our happy lot as children of the true Church; / ever in tender charity look with a compassionate eye on those who live but for this world; and continually pray that all may come to bless, / to praise / and to love the Saviour, who comes to redeem them.

Infant Jesus, poor and simple,
 grant our petitions.
Infant Jesus, humble and obedient,
 grant our petitions.

Infant Jesus, silent and recollected,
 grant our petitions.
Holy Mother of the Infant Jesus,
 pray for us.
Blessed St. Joseph,
 pray for us.
All you saints devoted to the Holy Infancy of Jesus,
 pray for us.

PRAYERS AFTER EXAMEN

Let us pray for our Sovereign Pontiff N . . .
 May the Lord preserve him / and give him life / and make him blessed on earth / and deliver him not to the will of his enemies.

Let us pray

O Almighty and Eternal God, / have mercy on your servant (N . . .), / our Sovereign Pontiff, / and direct him, / according to your clemency, / in the way of everlasting salvation, / that by your grace he may desire such things as are agreeable to your holy Will / and perform them with all his strength through Jesus Christ, Our Lord. Amen.

PRAYER TO ST. MICHAEL
O glorious St. Michael, the Archangel, Prince of the Hosts of Heaven, who stands always for the help of the people of God, who did fight with the dragon, that old serpent, and cast him out of Heaven, and valiantly defends the Church of God, we beg of Thee from the bottom of our hearts to assist us in this difficult and dangerous combat, which we, weak and infirm creatures, have to wage with the same enemy, that we may manfully resist and happily overcome him. Amen.

OUR LADY'S OFFICE, (p. 222, from vespers "Afternoon" to the end.)

PRAYERS AT ADORATION

SUNDAY
 Lord Jesus Christ, / in the depths of your heart you adore the eternal Father; / from him you come as radiant Son, / begotten in the love of the Holy Spirit. / Bring us close to your heart that we too, / sharing your divine sonship, may adore the Father who created us in your likeness. / Heavenly Father, bring all those who do not know you / to the creative love revealed in the heart of your Son. Amen.

MONDAY

We praise and adore You, Divine Providence.

We resign ourselves entirely to all Your just and holy designs,

Let us pray

Eternal God, / Your eyes are upon all Your works, / especially intent on Your servants, / turn away from us whatever is hurtful and grant us whatever is advantageous, / that through Your favour / and under the benign influence of Your special Providence / we may securely pass through the transitory dangers and difficulties of this life / and happily arrive at the eternal joys of the next. Through Christ Our Lord. Amen.

TUESDAY

Holy Angels, our advocates, PRAY FOR US
Holy Angels, our brothers,
Holy Angels, our counsellors,
Holy Angels, our defenders,
Holy Angels, our enlighteners,
Holy Angels, our friends,
Holy Angels, our guides,
Holy Angels, our helpers,
Holy Angels, our intercessors,
Lamb of God, etc. (3 times)

Let us pray

O Holy Angels, / guardians of the poor confided to our care, / we entreat your intercession for them and for ourselves. / Obtain of God to crown His work by giving a blessing to our endeavours, / that so we may promote His greater honour and glory procuring their salvation. / Through Christ Our Lord. Amen.

WEDNESDAY

O Glorious St. Joseph, / we most humbly beg of you, by the love and care you had for Jesus and Mary, / to take our affairs, spiritual and temporal, into your hands. / Direct them to the greater glory of God, / and obtain for us the grace to do His holy Will. Amen.

THURSDAY

Lord Jesus, / Our God and Saviour, / we believe that you are present in this sacrament of your Love, / a memorial of your death and resurrection, / a sign of unity and a bond of charity. / In your humanity, You veiled your glory, You disappear still more in the Eucharist, / to be broken, / to become the food of men.

/ Lord Jesus, / give us the faith and strength to die to ourselves / in order to become a harvest for you / so that You may continue through us / to give life to men. / May our minds be ever filled with You / the pledge of our future glory. Amen.

FRIDAY

O Sacred Heart of Jesus, humbly prostrate before you, / we come to renew our consecration, / with the resolution of repairing, / by an increase of love and fidelity to you, / all the outrages unceasingly offered you. / We firmly purpose: —

The more your mysteries are blasphemed, the more firmly we shall believe them, / O Sacred Heart of Jesus!

The more impiety endeavors to extinguish our hopes of immortality,

the more we shall trust in your Heart, / sole hope of mortals! /

The more hearts resist your divine attractions,

the more we shall love, you, / O infinitely amiable Heart of Jesus!

The more your divinity is attacked,

the more we shall adore it, / O divine Heart of Jesus!

The more your holy laws are forgotten and transgressed,

the more we shall observe them, / O most / holy Heart of Jesus!

The more your sacraments are despised and abandoned,

the more we shall receive them with love and and respect, / O most liberal Heart of Jesus!

The more your adorable virtues are forgotten,

the more we shall endeavor to practice them, / O Heart, model of every virtue!

The more the demon labours to destroy souls,

the more we shall be inflamed with a desire to save them, / O Heart of Jesus, zealous lover of souls!

The more pride and sensuality tend to destroy abnegation and love of duty,

the more generous we shall be in overcoming ourselves, / O Heart of Jesus!

O Sacred Heart, / give us so strong and powerful a grace that we may be your apostles in the midst of the world, / and your crown in a happy eternity. Amen.

SATURDAY

O Heart of Mary, / Heart of the tenderest of Mothers, / Cause of our Joy, / we consecrate ourselves unreservedly to you, / our hearts, our bodies, our souls; / we desire to belong to you, in life and in death. / You know, O Immaculate Mother, that your Divine Son has chosen us in His infinite Mercy / in spite of our misery and sinfulness, / not only as His children and His spouses, / but also as His victims, / to console His Divine Heart in the Sacrament of His love, / to atone for sacrileges, / and to obtain pardon for poor sinners. / We come today, to offer Him through your most Pure Heart, / the entire sacrifice of ourselves. / Of our own free choice we renounce all the desires and inclinations of our corrupt nature; / and we accept willingly and lovingly whatever sufferings He may be pleased to send us. / But conscious of our weakness, / we implore you, / O holy Mother, to shield us with your maternal protection / and to obtain from your Divine Son all the graces we need to persevere. / Bless our society, this house, and the houses we visit, / and each soul confided to our care, / our relations, friends, benefactors that all may persevere in grace or recover it if lost, and when the hour of death comes, / may our hearts, modelled on your Immaculate Heart, / breathe forth their last sigh into the Heart of your Divine Son. / Amen.

Sing: Sweet Lord, Thy thirst for souls, I satiate with my burning love, all for Thee. My chalice will be filled with love, sacrifices made all for Thee. Evermore, I will quench Thy thirst, Lord. Evermore I will quench Thy thirst, Lord, for souls, in union with Mary, Our Queen, I will quench Thy thirst.

PRAYER AFTER DINNER

We come to you, Our Heavenly Father, to renew our humble tribute of homage and adoration. / As it was by you we began the day, so it is with you we desire to continue it. / You are the centre where we seek for rest and comfort, / and we are desirous of no repose but what is found in you. We come also for a fresh supply of strength and vigour, / in order to finish the day and repair the faults we have committed in the earlier part

of it. / Grant us, O Lord, all the helps that are necessary for this purpose / and come into our hearts to be yourself our strength, our support and defence. Amen.

OUR LADY'S OFFICE, (p. 220, from opening prayer up to "Morning".)

NIGHT PRAYERS

I confess to almighty God, / and to you my brothers and sisters / that I have sinned through my own fault (strike the breast) / in my thoughts and in my words, / in what I have done, / and in what I have failed to do: / and I ask Blessed Mary, ever Virgin / and all the angels and saints, / and you my brothers and sisters, / to pray for me to the Lord our God.

3 Hail Marys

Our Queen! and Mother, we give you ourselves / and to show our devotion to you / we consecrate to you this day, and for ever / our eyes, ears, mouth, heart, ourselves / wholly and without reserve. / Wherefore / good Mother / as we are your own, / keep us defend us; as your property and your own possession.

Eternal Father, / we offer you the Sacred Heart of Jesus / with all its love, suffering, and merits:

To expiate all the sins we have committed this day / and during all our lives. / Glory be, etc.

To purify the good we have done in our poor way this day, and during all our lives. / Glory be, etc.

To make up for the good we ought to have done / and that we have neglected this day and during all our lives. Glory be, etc.

Eternal Father, we offer you the most Precious Blood of Jesus shed for us with such great love and bitter pain / from the wound in His right hand and through its merits and its might / we entreat your Divine Majesty to grant us your holy Benediction, / that by its power we may be defended against all our enemies / and freed from every ill.

May the blessing of God Almighty, / Father and Son and Holy Spirit, / descend upon us and remain with us for ever. Amen.

NOVENA FOR THE FIRST FRIDAY OF THE MONTH

Remember, O Jesus, meek and humble of Heart, / that in what need soever, / no one who had recourse to Your most loving Heart / was ever rejected or sent away unrelieved. / Animated with this confidence, / Jesus, / we come to You; / burdened with miseries we

fly to You, / and with our miseries we throw ourselves on Your Heart. / Do not, O God, our Father, cast us off, Your all-unworthy children, / but give us admittance, we beseech You, into Your Sacred Heart, / suffer us / never to be separated therefrom. / Aid us, we entreat you in all our wants now and forever, / but above all at the hour of our death, / O most benign, / O most compassionate, / O most sweet Jesus.

Sacred Heart of Jesus, we trust in You.

NOVENA TO ST. JOSEPH

O Glorious St. Joseph, faithful follower of Jesus Christ, / to you do we raise our hearts and hands, / to implore your powerful intercession in obtaining from the benign Heart of Jesus / all the helps and graces necessary for our spiritual and temporal welfare, / particularly the grace of a happy death, / and the special favour we now implore. /

O guardian of the Word Incarnate, / we feel filled with confidence / that your prayers on our behalf / will be graciously heard before the throne of God. /

O Glorious St. Joseph, / through the love you bear to Jesus Christ, / and for the glory of His name, / hear our prayers and obtain our petitions. (Repeat 7 times)

Let us pray

O Glorious St. Joseph, / spouse of the Immaculate Virgin, / obtain for us a pure, / humble, and charitable mind, / and perfect resignation to the divine Will. / Be our guide, father, and model through life, / that we may merit to die as you did, / in the arms of Jesus and Mary.

NOVENA TO OUR LADY

Let us spend our lives beside you, O Mother, / to bear you company in your sad solitude and deepest woe; / let us feel in our soul the sorrowful glance of your eyes / and the abandonment of your Heart.

What we ask for on the road of life is not the joy of Bethlehem, / not to adore the infant God in your virginal arms; we do not ask to enjoy the sweet presence of Jesus Christ in your humble home at Nazareth, nor to join the choir of angels at your glorious assumption. / Throughout our lives we beg for the mockery and jeers of Calvary. / We ask for the slow agony of your Son, / the scorn, the ignominy and the shame of the cross. / We ask only, O most sorrowful Virgin, to be allowed to stand beside you, / to strengthen our spirit by your tears, to consummate our sacrifice by your martyrdom, /

to sustain our hearts by your loneliness, / to love our God and your God by the immolation of our whole being.

NOVENA TO THE SACRED HEART

O Divine Jesus, who has said: / Ask and you shall receive, / seek and you shall find, knock and it shall be opened unto you; / behold us prostrate at Your feet. Animated with a lively faith and confidence in these promises, / dictated by Your Sacred Heart / and pronounced by Your adorable lips, we come to ask *(here mention the request).*

From whom shall we ask, O sweet Jesus, if not from You, / whose Heart is an inexhaustible source of all graces and merits? Where shall we seek, / if not in the Treasure which contains all the riches of Your clemency and bounty? / Where shall we knock, / if it be not at the door of Your Sacred Heart / through which God Himself comes to us and through which we go to God?

To You then, O Heart of Jesus, we have recourse. / In You we find consolation when afflicted, / protection when persecuted, / strength when overwhelmed with trials, / and light in doubt and darkness. / We firmly believe that You can bestow upon us the grace we implore, / even though it should require a miracle. We confess we are most unworthy of Your favours, O Jesus, / but this is not a reason for us to be discouraged. You are the God of Mercies / and You will not refuse a contrite and humble heart. / Cast upon us a look of pity, / we beg of You, / and Your compassionate Heart will find in our miseries and weakness / a pressing motive for granting our petitions.

But, O Sacred Heart, / whatever may be Your decision with regard to our request, / we will never cease to adore, love, praise, and serve You. Deign, Lord Jesus, to accept this, / our act of perfect submission to the decrees of Your adorable Heart, which we sincerely desire / may be fulfilled in and by us / and all Your creatures / for ever and ever. Amen.

O Sacred Heart of Jesus,
 Your Kingdom come!

NOVENA—COMMON PRAYER

Dearest and most loving . . . we unite with you / in bowing down to adore the Divine Majesty, / and we return thanks for the wonderful gifts of grace and of glory / which He conferred upon you in life and after

death. / Most earnestly do we entreat you to obtain for us by your powerful intercession, / the all-important grace of living and dying like a saint (*here ask the favour you desire*). And, if that which we ask, be not in conformity with God's glory / and the greater good of our soul, / be pleased to procure for us that which may secure the attainment of both.

Our Father . . . Hail Mary . . . Glory be to . . .

NOVENA TO INFANT JESUS

Hail and blessed be the hour and moment / in which the Son of God was born of the most pure Virgin Mary / at midnight in Bethlehem in piercing cold. / In that hour vouchsafe, O my God! / to hear our prayers and grant our desires, / through the merits of our Saviour Jesus Christ, and his Blessed Mother. Amen.

ACT OF CONSECRATION TO THE IMMACULATE HEART OF MARY CAUSE OF OUR JOY

O Heart of Mary ever virgin: / O Heart, the holiest, the purest, the most perfect that Almighty God has formed in any creature; / O Heart full of grace and sweetness, throne of love and mercy, / image of the adorable Heart of Jesus, / we, your children, the Missionaries of Charity, find our joy and consolation in consecrating ourselves to you, / in loving and honouring you. / We give you thanks for all the benefits which you have obtained for us from the divine Mercy, / and, in particular, for the privilege of having been chosen by your divine Son / to quench His thirst for souls / through our observance of the vows of Poverty, Chastity, and Obedience, / and by spending ourselves unremittingly in seeking out in towns and villages, / even amid squalid surroundings, / the poorer, the abandoned, / the sick, the infirm, the dying, by taking temporal and spiritual care of them / and in performing similar apostolic works and services, / however lowly and mean they may appear. / O, dear Mother, we are fully conscious of our weakness, / of the revolts of our nature, / of the snares of the world and of the devil that surround us; / we realize that / left to ourselves / we are utterly incapable of attaining the end of our Congregation, / of doing anything worthy of the glory of God and of your honour. / Yet, under your powerful protection; what can we not do, / what may we not hope for? / You are the dispenser of graces of your divine Son, / you are our Mother, / and the most tender of Mothers, / the Mother of Mercy and of love, the cause of our joy. / O, have pity on us / and on the souls we try to bring to your divine Son; / dispel the dangers to which we, and they, are exposed, / disperse our enemies, / support our weakness, / assist us at every moment of our lives, / guide us to the end of our course / across the ocean of this world. / Obtain for us the grace of perseverance in our vocation, / bless this our Society, / our community, / bless and protect the houses we visit, / the souls entrusted to our care, / bless our families, / our friends and benefactors; / lead us all to the harbour of eternal happiness, / where we hope to bless you, / to praise you and to love you, for ever / with all the elect. Amen.

Imprimi potest
✠ Ferdinandus, S.J.,
Archiepiscopus Calcutta

PART II

EXAMINATION OF CONSCIENCE

Reflect for a moment on the presence of God, adore Him . . . thank Him for His Love . . . ask for light to see yourself as He sees you.

OUR VOCATION

Am I truly conscious of the gift of the life of grace which I received at Baptism? How often do I turn to Jesus within me during the day?

Am I conscious of the special call I have received and do I live as one specially chosen?

Do I really renounce the world to live for God alone?

Am I really ready for Christ when He knocks at the door of my heart?

OUR CONSECRATION

Do I live a 'life dedicated to God'?

Has God first place in my life?

Am I really living for God or for my own security and my own ends?

Is there a link between my dedication to God in the Liturgy and adoration and my place of work?

Do I follow Christ 'with greater freedom'?

Do I do just what others do?

Do I feel happy in what I do?

When I have to obey the one I do not like?

When I have given up my own way or convenience?

Do I 'faithfully respond to the call'?

Faithfully—is my response fully of faith?

Am I aware of the call?

Do I remember who is calling me?

Even when I am dealing with someone I do not like?

Am I 'driven by the love with which the Holy Spirit floods my heart'?

Am I conscious of the Holy Spirit in my life?

Is my life an emptying of self as Christ did?

Am I attentive to His inspirations?

CHASTITY

Do I look upon my life of Chastity as an outstanding gift of grace?

Do I look on this life as a burden rather than a grace?

Do I really feel free to love others because I have only one love—Jesus?

Am I conscious at the time off work of the nearness of my Beloved?

Do I rejoice because Jesus is present in my community?

Do I take the necessary precautions to remain faithful to my Beloved?

Am I pure and do I inspire purity in those with whom I work?

Can I repeat in front of Jesus what I say to my Sisters? to the poor?

Do I treat anyone in an overfamiliar and exclusive friendship?

POVERTY

Do I realize that I am really rich when I possess the Kingdom, and am I therefore really happy to be poor?

Am I poor in fact and spirit when I ask for permissions?

Am I happy to be deprived of material comforts and am I detached?

Do I really take care of the things entrusted to me because they belong to my Father?

Do I make myself available precisely because I am poor and am available for Christ?

OBEDIENCE

Do I keep the steady vision of Christ in relation to His Father before me? Total dependence… openness to the Father…redemptive mission…?

Have I made a full surrender of my will as a sacrifice of myself to God?

Do I look upon my Superior as the vital link with God's saving will for me? Is my obedience active and responsible and the expression of my love for God?

Is my obedience prompt? cheerful? constant?

Is it unsullied by criticism?

WHOLE-HEARTED FREE SERVICE

Is my work such that I have made it a holy service full of love? Do I pray the work?

Do I really work with an openness to those for whom I work? avoiding partialities?

Do I meet Christ in the distressing disguise of the poor I serve?

Have the people I come in contact with been better because of me?

And conscious that my work is the apostolate of the community?

In my manner of working, am I afraid of difficulties and obstacles, forgetting that I can do all things in Him who strengthens me?

Have I tried to seek the admiration and appreciation of others, or have I sought only to please God?

LIFE OF PRAYER

Do I feel the need for prayer?

Do I use the means to pray better: recollection, custody of the eyes, silence, etc.?

Do I make the Eucharist the source of my life of union with Christ? Is my participation in the Eucharistic Sacrifice sincere? Do I live the Mass during the day?

Do I look upon community spiritual exercises as times of the day set apart for special intimacy with Christ? as moments when Jesus is very specially in our midst knitting us together in His Love? Do I strive to be punctual to Christ's call?

Do I derive from my daily meditation a deeper knowledge of Jesus Christ?

Is my choice of books for spiritual reading such that I am helped to a deeper understanding of God's love for us and of the response of love He awaits from me?

SPIRIT OF PRAYER

Am I truly united to Jesus as I should be so that I can say with St. Paul: 'I live, it is no longer I that live but Christ who lives in me'?

Do I really regard Jesus as my best and greatest friend, the guest of my soul?

Is my principal source of energy really my love of God and of my neighbour? Is it not only too often a hidden self-seeking?

How faithful am I to the practice of ejaculatory prayer?

Am I not inclined to forget that the interior life is a gift of God and that I should ask for it humbly?

Do I do my work with Jesus, for Jesus, and to Jesus?

Let us now express our sorrow to God for our infidelity and humbly beg Jesus, through the intercession of the Blessed Virgin Mary, to help us be faithful in the future.

GOD MADE ME FOR HIMSELF
ALONE WITH JESUS
EXAMEN OF CONSCIENCE—No. 2

SUNDAY: DAY OF FAITH
Faith is the gift I will ask today—to know, love, and serve God.

P.E.[1]: Make acts of faith.
G.E.[2]: Do I really take the trouble to pray,
To be in the presence of God?
How did I spend the time of Mass,
Communion, Adoration, meditation?
Did I make spiritual communion today?
My Rosary? Stations of the Cross?

Is my singing a prayer? My gesture and postures in Prayer / Kneeling, folding hands, taking holy water?
Do I see Jesus in my Sisters, in the poor?
Lord, increase my faith.
Jesus I believe in you, I adore You.

MONDAY: DAY OF SHAME
Sin, Hell, Purgatory

How terrible and real sin must be. God crucifies His Son Jesus to atone for it and creates Hell to punish.

P.E.: Did I sin today? In what? why? examine predominant fault.

G.E.: Do I fear sin / it is the only evil that can destroy the life of God in me. How weak is my love for my Father if I stoop down to sin. We insult God by wanting or being careless about our going to purgatory.

Father forgive.

TUESDAY: DAY OF HOME COMING.
Confession, Contrition

I will rise and I will go to my Father.
I am sorry.

[1]P.E.= particular examen
[2]G.E.= general examen

P.E.: Do I go regularly to Confession where I acknowledge the loving mercy of God and my own wretchedness, sinfulness?

Lord, Jesus have mercy on me, a sinner.

WEDNESDAY: DAY OF GENEROSITY
Chastity and Wholehearted and Free Service

What have I that I have not received?
Therefore all that I have belongs to God.

P.E.: Did I work hard today?
Did I escape humble work or did I grab the chance? Am I ready to do things for others with a smile? Have I a hearty YES to God and a big smile for all, even for myself when in a bad mood? Keep close to Jesus with a smiling face.

THURSDAY: DAY OF LOVING TRUST
Community Life

Jesus loves me, I belong to Jesus.

P.E.: I have NOTHING and NOBODY that separates me from Jesus. True?
Do I get my permissions?
G.E.: Do I trust my Superiors and my Sisters? our Poor? as Jesus entrusted Himself into the Hands of His Priest and me at Communion time.

FRIDAY: DAY OF LOVE
Cross—No greater love

Jesus my God, I have crucified Thee; now it is my turn, Crucify Thou me.

P.E.: Did I do my penance today?
Did I make any deliberate sacrifice today?
G.E.: Did I take my share in the Passion of Jesus, / in his suffering silence, or did I put my pain or sorrow in the market place by speaking of it publicly? With our Lady who stood near the Cross, put your resolution near Jesus crucified and ask:
Is this love for love?
He gave His all for me. Is this my all for Him?

SATURDAY: DAY OF JOY
Cheerfulness

God loves a cheerful giver. She gives best—who gives with a smile.

P.E.: Did I grumble or complain today?
 or did I radiate the Joy of Jesus today? in words?
in deeds?
G.E.: If you are always ready with your YES to God,
you will naturally have a smile for all.

Our Lady is the Cause of our Joy. Let us become Saints
and we shall be the Cause of her JOY.

STATIONS OF THE CROSS

I
V. Jesus is condemned to die.
R. God through sin I crucify.
V. We adore You, O Christ, and thank You
R. Because by your holy Cross You have redeemed the
world.
V. Mary sorrowing hears the death sentence "Crucify
Him, His Blood be on us."
R. O Mary, hear my prayer. Blood of Jesus, be my
redemption.
V. Have mercy on us, O Lord.
R. Have mercy on us.

II
V. Jesus bears the bitter cross.
R. Bear me up in grief and loss.
V. We adore. . . .
R. Because. . . .
V. Mary uncomplaining sees the Precious Blood flow
from the wound in His shoulder.
R. O Mary, help me to shoulder my cross patiently in
union with Jesus.
V. Have mercy on us, O Lord.
R. Have mercy on us.

III
V. Jesus falls in Blood and woe.
R. Sins of mine have struck Him low.
V. We adore. . . .
R. Because. . . .
V. Mary sore-distressed sees the parched earth quickly
drink up His red life.
R. O Mary, when my soul is parched by earthly desires,
recall to me the words of Christ 'He who believes in me
shall never thirst'.
V. Have mercy on us, O Lord.
R. Have mercy on us.

IV
V. Son and Mother meet in pain.
R. Must they grieve for me in vain.

V. We adore. . . .
R. Because. . . .
V. Mary broken-hearted sees Jesus in agony; Jesus sees
her in anguish.
R. O Mary, inspire me with contrition and penance for
causing such sorrow.
V. Have mercy on us, O Lord.
R. Have mercy on us.

V
V. Simon helps to bear the load.
R. Lead me too along your road.
V. We adore. . . .
R. Because
V. Mary bewildered sees all refusing to help Jesus.
R. O Mary, even as I ask Jesus to help me, may He ever
find me ready in apostolic action for the whole Church
and her missions.
V. Have mercy on us, O Lord.
R. Have mercy on us.

VI
V. On a cloth He prints his face.
R. In my soul your image trace.
V. We adore. . . .
R. Because. . . .
V. Mary calm in grief sees Veronica brave the fury of
the crowd.
R. O Mary by the grace of confirmation may I never
fear what the crowd may say or think.
V. Have mercy on us, O Lord.
R. Have mercy on us.

VII
V. Struck to earth again by me.
R. Help me rise to follow you.
V. We adore. . . .
R. Because. . . .
V. Mary in pain untold sees the cross crush Jesus; yet
He rises.
R. O Mary, obtain for me the strength to rise and follow
Christ, my Leader.
V. Have mercy on us, O Lord.
R. Have mercy on us.

VIII
V. "Weep for sin", He tells them here.
R. Jesus make my grief sincere.
V. We adore. . . .
R. Because. . . .
V. Mary suffering sees Jesus suffer from desertion by
His own; yet even now He comforts others.

218

R. O Mary, fill me with zeal for the spiritual works of mercy.
V. Have mercy on us, O Lord.
R. Have mercy on us.

IX
V. Thrice He falls by lashes torn.
R. In your Blood I rise reborn.
V. We adore. . . .
R. Because. . . .
V. Mary crushed in spirit sees Jesus prostrate in the dust.
R. O Mary, lest I fall again help me to prepare worthily and make proper thanksgiving at Confession and Holy Communion.
V. Have mercy on us, O Lord.
R. Have mercy on us.

X
V. Stripping Christ they tear His skin.
R. Help me tear my flesh from sin.
V. We adore. . . .
R. Because. . . .
V. Mary torn from Christ sees Him torn from the robe she made for him.
R. O Mary, strip me from all that stains my baptismal robe.
V. Have mercy on us, O Lord.
R. Have mercy on us.

XI
V. In His hands they drive the nails.
R. In your hands, I cannot fail.
V. We adore. . . .
R. Because. . . .
V. Mary pierced anew sees wells of His Redeeming Blood dug in His hands and feet.
R. O Mary, in His wounds help me to renew my vows and all my resolutions and with those nails bind me to Jesus forever.
V. Have mercy on us, O Lord.
R. Have mercy on us.

XII
V. Jesus dies His all to give.
R. By your death teach me to live.
V. We adore. . . .
R. Because. . . .
V. Mary overwhelmed sees Jesus die, His bleeding wounds pleading for me.
R. O Mary, place one drop of that Redeeming Blood on my sinful soul.

V. Have mercy on us, O Lord.
R. Have mercy on us.

XIII
V. Mary as you take your Son.
R. Take me too when life is done.
V. We adore. . . .
R. Because. . . .
V. Mary mourning receives her dead Jesus from the Altar of the Cross.
R. O Mary, help me to receive the living Christ from the Altar of the Mass with something of your reverence and love.
V. Have mercy on us, O Lord.
R. Have mercy on us.

XIV
V. Buried Christ, who died for me.
R. May I rest at last in you.
V. We adore. . . .
R. Because. . . .
V. Mary now desolate buries in death the son to whom she once gave birth.
R. O Mary, renew your Motherhood over me now and at the hour of my death.
V. Have mercy on us, O Lord.
R. Have mercy on us. Amen.

One Our Father, Hail Mary, and Glory be . . . for the Holy Father's intentions.

ROSARY

(Apostles' Creed)

I salute and venerate you, O most Blessed Virgin Mary, as the daughter of the Eternal Father, and I consecrate to you my body with all its senses that I may offer (renew) with my whole heart, (my) the Vow of Poverty. Hail Mary.

I salute and venerate you, O most Blessed Virgin Mary, as the Mother of the Eternal Son, and I consecrate to you my heart with all its affections, that I may offer (renew) with my whole heart, (my) the Vow of Chastity. Hail Mary.

I salute and venerate you, O most Blessed Virgin Mary, as the Spouse of the Eternal Spirit, and I consecrate to you my soul with all its powers, that I may offer (renew) with my whole heart, (my) the Vow of Obedience. Hail Mary.

I salute and venerate you, O most Blessed Virgin Mary, as the temple of the Holy Trinity, and I consecrate

to you my body and soul, that I may offer (renew) with my whole heart, (my) the Vow of Charity. Hail Mary.

JOYFUL
The Annunciation—Humility.
The Visitation—Charity.
The Nativity—Poverty.
The Presentation—Obedience.
The Finding in the Temple—Perseverance.

"For the Holy Father and our Society."

SORROWFUL
The Agony in the Garden—Perseverance in prayer.
The Scourging at the Pillar—Mortification.
The Crowning with Thorns—Love of humiliation.
The Carrying of the Cross—Fortitude
The Crucifixion—Forgiveness of injuries.

"For the Holy Father and our Society."

GLORIOUS
The Resurrection—Faith.
The Ascension—Hope.
The Coming of the Holy Ghost—Zeal and love for souls.
The Assumption—Union with God.
The Crowning of the Blessed Virgin Mary—Confidence in Her intercession.

"For the Holy Father and our Society."

SALVE REGINA
Hail, Holy Queen, Mother of Mercy! / Hail! Our life, our sweetness and our hope! / To You do we cry, poor banished children of Eve; / to You do we send up our sighs, mourning and weeping in this vale of tears. / Turn then, most gracious advocate, Your eyes of mercy toward us / and after this our exile show unto us the blessed fruit of Your womb, Jesus, / O clement, O loving, O sweet Virgin Mary.
Pray for us, O Holy Mother of God, that we may be made worthy of the promises of Christ.

THE LITTLE OFFICE OF THE IMMACULATE CONCEPTION (OUR LADY'S OFFICE)

PRAYER
Open, O Lord, our mouths to bless your holy name; cleanse our hearts from all vain and distracting thoughts; enlighten our understanding, inflame our will, that we may worthily, attentively, and devoutly recite this office and deserve to be heard in the presence of your divine Majesty. Through Christ Our Lord.

R. Amen.

O Lord, I offer this office to you in union with that divine intention with which you yourself, while on earth, did render praise to God.

AT MATINS "EVENING"
V. Come, O my voice, and let us raise
R. To heaven's bright Queen a song of praise.
V. Propitious thought, O Mother, send us.
R. And from the dreadful foe defend us.
V. Glory be, etc.

HYMN
Hail, mistress of earth;
 hail, heavenly queen!
Hail, Virgin of virgins,
 all chaste and serene!
Bright star of the morning,
 the light of whose face,
Reflects His effulgence,
 who filled you with grace.
O sovereign of angels,
 come quickly, we pray,
And drive every ill,
 that besets us away.
 You from eternity
 God did ordain,
 Over His household
 As mistress to reign;
 You He predestined
 The mother to be
 Of Him who created
 Earth, heaven, and sea;
 You He elected
 The spouse of His Heart.
 Because in our sin
 You never had part.

V. God elected and prepared Her;
R. And gave His own tabernacle for a dwelling.

Let us pray

O Holy Mary, Mother of Our Lord Jesus Christ, Queen of Heaven and Mistress of the world, who never forsakes nor despises anyone, look upon us with an eye

of pity and beg of your beloved Son the pardon of all our sins that we who now devoutly celebrate your Immaculate Conception may receive the reward of eternal joy through the mercy of Jesus Christ our Lord, whom you, pure Virgin, did bring into the world, and who, with the Father and the Holy Spirit in perfect Trinity, lives and reigns one God, world without end. Amen.

V. O Mother, turn a mother's ear.
R. And kindly our petitions hear.
V. Blessed be the Lord.
R. Thanks be to God.
V. May the souls of the faithful departed through the Mercy of God, rest in peace.
R. Amen.

AT PRIME "MORNING"
V. Your help, propitious Mother, tend us.
R. And from the dreadful foe defend us.
V. Glory be, etc.

HYMN
Hail, Virginal wisdom;
 hail, mansion of God,
Where sevenfold pillars
 befit His abode.
All stately without and
 all perfect within,
He chose Him a dwelling
 undarkened by sin;
For even before your
 miraculous birth
you were free from the stain that
 has sullied the earth.
 Mother of all saints
 Living and dead,
 New star that shone
 Over Israel's head
 Sovereign of angels,
 Terror of hell,
 Be you our refuge,
 Who love you so well.
V. In His Holy Spirit He created Her.
R. And exalted Her above all His works.

Sing "AVE, AVE, AVE MARIA"

AT TIERCE
V. Your help, propitious Mother, lend us.
R. And from the dreadful foe defend us.
V. Glory be, etc.

HYMN
Hail, Ark of the Covenant,
 Solomon's throne,
The rainbow you are
 through the Deluge that shone.
Bright bush of the vision,
 fair flowering rod!
Sweet morsel of Samson,
 sealed closet of God!
 O, how befitting
 The Wisdom divine
 To prepare for Himself
 A nature like Thine!
 To which not a speck
 Of the error of Eve,
 That taints all beside,
 For a moment could cleave.

V. My dwelling place is in the highest heavens;
R. And my throne I have placed above the clouds.

Sing "AVE, AVE, AVE MARIA"

AT SEXT
V. Your help, propitious Mother, lend us.
R. And from the dreadful foe defend us.
V. Glory be, etc.

HYMN
Hail, Virginal Mother,
 hail, temple divine;
The glory of angels
 and purity's shrine;
Hail, comfort of mourners,
 bright garden of joy;
Whose beauties the songs
 of all angels employ.
The type of your patience
 is victory's palm;
your chastity's figure the
 fragrance of balm.
 Oh, blessed the clay
Out of which you were wrought,
 So utterly free
 From original blot,
 Oh, city exalted.
 Bright orient gate,
 What graces unite
 In your singular state!

V. Like a lily in the midst of thorns.
R. So among Adam's daughters is my beloved.

Sing "AVE, AVE, AVE, MARIA"

AT NONE
V. Your help, propitious Mother, lend us,
R. And from the dreadful foe defend us.
V. Glory be, etc.

HYMN
Hail, city of refuge,
 the safety of all;
Hail, tower of David,
 impregnable wall;
All flaming with zeal
 for man in his woe,
You crushed the head of
 his Stygian foe.
 Invincible woman,
 Than Judith more bold,
 Fair Abisag cherishing
 David of old;
 Rachel a saviour
 To one people gave;
 You a Redeemer
 All nations to save.

V. All fair are you, my beloved.
R. And there was never a stain of Adam's sin in you.

Sing: "AVE, AVE, AVE MARIA"

Let us pray

O HOLY MARY, etc., (p. 220)

AT VESPERS "AFTERNOON"
V. Your help, propitious Mother, lend us.
R. And from the dreadful foe defend us.
V. Glory be, etc.

HYMN
Hail, wonderful dial
 Ezechias of old
Beheld when the prophet
 His destiny told;
The Word That incarnate
 in you did become,
Receded, descending to
 man's lowly home.

Nine choirs He passed
 of superior powers,
To take up the tenth in
 this nature of ours.
 The beams of this sun
 Are the light of your face,
 And you the aurora
 Preceding his race.
 The serpent that lurks
 In night's desperate gloom
 You crushed, and caused,
 All beauties to bloom.

V. I have caused a never-fading light to rise in heaven;
R. And like a luminous veil have spread it over the earth.

Sing, "AVE, AVE, AVE MARIA"

AT COMPLINE
V. May Jesus Christ, Your Son, at Your intercession convert us.
R. And turn away His anger from us forever.
V. Your help, propitious Mother, lend us.
R. And from the dreadful foe defend us.
V. Glory be, etc.

HYMN
Hail, Virgin productive, yet
 mother unstained;
A Virgin brought forth yet
 a Virgin remained.
No crown was e'er given
 to creature, like Thine,
Twelve stars are the gems
 in its circle that shine.
Above all the angels,
 Immaculate, pure,
At the right of the king
 You shall sit evermore.
 O Mother, through you,
 The sinner's great hope,
 Bright star of the sea,
 May paradise open,
 And thus, in the mansions,
 Of peace and of rest
 with the sight of your Son
 May our vision be blessed.

V. Like fluent oil, O Mary, is your name.
R. And your servants have loved you,
 O how much!

Sing "AVE, AVE, AVE MARIA"

CONCLUDING PRAYERS

Sweet Virgin, we offer
On suppliant knee
These prayers that the Church
Has devoted to you.
O Mary, conduct us
In happiness' way
And at the last hour
Assist us, we pray,
There is a bough in which no blur
of either kind, original
Or wrought hath touched the
virgin rind.

V. In your conception, O virgin, you were immaculate.
R. Pray for us to the Father, whose Son you didst bear.

Let us pray

O God, Who by the Immaculate Conception of the Blessed Virgin Mary did prepare a worthy habitation for your Son, we beseech you that as, by the foresight of His death, you did exempt her from all stain so we, purified by her intercession, may come to you; through the same Jesus Christ our Lord, who lives and reigns world without end. Amen.

COMMON PRAYERS

OUR FATHER

Our Father in heaven, / holy be your Name, your kingdom come, / your Will be done on earth as in heaven. / Give us today our daily bread. / Forgive us our sins / as we forgive those who sin against us. / Do not bring us to the test, / but deliver us from evil. Amen.

HAIL MARY

Hail Mary, full of grace, the Lord is with you. Blessed are you among women, / and blessed is the fruit of your womb Jesus.
Holy Mary, / Mother of God, / pray for us sinners now / and at the hour of our death. Amen.

THE APOSTLES' CREED

I believe in God, / the Father almighty, / creator of heaven and earth. / I believe in Jesus Christ, / his only Son our Lord. / He was conceived by the power of the Holy Spirit / and born of the Virgin Mary. / He suffered under Pontius Pilate, / was crucified, died, and was buried. / He went down to the dead. On the third day he rose again. / He ascended into heaven, and is seated at the right hand of the Father. / He will come again to judge the living and the dead. / I believe in the Holy Spirit, / the holy Catholic Church, / the communion of saints, / the forgiveness of sins, / the resurrection of the body, / and life everlasting. Amen.

GLORIA

Glory to God in the highest, / and peace to his people on earth. / Lord God, heavenly King, / Almighty God and Father, / we worship you, / we give you thanks, / we praise you for your glory. / Lord Jesus Christ, / only Son of the Father, / Lord God, Lamb of God, / you take away the sins of the world: / have mercy on us: / you are seated at the right hand of the Father, / receive our prayer. / For you alone are the Holy One, you alone are the Lord, / you alone are the Most High, / Jesus Christ, / with the Holy Spirit, / in the glory of God the Father. / Amen.

NICENE CREED

We believe in one God, / the Father, the Almighty, / maker of heaven and earth, / of all that is seen and unseen. / We believe in one Lord, Jesus Christ, / the only Son of God, / eternally begotten of the Father, / God from God, Light from Light, / true God from true God, / begotten not made, one in Being with the Father. / Through him all things were made. / For us men and for our salvation / he came down from heaven: by the power of the Holy Spirit / he was born of the Virgin Mary, / and became man. / For our sake he was crucified under Pontius Pilate; / he suffered, died, and was buried. / On the third day / he rose again in fulfillment of the Scriptures; he ascended into heaven / and is seated at the right hand of the Father. He will come again in glory / to judge the living and the dead, / and his kingdom will have no end. / We believe in the Holy Spirit, / the Lord, the giver of life, / who proceeds from the Father and the Son. / With the Father and Son he is worshipped and glorified. / He has spoken through the Prophets. / We believe in one, holy, catholic, and apostolic Church. / We acknowledge one baptism for the forgiveness of sins. / We look for the resurrection of the dead, / and the life of the world to come. / Amen.

PRAYER TO JESUS CRUCIFIED

Behold, O kind and most sweet Jesus, / I cast myself upon my knees in your sight, / and with the most fervent desire of my soul I pray and beseech you that you impress upon my heart / lively sentiments of

faith, hope, and charity, / with a true contrition of my sins / and a firm purpose of amendment; / whilst with deep affection and grief of soul / I ponder within myself and mentally contemplate your five wounds, / having before my eyes the words which David the prophet put (on my lips) concerning you. "They have pierced my hands and my feet, they have numbered all my bones".

ON RISING
V. Let us bless the Lord.
R. Thanks be to God.

O Jesus, through the most pure Heart of Mary, I offer You the prayers, works and sufferings of this day for all the intentions of Your Divine Heart.

 Hail Mary. . . .
 Sacred Heart of Jesus, I trust in You.
 Immaculate Heart of Mary, cause of our joy, pray for us.
 St. Joseph, pray for us.

WHILE DRESSING
Habit: Mary, my dearest Mother, grant that this holy habit (kiss it) remind me of my separation from the world and its vanities. Let the world be nothing to me and I nothing to the world. Let it remind me of my baptismal robe and help me to keep my heart pure from sin just for today.

Girdle: May this girdle (kiss it) remind me, dear Mother, Mary, that I am your child, and as such I must try to imitate your angelic purity, surrounded and protected by that absolute poverty which crowned all that you did for Jesus.

Sari: O Most blessed Virgin Mary, cover me with the mantle of your modesty, and let this sari (kiss it) make me more and more like you.

Crucifix: Let this crucifix (kiss it) remind me that I am the spouse of Jesus Crucified, and as such I must in all things live the life of a victim and do His work of a Missionary of Charity.

Sandals: Of my free will, dear Jesus, I shall follow You wherever You shall go in search of souls, at any cost to myself and out of pure love of You.

ON THE WAY TO THE CHAPEL
Each sigh, each look, each act of mine
Shall be an act of Love Divine,

And every thing that I shall do
Shall be dear Lord, for love of You.
Take this my heart and keep it true.
A fountain sealed, to all but You.
What is there that I would not do today.

DE PROFUNDIS
Out of the depths I cry to you, O Lord, Master listen to my voice; let but your ears be attentive to the voice that calls on you for pardon.

If you, Lord, will keep account of our iniquities, Master who has strength to bear it. Ah! but with you there is forgiveness, be your name ever revered I wait for the Lord. For His word of promise, my soul waits, patient as watchman that looked for the day, patient as watchman at dawn for the Lord; let Israel wait, the Lord with whom there is forgiveness, the Lord with whom there is power and ransom.

He it is that will ransom Israel from all his iniquities.

ON GOING TO BED
Kiss the ground.
Recite the Act of Contrition.
5 Our Fathers, 5 Hail Marys, and
1 Glory be; with arms outstretched.

RECITE THE FOLLOWING PRAYERS ON THE CRUCIFIX
O Jesus, by the wound of your right hand (kiss it) give me a great love for my vow of Poverty and grace to understand and observe it faithfully.

O Jesus by the wound in your left hand (kiss it) give me a great love for my vow of Chastity and grace to understand and observe it faithfully.

O Jesus, by the wound of your right foot (kiss it) give me a great love for my vow of Obedience and grace to understand and observe it faithfully.

O Jesus, by the wound of your left foot (kiss it) give me a great love for my vow of Charity and grace to understand and observe it faithfully.

O Jesus, by the wound of your Sacred side (kiss it) give me the grace of perseverance in your holy service, in this Society and a martyr's death.

224